FRANCISCO GOYA

SERGEI EISENSTEIN

ROBERT LONGO

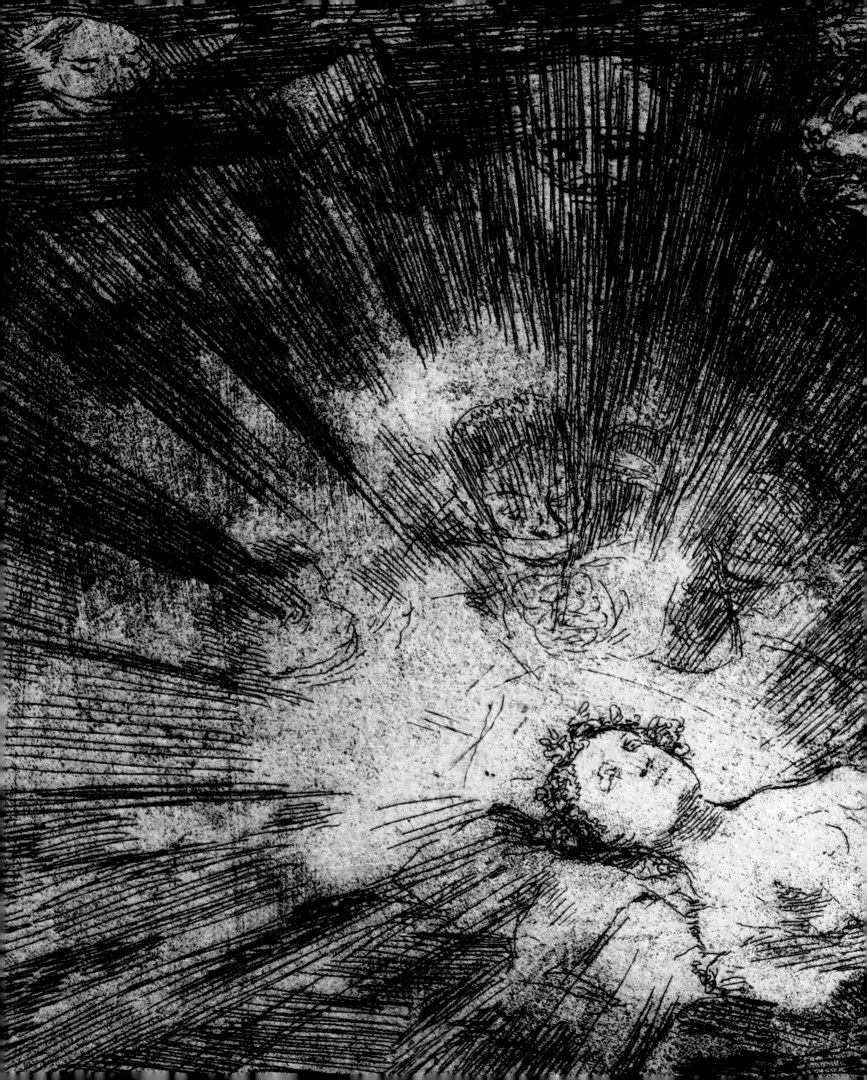

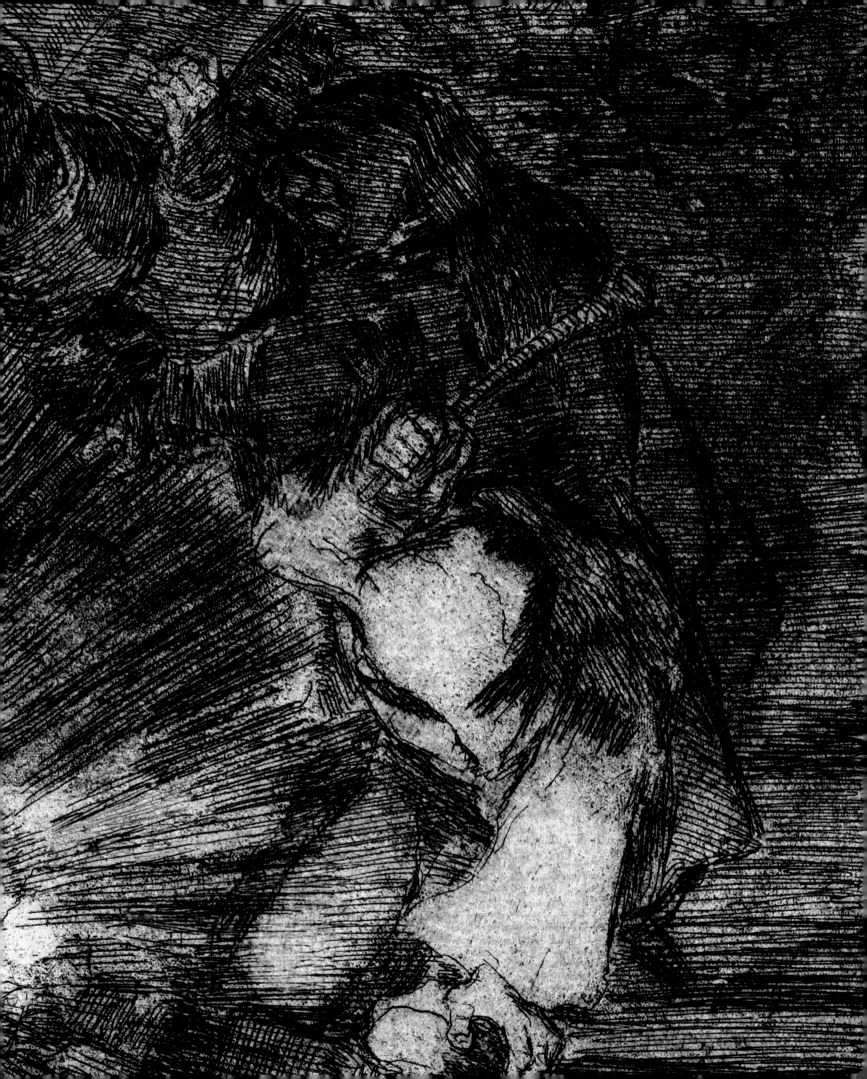

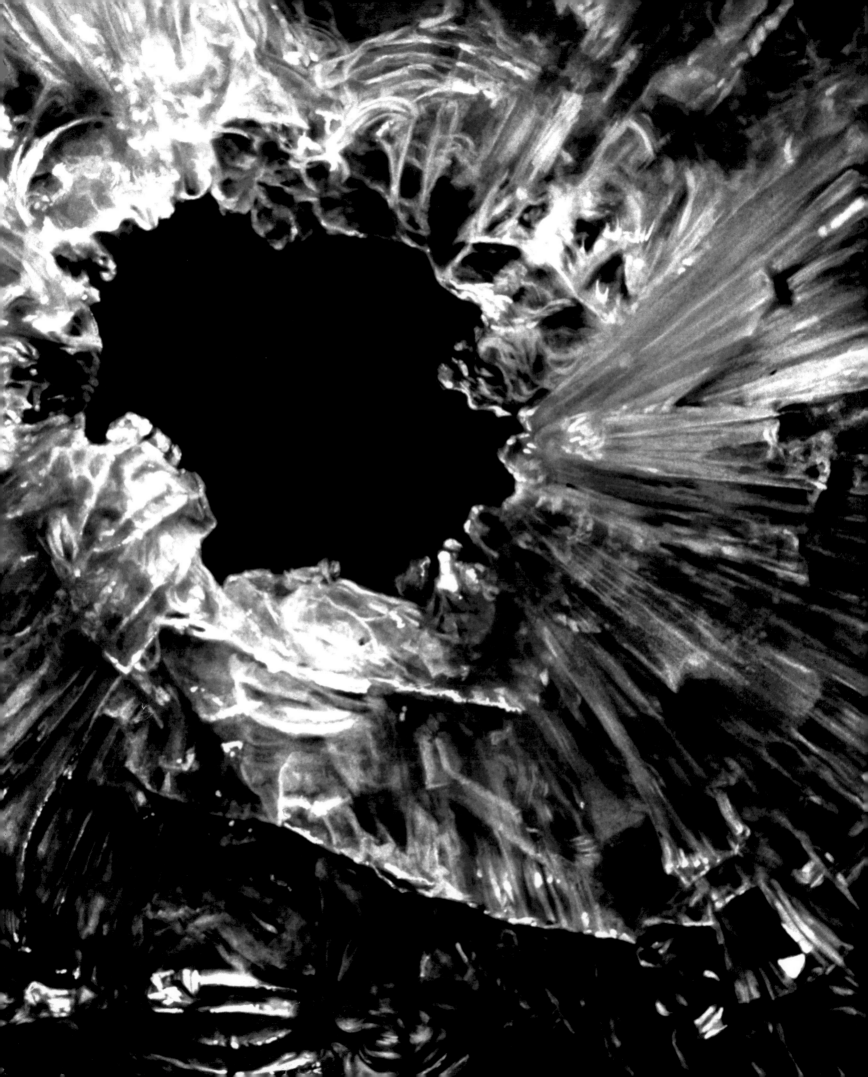

CONTENTS

This book is dedicated
to the memory of
Leigh Markopoulos

Proof: Francisco Goya, Sergei Eisenstein, Robert Longo is published to mark the exhibition of the same name, curated by Kate Fowle in collaboration with Robert Longo and first shown at Garage Museum of Contemporary Art from September 30, 2016 to February 5, 2017. *Proof* arises out of Longo's decades-long interest in Goya and Eisenstein and brings together works by all three artists. It was developed through extensive conversations between the artist and the curator, followed by two research trips by Longo to Russia during which he met leading Eisenstein specialist Naum Kleiman and visited the Russian State Archive of Literature and Art to study the Eisenstein archive and select drawings for the show. He also consulted with curators at the State Central Museum of Contemporary History of Russia (formerly the Museum of the Revolution) in Moscow and the State Hermitage Museum in St. Petersburg regarding the importance of Goya in Russia, particularly in relation to the 1917 Russian Revolution. Conceived on the eve of the Revolution's centenary, the exhibition offers insight into the singularity of vision through which artists can reflect the social, cultural, and political complexities of their times.

Proof aims to show the historical works in the exhibition—which Garage introduced to its programming for the first time—in a contemporary context and from a contemporary perspective. The Goya etchings in the Moscow iteration of the exhibition are from the State Central Museum of Contemporary History of Russia. They were a gift from the Spanish government in 1937 to mark the twentieth anniversary of the Revolution. The prints are the last set made from Goya's original plates and they are rarely exhibited. Eisenstein's work is represented through seven films—projected in slow motion so that each frame can be experienced as an independent image—and forty-three sketches from the Russian State Archive of Literature and Art which have not previously been exhibited. *Proof* also includes more than thirty-five works by Longo, produced in the last fifteen years, on loan from international collections.

I would like to thank all of the specialists, institutions, and lenders who made the exhibition and catalogue possible, and especially Robert Longo and his studio for creating a ground-breaking exhibition.

Anton Belov
Director, Garage Museum of Contemporary Art

"Art is not a mirror held up to reality, but a hammer with which to shape it," goes the famous revision of Shakespeare attributed to the early twentieth-century German playwright Bertolt Brecht. The sentiment persists, and profoundly, as seen in the Brooklyn Museum's presentation of *Proof: Francisco Goya, Sergei Eisenstein, Robert Longo*.

This extraordinary exhibition, conceived by Kate Fowle and curated with artist Robert Longo, brings together the work of three unsparing chroniclers of their times: the legendary Spanish artist Francisco Goya (1746–1828), the pioneering Soviet filmmaker Sergei Eisenstein (1898–1948), and Robert Longo himself (b. 1953). Together their work scrupulously examines, without merely documenting, the political, social, and cultural complexities of their times. A symphony in black and white, the selections of their works shown here span three centuries and three mediums—etching, film, and charcoal drawing. In their own time, each is remarkable for observational acuity and emotional charge, as well as for their masterful experimentation in form and technique. The exhibition experience is at once richly visual and historically poignant.

As the exhibition title suggests, Goya, Eisenstein, and Longo seek not only to provide proof of the existence of certain events and facts, but to ignite a powerful sense of their force. They too prove art's power to build energy and empathy, to reshape and break open what is accepted as truth. We are proud to present *Proof* in the context of the Brooklyn Museum's long and continuing history of showcasing the work of artists who expand the ways we see ourselves, the world, and its possibilities. During a time of social, economic, and political upheaval at home and around the world, this exhibition reminds us all of the important roles we play as individuals, communities, and institutions to bear witness, reflect, and act.

The Brooklyn Museum remains indebted to the vision of co-curators Robert Longo and Kate Fowle, Chief Curator of Garage Museum of Contemporary Art in Moscow, who debuted this exhibition there to great acclaim. We extend ongoing gratitude to Garage co-founders Dasha Zhukova and Roman Abramovich, Director Anton Belov, and all of their colleagues for their consummate professionalism, as well as the devoted team at Robert Longo's studio. I must specially thank the lenders to the exhibition, private collectors, and public institutions alike, without whom the depth and breadth of work on display would not be possible. My appreciation is constant for the exhibition's funders, and the ongoing support of the Brooklyn Museum's Board of Trustees, Board of Advisors, and staff, who have realized this exhibition with care and imagination. Lastly, we stand in awe of the mastery of Goya and Eisenstein, whose spirits live on—not least in the brilliance of artists like my dear friend Robert Longo.

Anne Pasternak
Shelby White and Leon Levy Director, Brooklyn Museum

The exhibition *Proof: Francisco Goya, Sergei Eisenstein, Robert Longo* brings together the etchings of Francisco Goya, the films and sketches of Sergei Eisenstein, and the charcoal drawings of Robert Longo. Given the veracity of the works of the Spaniard Goya, the whirling sequences of images of Russian film pioneer Eisenstein, and the light of x-rays of the works by American artist Longo, the exhibition challenges its audience with complex sensory impressions and high standards of perception. Moreover, all three collections of work and their tools appear to present a history of the media. The printing plate and camera represent the advent of the mass media, while Longo's drawings, which he executes using the anachronistic charcoal stick, evoke a hyper-real, slowed down response to photography. The close relationship between the artists' oeuvre is indicated by their works' visual structures: all three artists are among the great visual dramatists of their respective times. They harness the power of optical illusion to depict the mystery of passion, the coldness of power, and the burden of human destiny. Goya, Eisenstein, and Longo present history as autonomous, as taking place outside of the audience's reality. Enlightenment, modernism, and postmodernism converge in this exhibition, which is clearly predestined for Hamburg, the city where Aby Warburg and Werner Hofmann once lived.

I would like to thank Robert Longo, who first displayed his work at the Deichtorhallen back in 1991 and who enjoys a long association with Hamburg. It was here that he met his wife, the actress Barbara Sukowa, and their life together has been accompanied by the mediums of drawing and film ever since. I am indebted to Kate Fowle, the exhibition's curator, for her dedication. Finally, I would like to express my gratitude to the superb team at the Deichtorhallen, especially Bert Antonius Kaufmann, Annette Sievert, and Basil Blösche, and everyone else involved in staging this very successful exhibition.

Dirk Luckow
Director, Deichtorhallen

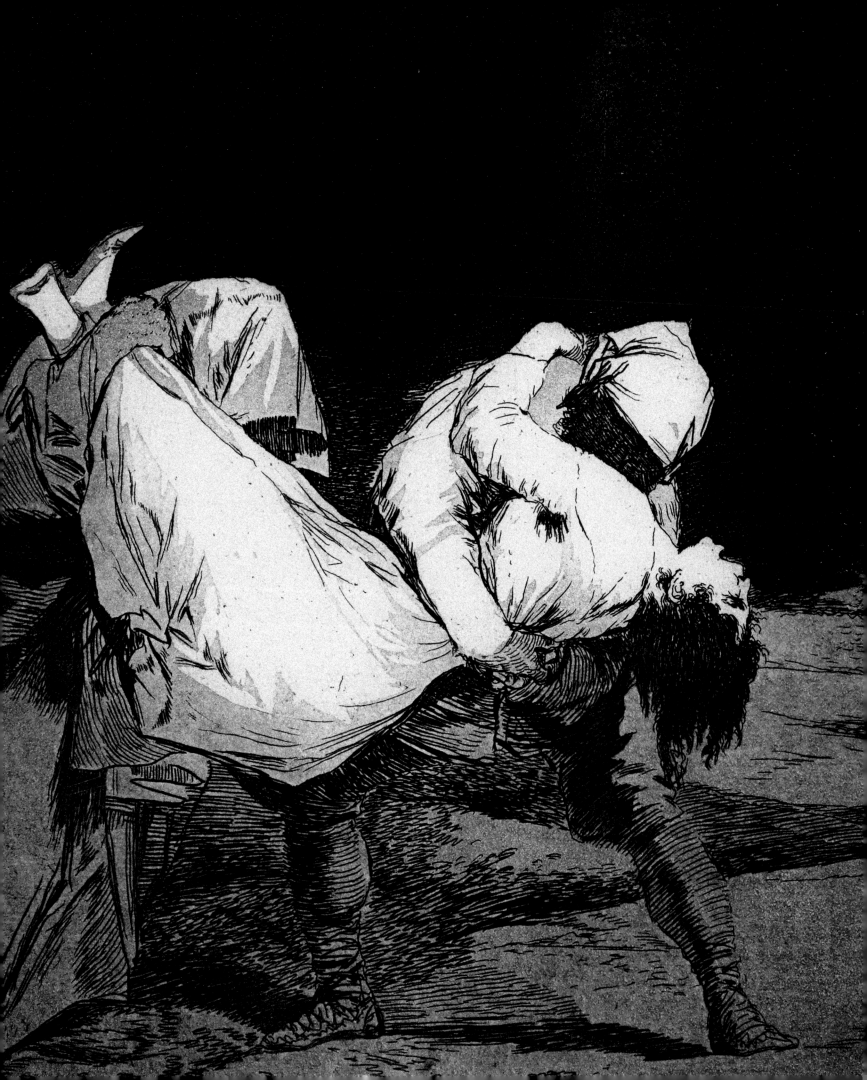

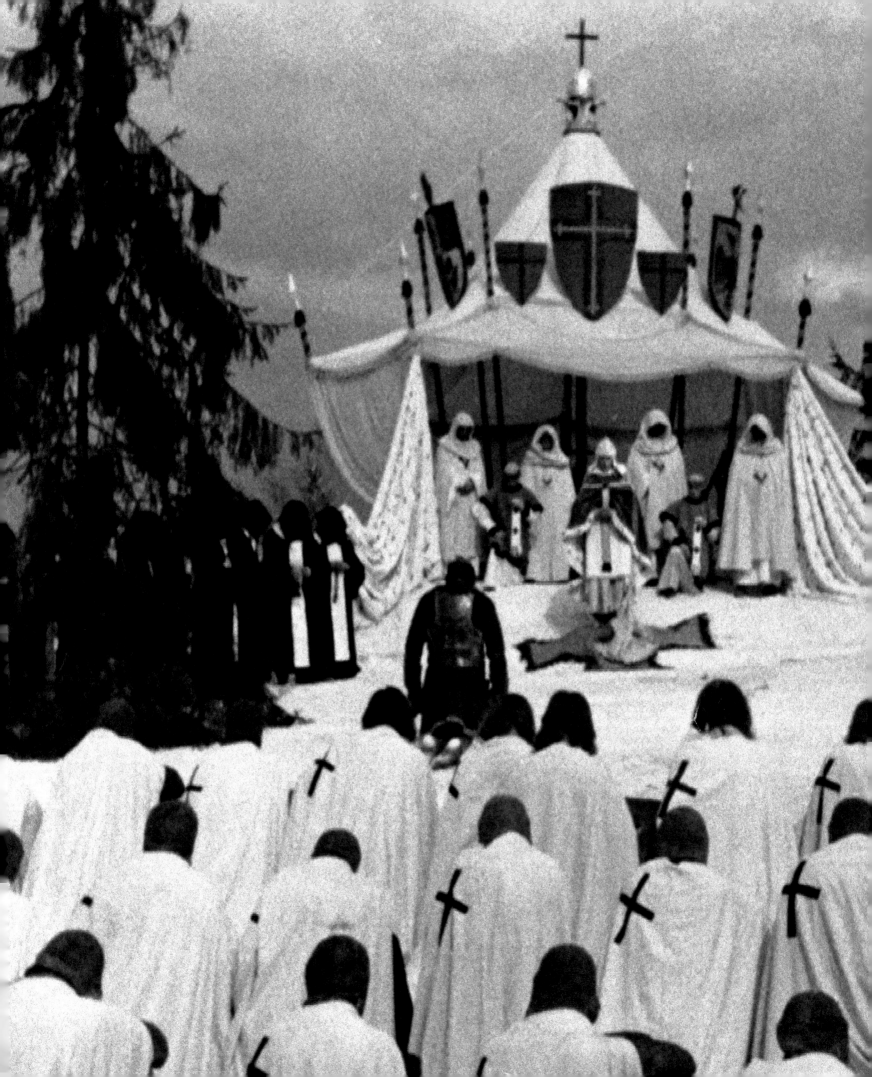

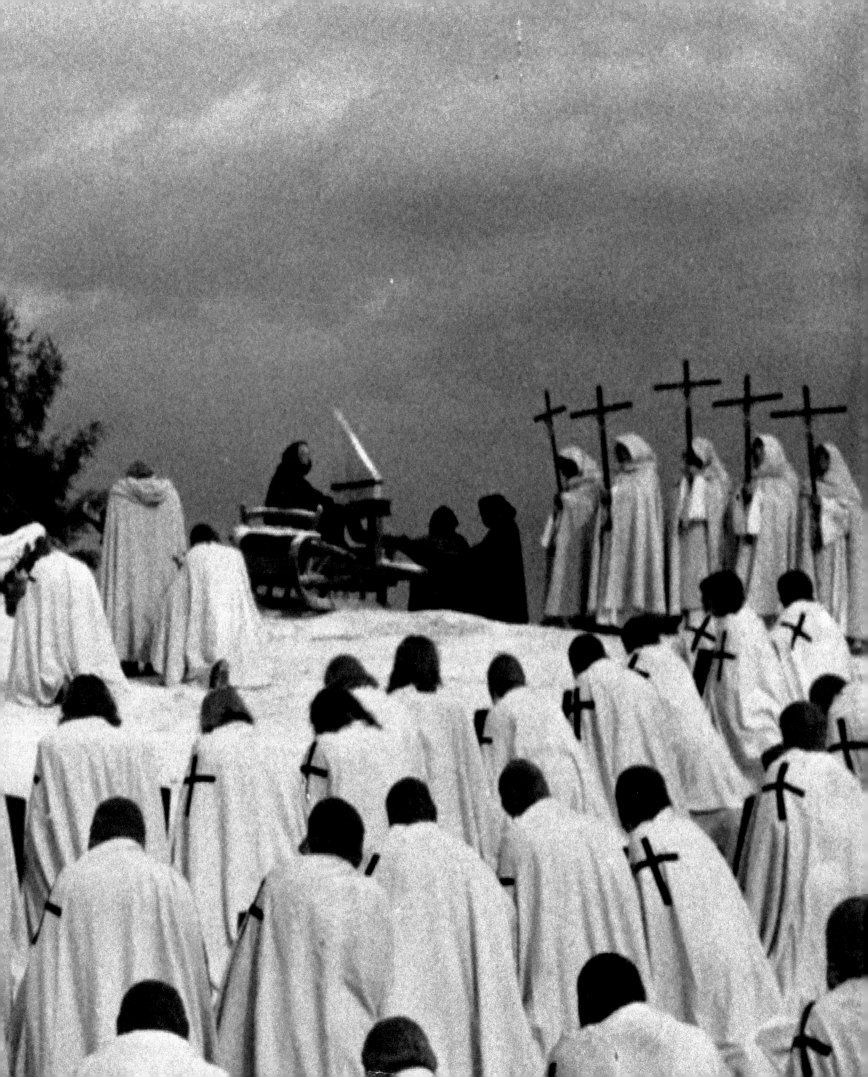

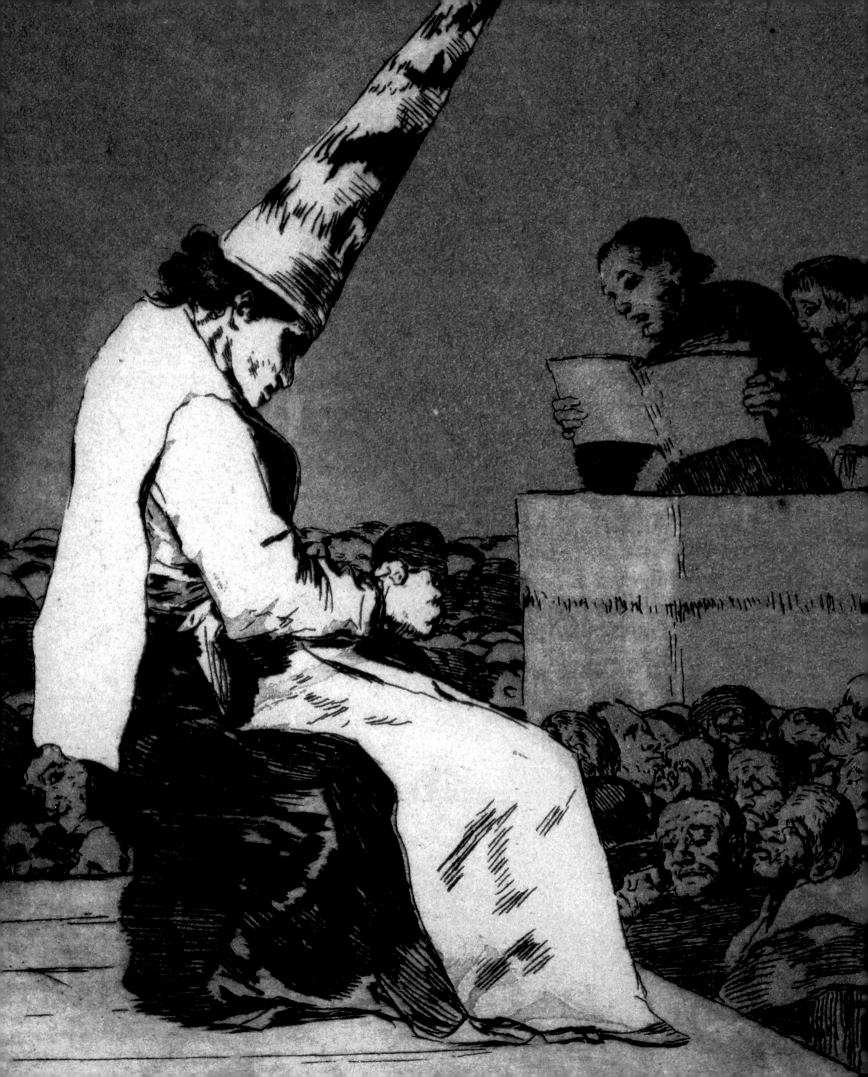

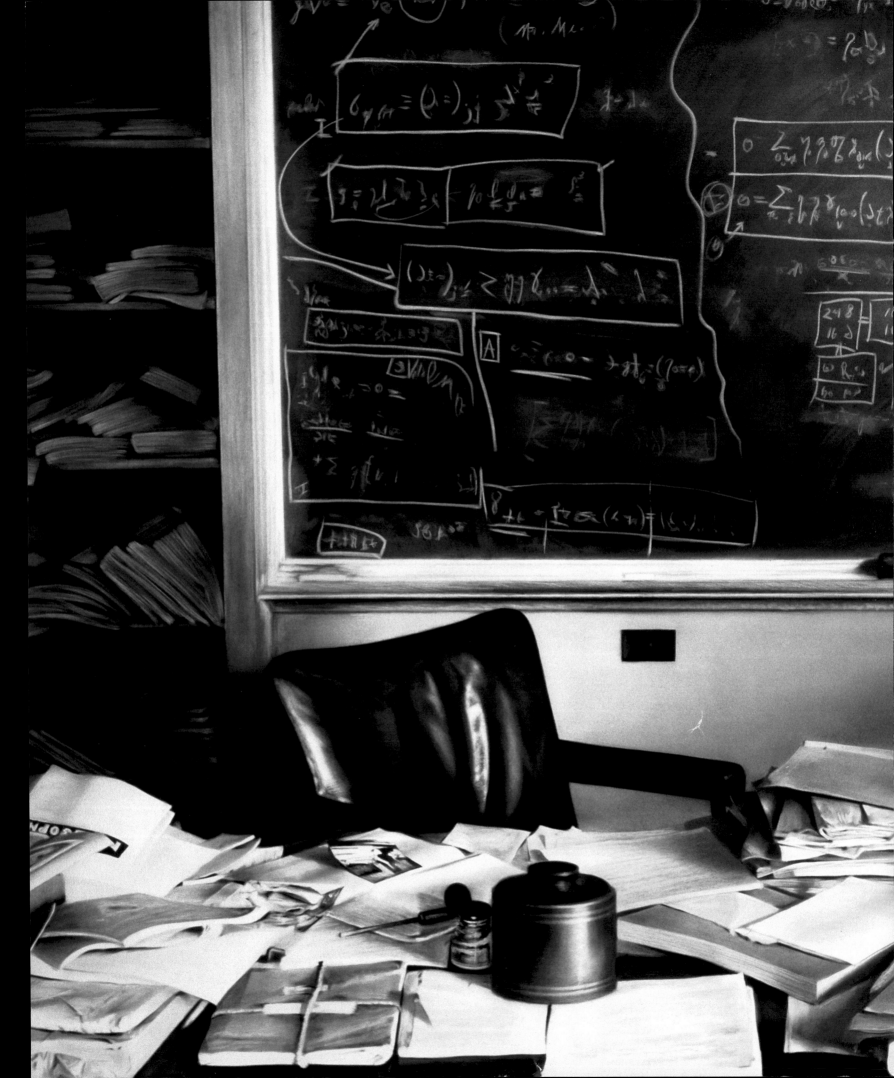

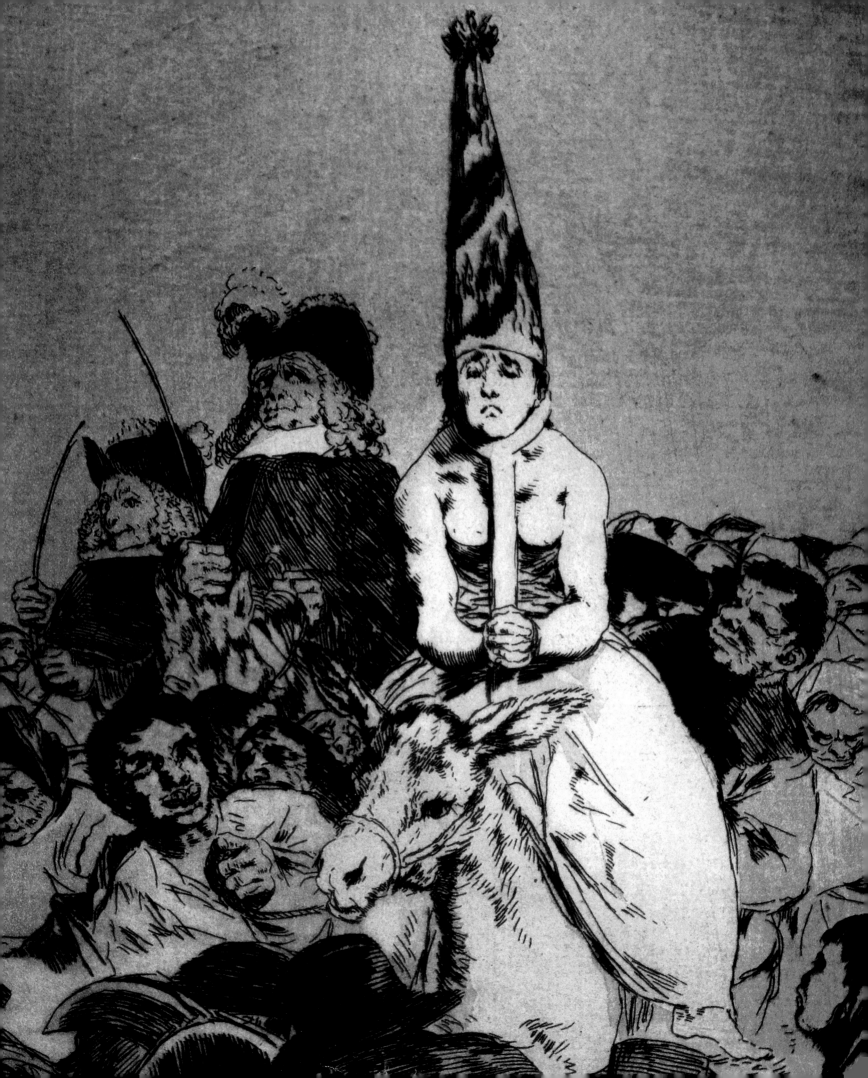

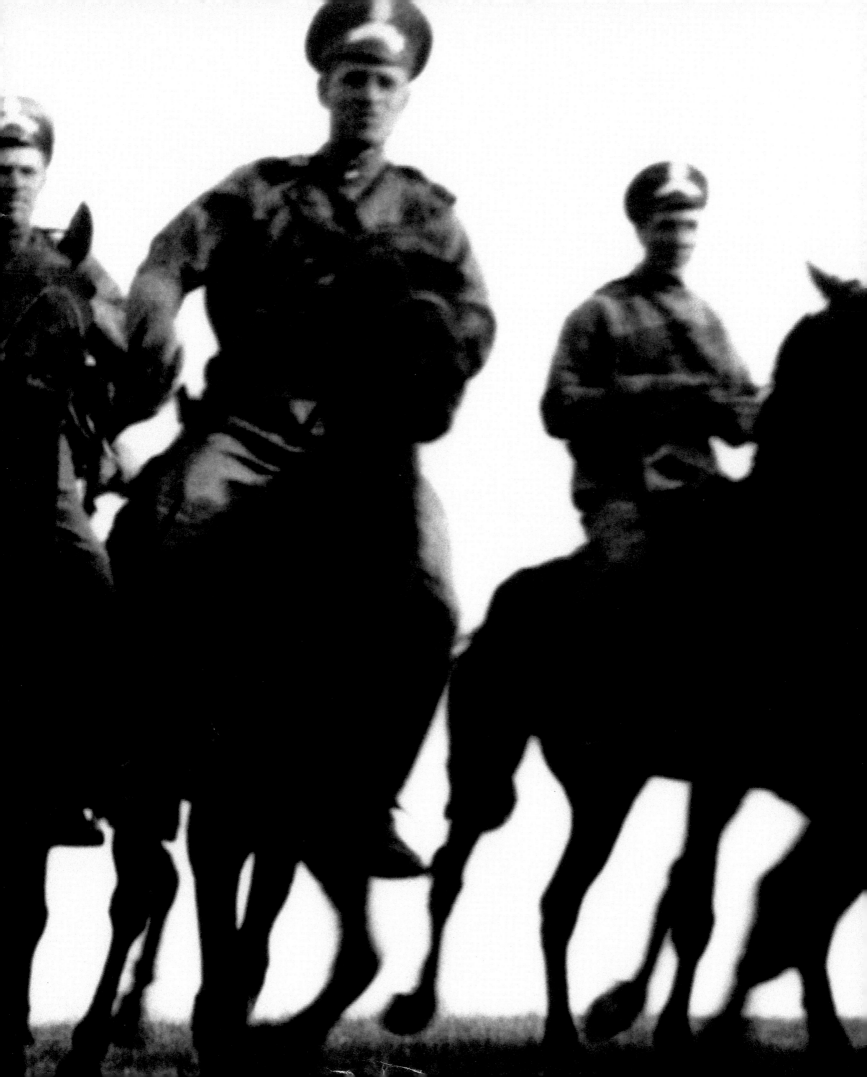

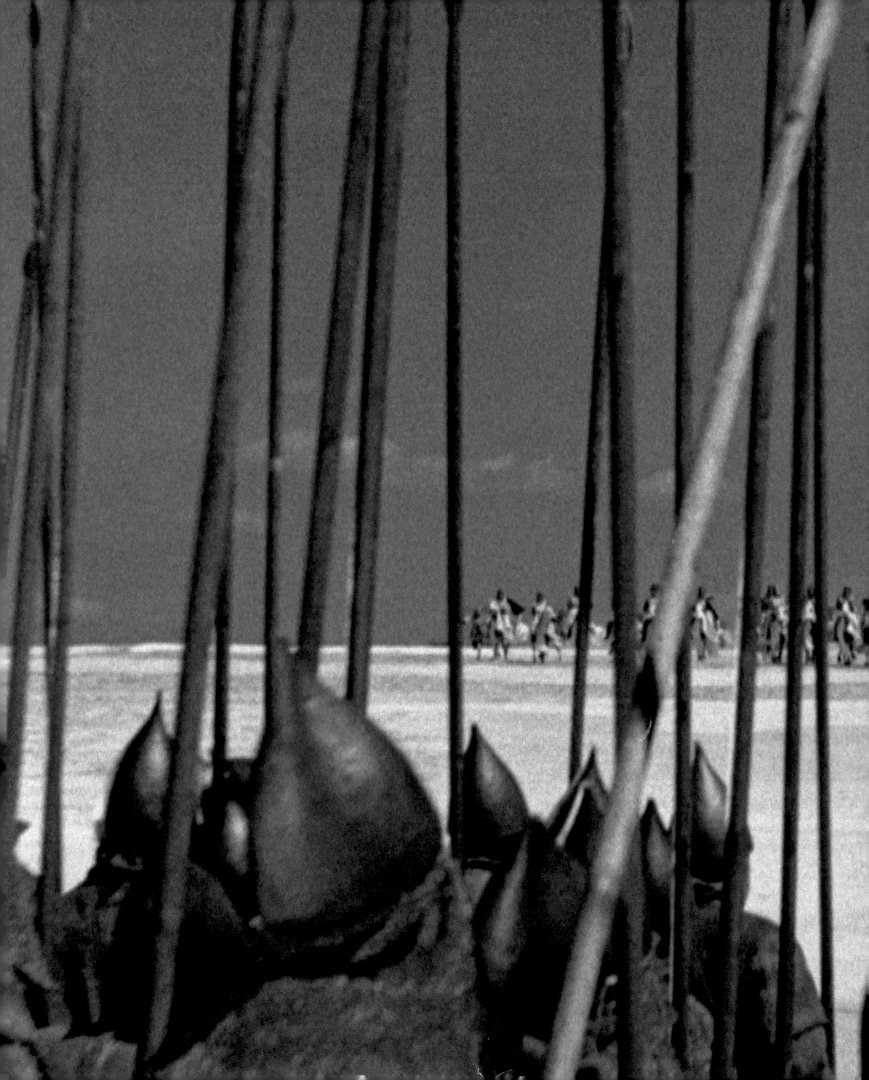

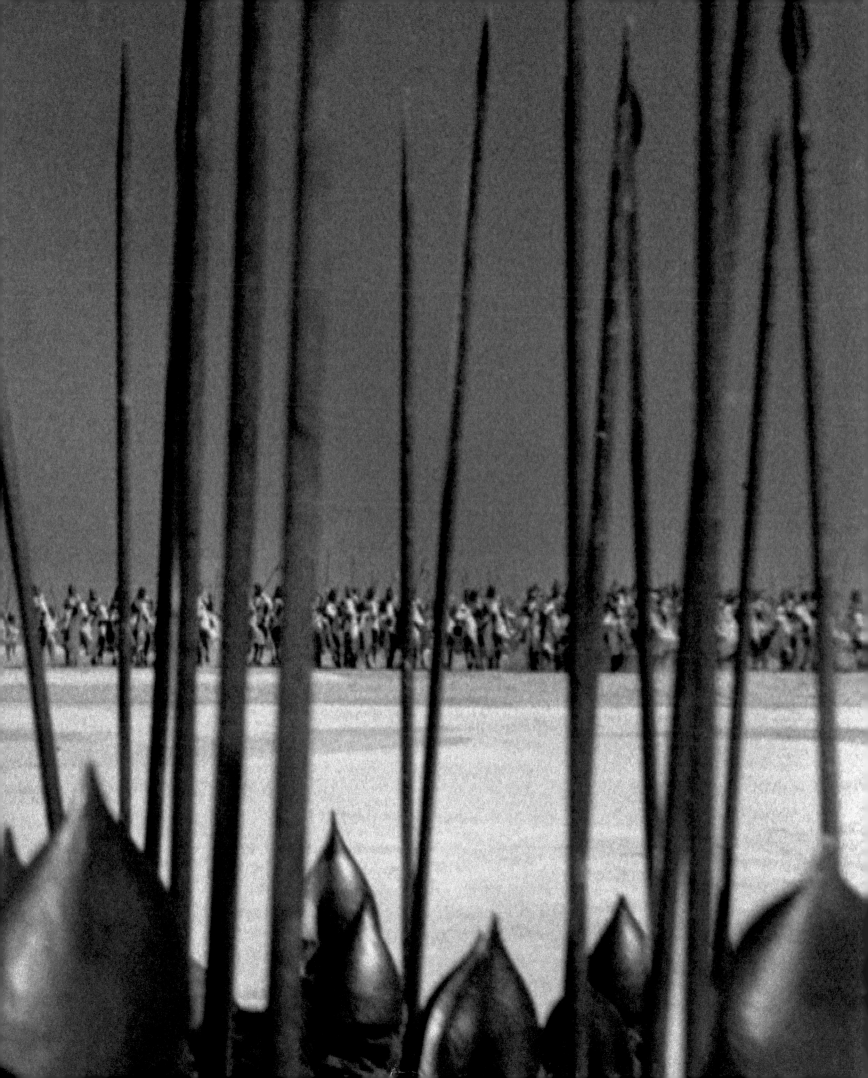

PROOF

Kate Fowle

PROOF, *n.*

1. Evidence or an argument establishing or helping to establish a fact or the truth of a statement.

2. The spoken or written evidence in a trial.

3. A test or trial.

4. A series of stages in the resolution of a mathematical or philosophical problem.

Oxford English Dictionary

It was a humid summer afternoon in Robert Longo's studio. We were in the midst of brainstorming potential titles for the exhibition when the artist momentarily fell silent and started rifling through the piles of papers on his desk. "It's in one of these notebooks, I'm sure," he said rather cryptically. "Good," I responded, hoping that this digression would somehow result in a fitting name for the show. "I'm trying to find the invention of drawing," he announced. My heart sank. The exhibition had started with a simple idea: to present monochromatic works by Goya, Eisenstein, and Longo, with the intention of revealing how artists chronicle the times in which they live. But in the process of developing the project we had landed in the proverbial rabbit hole: the correlations we were discovering between these three practices were myriad, and so were the research paths that we were pursuing. It was soon evident that our foray into exhibition-making had turned into an epic quest to articulate what it means to render "Truth" in pictures.

Longo did not find the notebook he was looking for that day. He was searching for a reference to Joseph-Benoît Suvée's painting *The Invention of the Art of Drawing* (1791), which depicts a woman sketching a man's silhouette (see facing page). It is one version of a story originating in Pliny the Elder's encyclopedic work *Natural History* (c. 77–79 AD), which became briefly popular as subject matter among painters in the late eighteenth and early nineteenth centuries.[1] In his book, the Roman scholar describes how the daughter of a potter named Butades of Sicyon, "…being deeply in love with a young man about to depart on a long journey," inadvertently inspires her father to invent "the art of modeling portraits" by outlining her lover's profile in his studio, "as thrown upon the wall by the light of the lamp." Subsequently, Pliny goes on to explain, Butades "filled in the outline by compressing clay upon the surface, and so made a face in relief, which he then hardened by

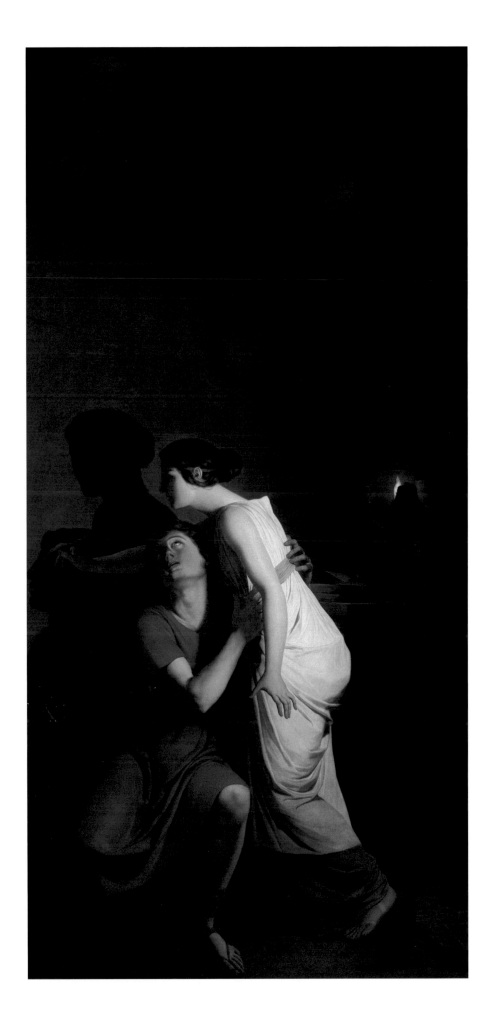

fire along with other articles of pottery."[2] Pliny's account has been subject to wide interpretation in the (nearly) 2000 years since it was first penned, but for the most part has been thought to suggest that art is an imitation of reality. While this may be the case with Butades' clay portrait, his daughter's line drawing offers something more poignant: the expression of physical and emotional urgency.

In explaining Pliny's account and Suvée's painting, Longo described that he was interested in how projection is introduced as a translation of three-dimensional experience into two-dimensional imagery: tracing the shadow had given verisimilitude to the daughter's perception of a moment in time. Perhaps to her, the act of drawing was a way of creating a lasting proof of her passion for the man she loved, or at least materializing it in concrete form.

One of the key attributes that unites the three artists presented in *Proof* is a life-long drawing practice. An illicit rendezvous was not among the motivating factors that prompted them to begin, but a desire to capture people informally was: Francisco Goya's (1746–1828) earliest sketchbooks were filled with the people he observed on the streets of Rome; Sergei Eisenstein (1898–1948) made caricatures in school; and Robert Longo (b. 1953) started out drawing suited men having convulsions. While the camera was not available to Goya, it was also not a tool that Eisenstein or Longo chose as their modus operandi, insofar as both ultimately focused on image-making rather than documentation of their subjects. Furthermore, even if using a camera had been an option for Goya, it seems unlikely that he would have relied on one to depict the way he saw the world, based on the evidence that has been handed down to us.

In 1779, for example, a public announcement for the sale of an album of Goya's eighty *Los Caprichos* etchings (1779–1798), informed the reader that the artist had chosen as his subjects "the innumerable eccentricities and errors common to all civil society," and the "vulgar deceptions allowed by custom, ignorance, or personal gain." This decidedly experimental and critical suite of etchings comprised Goya's depictions of the evils plaguing Spanish society, from avarice and superstition to bigotry and ignorance. Furthermore, since "most of the objects represented in this work belong to the realm of ideas [. . .] the author has neither followed the examples of another, nor has been able to copy Nature." This, the writer of the text posits, is "deserving [of] some esteem, for having had to expose to the eye forms and attitudes that until now only existed in the human mind, obscured and confused by the lack of enlightenment, or heated by bridled passion." This train of thought concludes by emphasizing Goya's complex conception of art's function as its task to "[unite] in one fantastic character, circumstances and traits that Nature presents shared among many," suggesting ultimately that this is how "a good artist attains the title of inventor, and not servile copyist."[3] The description is so perceptive of, and sympathetic to, the artist's satirical intentions that we are led to wonder whether he himself was, perhaps, involved in its writing.

A few years before this announcement was published, Goya had already asserted his conviction that an artist need not be enslaved by the rules of art. During his tenure as Deputy Director of the Royal Academy of San Fernando in Madrid, as recorded in a Memorandum[4] on the reform of the curriculum in 1792, the artist called for students to cultivate personal styles, rather than to simply follow the laws of geometry and perspective: "There are no rules in painting," he stated.

According to art historian Werner Hoffmann, Goya also spoke out against practitioners who placed a higher value on classical Greek statuary than on nature, suggesting that this mistaken emphasis had directly contributed to the decadence he observed in much of the art of the time. Instead, Goya called for the "precise imitation" of either "divine nature," or "Truth." In other words, he believed nature is Truth. Art is not. He therefore encouraged artists to seek out Truth and to develop their practices in its service, rather than to follow fashions in art. Furthermore, as "divine nature"—initially described in the Bible as everything which pertains to life and to godliness[5]—can take on many different guises, there is no one way to communicate its presence. Artists therefore should interpret their subjects freely in pursuit of Truth.

Goya's output ranged from formal court paintings commissioned by successive Kings of Spain, to sketches and suites of etchings, most of which remained unpublished in his lifetime. While the artist spent decades in the service of the Royal Court, his drive to make art was fueled by his independent practice and the experimentation and freedom of expression this allowed, even if he sometimes questioned the sense of this particular truth: "How comes it about that one has perhaps been happier in a less careful work than in one done with greater application?"[6]

While Goya may have rued the lack of recognition accorded to his "less careful work," these visceral, searing portrayals of revolution, civil war, religious persecution, and a debased society lacking moral values—the Spain he portrayed in the etchings and drawings—are images that remain as immediate and impactful to contemporary audiences as they must have been to the (very few) of the artist's contemporaries who saw them. His quest to better express Truth, which in his case was perhaps less about the presence of the divine and more about its regrettable absence, remained a lifelong motivating factor: a small self-portrait in black crayon of the artist, made in his eighties, depicts him as a wizened, bearded old man propped up by walking-sticks, and is captioned with the phrase, "Aun Aprendo" ("I am still learning") (see page 42).

* * *

Scholarly research suggests that Eisenstein made his first drawings in 1913, at the age of fifteen. The Russian State Archive of Literature and Art in Moscow has

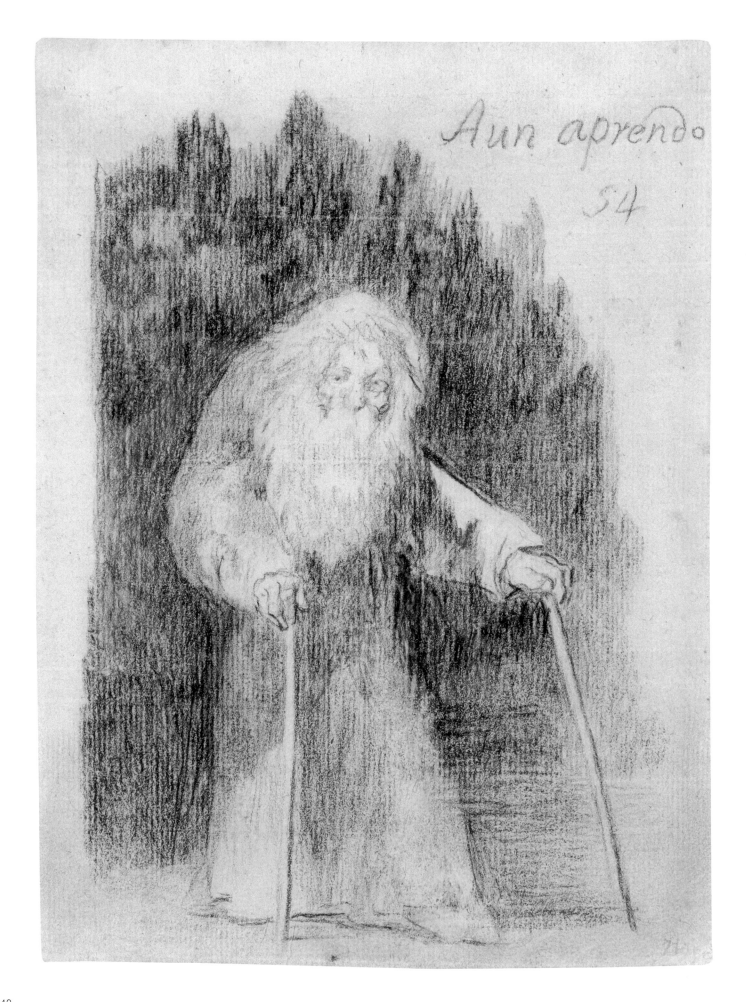

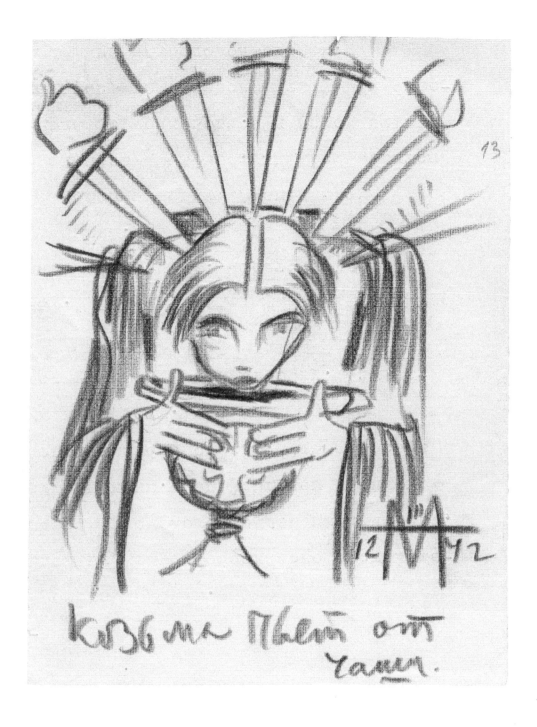

preserved hundreds of subsequent examples of his caricatures, costume designs, political cartoons, and film sketches. Made for his last films—*Alexander Nevsky* (1938) and *Ivan the Terrible: Parts I and II* (1944, 1946)—the latter are, however, the only drawings that the filmmaker wrote about at length.

In an article entitled "A Few Words about My Drawings. For the Publication of the Screenplay of *Ivan the Terrible*," (1943)[7] Eisenstein explains that when making a film, the process is "immediate, simultaneous, and instant, it starts from all sides, on all sides. … [and the] finished film is a huge assemblage of the most diverse means of expression and influence." The prologue of *Ivan the Terrible*, for example, came to the filmmaker while he was at the Bolshoi Theater: "The first sketch of the

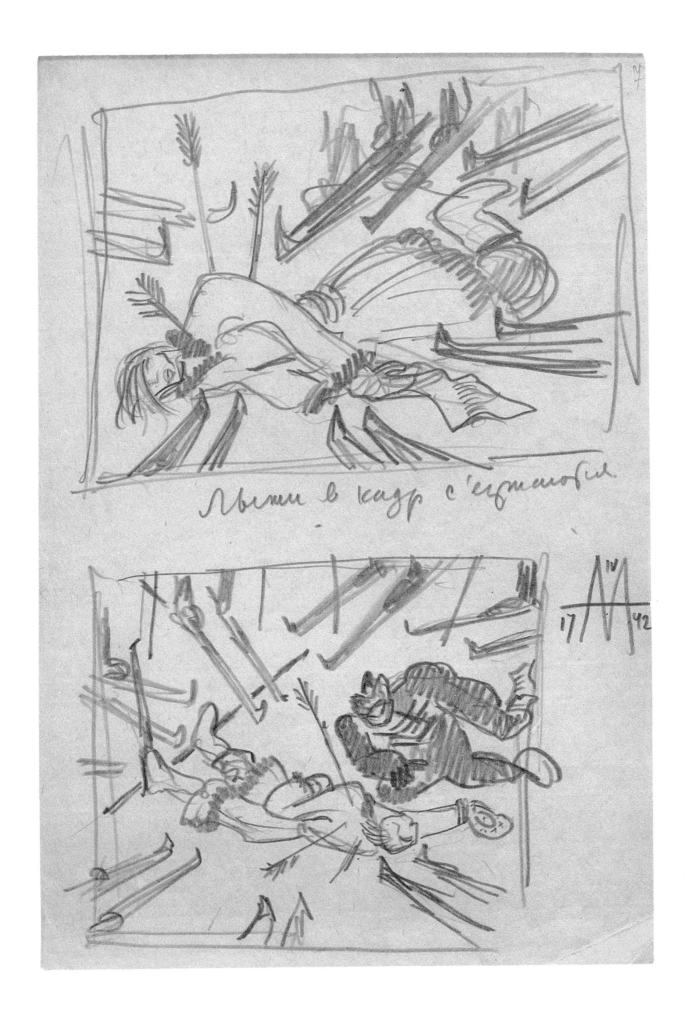

Лыжи в кадр с'егтаюбил.

Sergei Eisenstein
Sketch for the film *Ivan the Terrible*
(1942)
The skis meet in shot
Russian State Archive of Literature and Art
(RGALI), Moscow

Sergei Eisenstein
Part of a draft of the unfinished
book *Close Up*, May–September,
1940
PLAN
OF THE BOOK BY SERGEI
EISENSTEIN
"CLOSE-UP"
1. Introduction by Professor
M. I. Burskoi
2. Foreword by S. M. Eisenstein
3. "Pride"
Chapter I
4. On Montage
"Searches"
"The Middle One of Three"
"Japanese Cinema"
"The Unpredictable Cut"
"El Greco and Cinema"
"Goya and Others"
The Present
"Montage 938"
"Montage 939"
Chapter II
On Composition
"On the Structure of Things"
"Once More on the Structure
of Things"
Russian State Archive of Literature and Art
(RGALI), Moscow

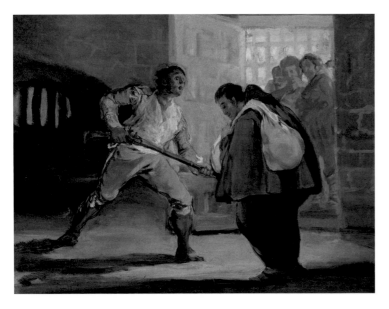
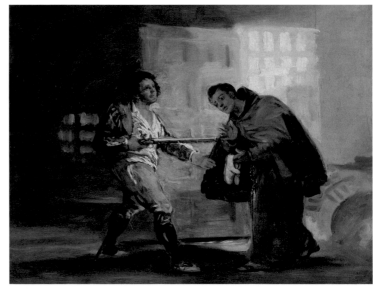
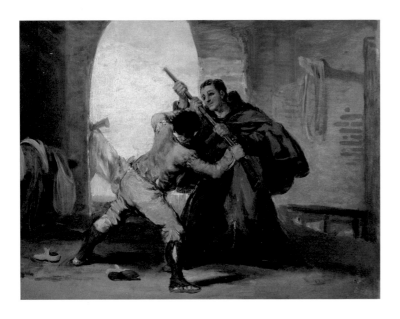
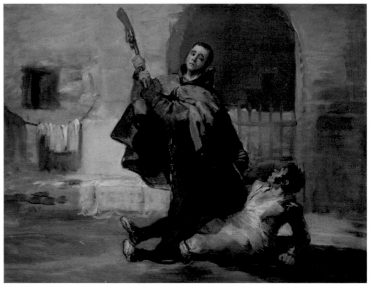
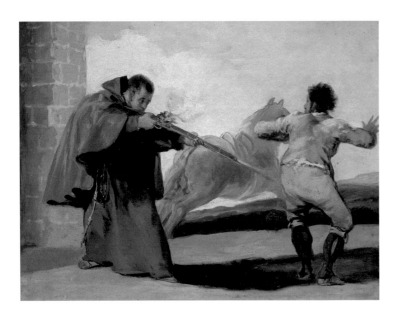
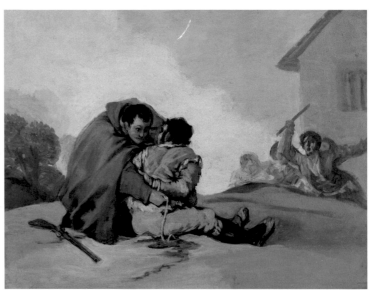

Francisco Goya
*El Maragato Threatens Friar Pedro
de Zaldivia with his Gun* (c. 1806)

*Friar Pedro Offers Shoes to El Maragato
and Prepares to Push Aside his Gun*
(c. 1806)

*Friar Pedro Wrests the Gun from
El Maragato* (c. 1806)

*Friar Pedro Clubs El Maragato
with the Butt of the Gun* (c. 1806)

*Friar Pedro Shoots El Maragato
as his Horse Runs off* (c. 1806)

*Friar Pedro Binds El Maragato
with a Rope* (c. 1806)

The Art Institute of Chicago,
Mr. and Mrs. Martin A. Ryerson Collection

scene was on the reverse of my ticket," he reveals. Ultimately, Eisenstein concludes, it is the drawings that help to give "a fuller sense of the author's intention," and in the act of making them, the immediacy of expression is a way to "record the most essential elements" (see pages 43–44):

> Sketches spring up.
> They are not illustrations for a screenplay.
> Still less are they decorations for a little book.
> . . .
> Sometimes they are a concentrated record of the sense
> that should derive from a scene, but most often they are
> searches.
> And what endless searches...[8]

Rarely using drawing as a means to observe, or document nature—he was not in search of subject matter—Eisenstein employed the medium rather as a way to weigh and establish composition, rhythm, mass, and perhaps most importantly, to give physical form to emotional and psychological tension.

In an earlier essay, "The Problem of the Materialist Approach to Form" (1925), Eisenstein wrote that to create revolutionary art it was necessary to catalyze "the maximum intensification of the emotional seizure of the audience."[9] Echoing, or perhaps expanding on, Goya's argument against following the "rules" to capture an image, Eisenstein here distinguishes between "recording" an event and "effecting" the experience of it.

In this exhibition, Longo has pushed the rules even further by slowing Eisenstein's films down to one percent of their regular projection speed, so that each frame can be registered individually. As seven slow-motion films are projected simultaneously, the gallery is charged with images continuously in transition, creating a giant kaleidoscope of sorts. In addition, the experience of seeing frames from multiple films in parallel offers viewers the opportunity to consider Eisenstein's visual vocabulary, rather than to focus exclusively on the narrative plot of each film.

Interestingly, Eisenstein mentions Goya a number of times in some of his later writings. One set of papers from 1940, housed in the Russian State Archive of Literature and Art, outlines a book that he was intending to write, titled *Close-Up*. He had planned to dedicate the first chapter to film editing, and to write in particular about four antecedents to his practice: "Japanese Cinema," "The Unpredictable Cut," "El Greco and Cinema," and "Goya and Others" (see page 45).[10] In a later draft, the "others" grouped with Goya are mysteriously replaced by the word "phoenix," although it remains unclear in the notes where the similarities between this mythical beast and the seventeenth-century Spanish artist lie. Eisenstein's

notes for "A General History of Cinema," feature an outline titled "The Heir" (1946), in which he lists Goya among his proposed topics for the eventual book. Goya, in fact, appears twice: once via *The Disasters of War*, grouped under the category "Chronicle," and elsewhere under the heading "The Phenomenon of Cinema," where his little-known series of six small paintings titled *El Maragato* (1806) is referenced (see page 46).[11]

It is clear that the gritty reality of Goya's subject matter resonated with Eisenstein. The *El Maragato* paintings depict the true story of the eponymous bandit who, after escaping from the Arsenal in Cartagena, was captured by a friar seeking alms at the household where he was quartered. The event, which reportedly ignited the imagination of the entire Spanish nation, was described in detail in a pamphlet published in Madrid in 1806. Goya's six small paintings on wood panel vividly relay the friar's apprehension of the convict, with swift, bold brushstrokes that do not fully conceal the alterations made by the artist to each composition. The resulting blurs enhance the impression of immediacy, as if the artist were depicting the event live. It is clear how Eisenstein would have been fascinated by the series, the only sequential narrative of any length that Goya painted, which in a way prefigured the use of photographs or film to convey a news story.

As described by Naum Kleiman, the film historian and Eisenstein specialist, although the filmmaker would sometimes source newsreels and study them closely in order to fully understand events, his images were self-contained, metaphorical explanations of occurrences.[12] Once he had deconstructed an event, he was able to distill its essence and its impact in images of his own making. Rather than focusing on unfolding real-time action—with the superfluous and distracting details that approach might include—Eisenstein used montage to create deliberately loaded and self-contained imagery.

In effect, Eisenstein's approach to composition and editing mirrored Goya's search as detailed in the eighteenth-century advertisement for *Los Caprichos*, namely, "to expose the eye to the forms and attitudes that until now only existed in the human mind." Both availed themselves of the forms of mass production popular in their times—Goya used prints, while Eisenstein took advantage of the potential of film and cinema—to offer audiences a different perspective on the revolutionary and epic histories that were their subjects.

* * *

Longo's generation was the first to grow up with television, the newest mass media tool of the immediate postwar era. Disseminated straight into the home, black-and-white footage of news, drama, and advertisements was available for daily consumption. This phenomenon forever changed the way in which "forms and attitudes" were "exposed" to the eye and fundamentally influenced Longo's

relationship to images. In an essay on Longo, written in 1989, art critic and historian Hal Foster describes the impact of TV and film on artists who rose to prominence in the mid-1970s. He cites the exhibition, *Pictures*, curated by theorist Douglas Crimp in 1977, in New York, as being the first to present a new generation of practitioners—one of whom was Longo—who explored the newly mediated experience of the world:

> The new work could not be measured in terms of style or medium; it cut across too many forms. Rather it was marked by a new conception of picturing: on the one hand, it contained in tableau form the temporal or theatrical "presence" that modernist-formalist criticism had decried in minimalism and performance […] on the other hand, it conceived this presence as an effect of representation, its immediacy as a product of mediation. In short, the new art was a conundrum of images: montaged, it advertised its artificiality—it did not pretend to be a representation of the world; appropriated, it advertised its contingency—it did not presume to be an abstraction above the world.[13]

Following Foster, we could posit that "artificiality" is an attribute which Longo's work shares with that of Eisenstein and Goya, insofar as each artist amplifies, or personifies, subjective psychological affect in their images. Each is additionally influenced by other artists' work, although Longo is alone in repurposing imagery.[14] This expression of an arm's-length relationship to reality—what Foster calls the creation of "an image with no origin except other images"—is what separates their various approaches to seeking truths and their relationship to narrative.

What Foster terms the "contingency" of appropriation indicates that making art from life—manifesting the Truth of "divine nature"—is no longer pressing in communicating to contemporary audiences, whose understanding of the world is predominantly mediatized. In fact, the power of art is in question: its ability to create an imaginative depiction of history has been challenged, while the notion of "authentic vision" is considered outdated. Instead, to quote Foster again, art now "uses representation against representation in order to disrupt our naive belief in its referential truth." As we have seen in the work of Goya and Eisenstein, the drive in artists to break the rules of art in the service of seeking truth is not new, but the daily barrage of mediatized images *has* changed our sensitivity to pictures and the immediacy of their impact.

Longo manufactures composite images from appropriated sources, translating them by hand into meticulously detailed, large-format charcoal drawings. In the interview published in this book, he explains how the act of drawing, by transitioning an image "from the eye to the hand," enables him to digest and internalize it on a molecular level. This process also has the effect of slowing

down his response to mediatized images, allowing time for a relationship to develop: "A photograph is recorded in an instant. A drawing takes months to make."[15] Not least by slowing down, or interrupting, the process of seeing and cognition, Longo taps into the symbolic potential of an image, establishing a different relationship between art and truth. Where Eisenstein used montage to collide images in his efforts to awaken his audiences' senses, and Goya used satire and shock in his etchings to comment on the depravities of human nature, Longo uses the scale of his drawings and what he calls the "inherent intimacy of the medium" to create images that have the power to captivate audiences numbed by the daily assault of images on their eyes. In an era where mass production and mass media are ubiquitous, he creates unique works in a medium often dismissed as minor, but elevated in stature through the persuasive nature of his technique.

At one point during our discussion around the titling of the exhibition, Longo suggested that, "art is an attempt to try to understand our own contemporary situation through making images that are completely personal, while also addressing our social context."[16] His apparent conceptual detour via Pliny's story of the woman drawing her lover's outline, and the eighteenth-century painting that it inspired, was perhaps his way of getting to the heart of this matter: that art has the potential to be the proof—the evidence of *establishing* a fact or truth—not only of an event or action, but of its resonance through time.

<p style="text-align:center">* * *</p>

The pulse of this book is a series of triptychs, juxtaposing reproductions of Goya's etchings with stills from Eisenstein's films and Longo's charcoal drawings. Selected by Longo, they reveal visual correlations between the subjects favored by all three artists, as well as exposing how works usually considered as historically and contextually fixed can take on new meaning when contrasted with others.

Interspersed with the triptychs are texts, including an extensive interview with Longo that elucidates his methods in detail while exploring his interests in developing this project. Biographies of the artists provide an overview of their output in relation to the circumstances in which they practiced, and highlight the parallels between their respective times in terms of turbulent transitions from one era to another, and the impacts of revolution, protest, and war. Vadim Zakharov, a leading light of the Moscow Conceptualist circle, has written an essay giving an artist's perspective on the project and describing the "Bermuda Triangle" Goya, Eisenstein, and Longo produce, which gives the viewer "the sense that they can move from the exhibition space into unknown territory." Nancy Spector, Artistic Director and Chief Curator at the Solomon R. Guggenheim Museum and Foundation, considers Longo's practice in relation to the current "divisive political reality" and the question of whether art imitates life or life imitates art. Lastly, Chris Hedges, author, journalist, and activist,

provides a cautionary tale that focuses on the impossibility of capturing the impact of war and combat in any narrative, which, he explains, creates "the road to mythology." Instead, he suggests that artists "who seek to explore truth, especially the truth about war," should "concentrate on the residue of war and the instruments of war, rather than attempting to portray the momentary high of combat and rush of violence." These "back windows," as he describes them, are the only effective view that we have.

To apply Hedges' analogy, what we see through the back windows given to us by Goya, Eisenstein, and Longo—the residues and instruments of war that they observe—is accumulated proof of the follies of mankind over centuries. The question is, does seeing these perpetuated "truths" portrayed over and over again in black and white make any impact on how we understand our own part in this story? The final proof is down to us.

1 Often titled to reference the "beginning of painting" rather than drawing, other examples of this subgenre include Jean Raoux's *The Origin of Painting* (1714–1717), Jean-Pierre Norblin de la Gourdaine's T*he Invention of Drawing* (1773), David Allan's *The Origin of Painting* (1775), Jean-Baptiste Regnault's T*he Origin of Painting* (1785), and Karl Friedrich Schinkel's *Origin of Painting* (1830).

2 Pliny the Elder, *Natural History*, 35.43.

3 Thomas Harris, *Goya: Engravings and Lithographs*, vol. 1 (Oxford: Bruno Cassirer, 1964), 103.

4 Werner Hofmann, "Unending Shipwreck," in Goya: *Truth and Fantasy. The Small Paintings*, edited by Juliet Wilson-Bareau and Manuela B. Mena Marqués (New Haven and London: Yale University Press, 1994), 43.

5 2 Pet. 1:3–4.

6 Hofmann, op. cit., 44.

7 See Ivan Pyryev et al., eds, *Mosfil'm: stat'i, publikatsii, izobrazitel'nye materialy*, vol. 1 (Moscow: Iskusstvo, 1959), 207–212.

8 Sergei Eisenstein, *Izbrannye proizvedeniya*, vol. 1 (Moscow: Iskusstvo, 1964), 198.

9 Ibid., 112.

10 Sergei Eisenstein, drafts of *Close-Up*, Russian State Archive of Literature and Art (archive ref. Ф. 1923. Оп. 2. Ед. хр. 931. Л. 1–18, May–September 8, 1940).

11 Sergei Eisenstein, "Zametki ko 'Vseobshchei istorii kino,' Gl. 1, 'Naslednik'," *Kinovedcheskie zapiski*, 100, 2012, 109–117.

12 Naum Kleiman in an unpublished interview by the author, September 28, 2015.

13 Hal Foster, "Atrocity Exhibition," in *Robert Longo*, edited by Howard N. Fox (New York/Los Angeles: Rizzoli/Los Angeles County Museum of Art, 1989), 52–53.

14 As already outlined, Eisenstein was influenced by a number of artists, including Goya. Some of Goya's first etchings were detailed, miniature, black-and-white renderings of paintings by Velázquez, such as *Las Meninas* (1656), through which Goya was clearly studying arrangements of form and tone. Similarly, since 2005, Longo has developed a series of graphite works entitled *Heritage Drawings*—monochromatic versions of artworks he admires and wants to understand more clearly in terms of their composition. Both Goya and Eisenstein's works have been subjects of this series (see pages 52–55).

15 See the interview "Time Traveling" on pages 100–129 of this catalogue.

16 Robert Longo in conversation with the author, May 9, 2016.

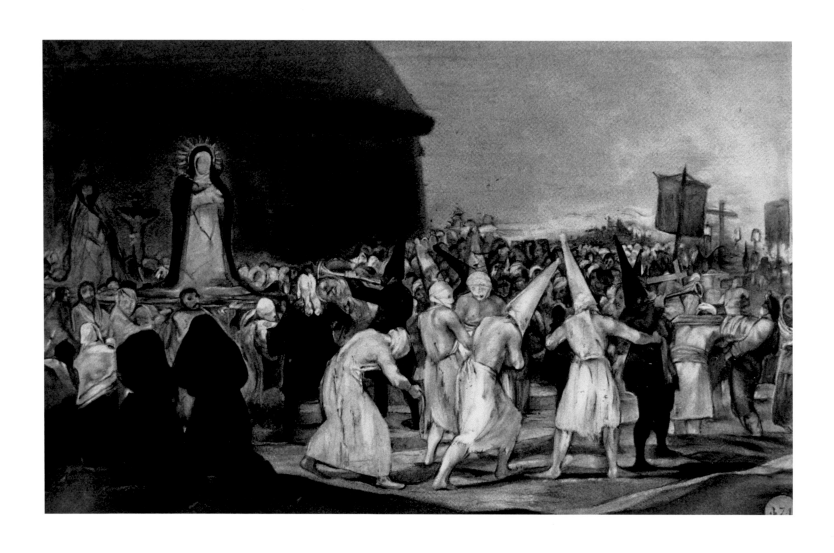

Robert Longo
*Untitled (After Goya, A Procession
of the Flagellants, 1812–1819)*
(2012)
Private collection
Courtesy of the artist and Galerie Thaddaeus
Ropac, London · Paris · Salzburg

Robert Longo
*Untitled (After Goya, Saturn
Devouring His Son, 1819)*
(2016)
Courtesy of the artist

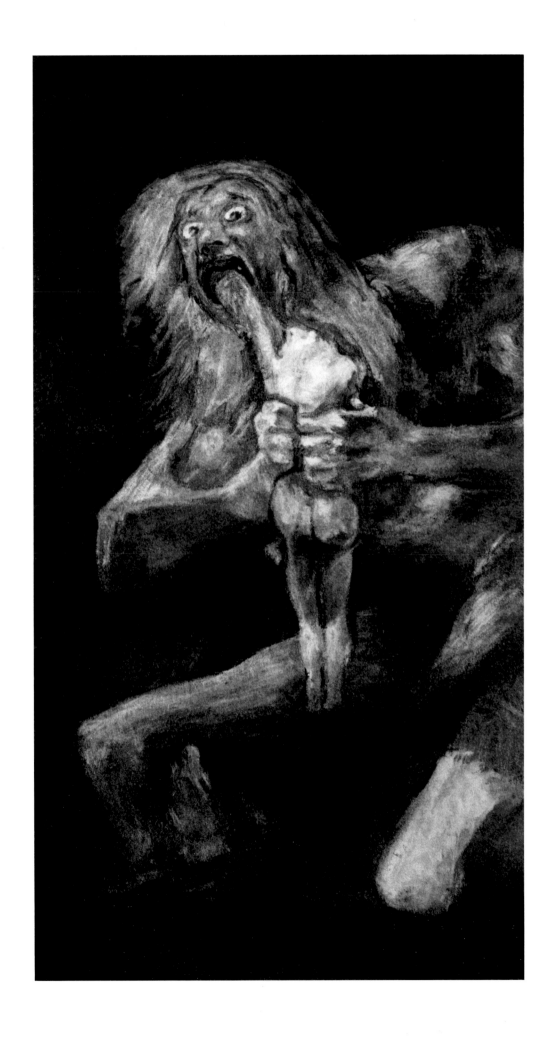

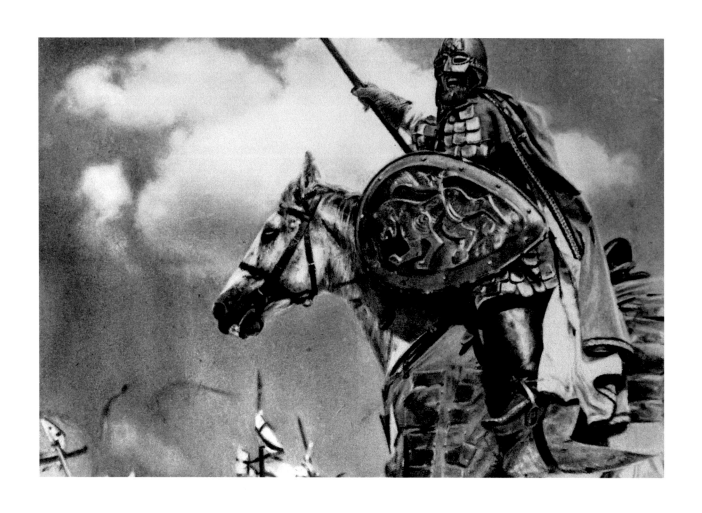

Robert Longo
Untitled (After Eisenstein,
Alexander Nevsky, 1938)
(2016)
Courtesy of the artist and Metro
Pictures, New York

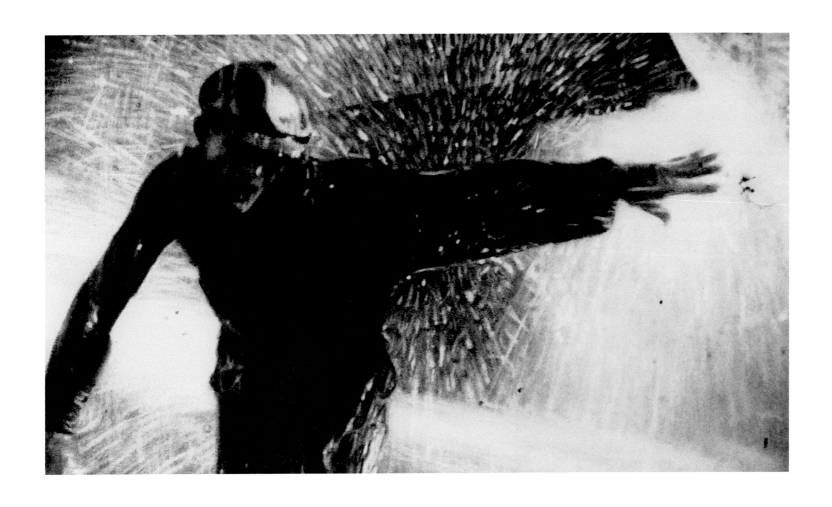

Robert Longo
Untitled (After Eisenstein,
Strike, 1925) (2016)
Courtesy of the artist and Metro Pictures,
New York

ARTIST BIOGRAPHIES

FRANCISCO JOSÉ DE GOYA Y LUCIENTES
(1746–1828)

Francisco Goya was born in 1746 in Fuendetodos, in the northern region of Aragon, Spain. The child of lower-middle-class parents, he was educated by a Roman Catholic teaching order, before being apprenticed to a religious painter in Saragossa who worked as an artistic censor for the Inquisition. In 1770, Goya traveled to Italy to study the Great Masters and classical antiquity, while also embarking on his first sketchbook, of street life in Rome. Goya would later regard this as an early turning point in his career, giving him the impetus to leave the provinces for Madrid.

From 1775 to 1791, he was employed by the Royal Tapestry Factory to paint cartoons (preparatory paintings) commissioned by the King, of leisure activities, sport, and other noble pursuits. In 1780, he was elected to the Royal Academy in Madrid, where he would eventually become Director of Painting from 1795 to 1797. By the end of the 1780s, Goya had earned a reputation as a portraitist for government officials and the aristocracy. In 1786, he was appointed Painter to the King (Charles III). In 1789, Charles IV promoted him to Court Painter. This was a position he would occupy for thirty-four years, serving three reigning monarchs.

From 1778 onward, Goya produced etchings in parallel with his official career. His first suites translated works by Old Masters such as Velázquez into black and white, as well as recording working-class life in Madrid, depicting criminals, the poor, scenes of executions, and social injustices. This independent practice intensified when he suffered a chronic illness in 1792 that left him permanently deaf at the age of forty-two. During his two-year convalescence, he made a series of experimental, small paintings that introduced new subjects to eighteenth-century Spanish art, such as bullfights, a prison, a shipwreck, and the yard of a lunatic

asylum. Part observation and part invention, these works established Goya as an artist of the European Enlightenment, engaged in questioning religious and folkloric doctrines, while chronicling—often satirically—the modernization of Spain.

Goya came of age in a period of relative prosperity and progress in Spain under a king who supported commercial, industrial, and agricultural reforms. By the time the artist died in 1828, he had experienced the impact of the French Revolution of 1789, the subsequent Napoleonic invasion of Spain and the Peninsular Wars of 1808–1814, the return of an absolute monarchy that revoked the constitution and reinstated the Inquisition, the Spanish Revolution of 1820, and a second French invasion in 1823.

During this time, while continuously maintaining favor in the royal court, Goya responded to social and political instability with four defiantly critical suites of etchings, *Los Caprichos (The Caprices)* (1797–1798), *Los Desastres de la Guerra (The Disasters of War)* (1810–1820), *La Tauromaquia (Bullfighting)* (1815–1816), and *Los Proverbios (Proverbs)* (1815–1823). In 1819, he purchased a house on the outskirts of Madrid, where he painted fourteen murals—now known as the *Black Paintings*—that were deeply reflective of his increasingly bleak outlook on humanity. In 1824, disillusioned by a series of personal as well as professional disappointments, he left Spain, living the last four years of his life in exile in Bordeaux, France.

SERGEI EISENSTEIN
(1898–1948)

Sergei Eisenstein was born in 1898 in Riga, then a largely German-speaking city of the Russian Empire (now the capital of Latvia) and grew up in Petrograd (now St. Petersburg) from 1910. A child of the colonial classes, he learned four languages and read widely, on architecture, art, literature, mythology, anthropology, linguistics, and psychology—subjects that would continue to interest him throughout his life. As a pupil, Eisenstein did not excel in art, although his earliest known caricatures, dating from 1913, were published in his school's magazine. He sold his first political cartoons to newspapers in 1917 and went on to develop a prolific drawing practice that spanned his career. It was also around 1917 that Eisenstein's aunt, who had a private collection of engravings, encouraged him to study Goya's etchings, which the filmmaker would cite as an influence in his unpublished "Notes for a General History of Cinema" (1946).

In 1915, Eisenstein enrolled in the Petrograd Institute of Civil Engineering, which was closed after the 1917 Revolution. He then joined the Red Army as an engineer and served in the Civil War (1918–1921), receiving an officer's training and learning Japanese, which triggered his longtime interest in kanji characters and Kabuki theater. While in the Army, he also began to exercise his skills as a technical draughtsman and caricaturist, making set and costume designs for theater productions for the troops.

In 1920, he was employed by the newly established Proletkult (Proletarian Culture) Theater in Moscow, an independent federation of local cultural societies and avant-garde artists created under the Peoples Commissariat for Education (Narkompros) to establish anti-bourgeois culture. Starting as a stage and costume designer, he learned from theater director Vsevolod Meyerhold (1874–1940),

who introduced him to the filmmaker Lev Kuleshov (1899–1970), an early champion of cinema's autonomy from theater. After his promotion to co-director, Eisenstein experimented with new forms, drawing inspiration from the modernization of industrial society, detective stories, vaudeville, and the circus in an effort to express revolutionary plotlines.

Eisenstein's first theoretical text, "The Montage of Attractions," was published in 1923. In it he outlined how to stage mise-en-scènes that emotionally or psychologically impact audiences, arguing that the viewer could better understand concepts through imaginative association. This was a theory that Eisenstein would develop extensively as a filmmaker, using editing processes to create visual juxtapositions, or "collisions," which he believed could stimulate the masses to understand the history and theory of their political movement.

A year later, Eisenstein made *Strike* (1924)—the first film in his trilogy about the Russian Revolution—followed by *Battleship Potemkin* (1925), and *October* (1927). All three were funded by the state and Eisenstein was given full artistic license, enabling him to further develop his notions of montage (although scenes in *October* depicting Leon Trotsky were censored.) While the films received critical attention in Europe and the United States, general audiences in the Soviet Union were not receptive.

In 1928, Stalin launched his first Five Year Plan, which greatly restricted cultural freedoms, signaling the political, artistic, and financial difficulties that would impact Eisenstein's work for the rest of his life. His subsequent film, *The Old and The New* was heavily censored and reworked by the state. One week before the re-edited film was released as *The General Line* (1929), Eisenstein traveled to Europe to lecture and study Western sound technologies. There, he also directed the film-short *Romance Sentimentale*—which was devoid of plot, narrative, or revolutionary message—in 1930, before traveling to California to take up a contract with Paramount Pictures in Los Angeles. This was soon rescinded due to rising anti-communist sentiment and Eisenstein's expressed incompatibility with mainstream Hollywood ideals. Traveling on to Mexico, he started work on *Qué Viva México!* which was never completed due to the withdrawal of financial support and Stalin's suspicion that Eisenstein was intending to defect.

Returning to the Soviet Union in 1932, Eisenstein found the country suffering from famine and the centralization of all industries, including cinema. Amidst accusations of making films "unintelligible to the millions," he was assigned a teaching position in the Gerasimov Institute of Cinematography (VGIK) to re-establish his value to the state. In 1935, on the eve of Stalin's Great Purge (1936–1938), he embarked on making *Bezhin Meadow*. The state, however, brought filming to a halt in 1937, executing the executive producer, and forcing Eisenstein to make a public apology for becoming "self-absorbed." He was

subsequently given "one last chance," and in response made the historical epic *Alexander Nevsky* (1938), which met with popular acclaim and state approval, particularly for its relevance on the eve of World War II.

In the last years of his life, Eisenstein wrote extensively and made the two-part historical epic *Ivan The Terrible. Part One* (1944), was awarded the Stalin Prize, raising questions about Eisenstein's complicity with Stalin's cult of personality. *Part Two*, in contrast, met with the Leader's complete disapproval and was not released until 1958, five years after Stalin's death and ten years after Eisenstein had died from a heart attack, aged fifty.

ROBERT LONGO
(b. 1953)

Robert Longo was born in 1953 in Brooklyn, New York, and grew up in Long Island, New York. He graduated high school in 1970, the same year as the Kent State University Massacre in Ohio, which started as a student protest against the US invasion of Cambodia and led to nationwide uprisings. One press photo in particular became symbolic of the social unrest, winning a Pulitzer Prize (see page 122.) The dead student pictured was a former classmate of Longo's, forever affecting the artist's relationship to media images.

In 1972, Longo received a grant to study restoration and art history in Florence, where he discovered that he wanted to make, rather than preserve, art. While in Europe he devised his own "Grand Tour" of the major museums. This was when he first encountered Goya, among other artists who would have a long-term influence. Seventeen years later, in 1990, he would live in Paris for two years and returned to looking closely at painting again.

In the fall of 1973, he enrolled as an art student at the State University College in Buffalo, where he worked under the experimental filmmakers Paul Sharits and Hollis Frampton, who introduced him to structural filmmaking and Eisenstein's films. He graduated in 1975. While at Buffalo, he also co-founded the exhibition space Hallwalls (1974–), where he organized shows and talks with artists such as John Baldessari, Lynda Benglis, Robert Irwin, Joan Jonas, and Bruce Nauman, establishing an informal network that proved seminal to his development.

After graduating, the artist moved to New York in 1977, working as a studio assistant to Vito Acconci and Dennis Oppenheim. That year he also participated in a five-person show entitled *Pictures* that was the first to contextualize a new generation

of artists who were turning away from minimalism and conceptualism and towards image-making, inspired by newspapers, advertisements, film, and television. Over the next decade, Longo became known as a leading protagonist of the "Pictures Generation," working across drawing, photography, painting, sculpture, performance, and film to make provocative critiques of the anaesthetizing and seductive affects of capitalism, mediatized wars, and the cult of history in the United States.

Longo has been represented by Metro Pictures—the first New York commercial gallery to establish a market for the Pictures Generation artists—since it opened in 1980. He presented the *Men in the Cities* drawings that were to establish his name at his first solo show at Metro, in 1981. The gallery then premiered his *Combines* series—wall-based works that were part sculpture, part relief, part painting—in 1984, which used Eisenstein's theory of montage to juxtapose conflicting imagery and forms exploring the machinations of reason, intuition, fantasy, and power; concepts that continue to be important to Longo's practice.

As the poster child for what theorist Hal Foster termed "spectacle culture," Longo was selected for Documenta in 1982 and 1987, and presented his first US and European retrospectives in 1989 and 1991 respectively. Throughout the 1980s, he remained involved in underground culture, initiating performances, collaborating with rock bands and alternative magazines, programming non-profit spaces, and designing stage sets. Long fascinated by the moving image, in 1986 he produced his first commercial music videos, directed his first low-budget commercial film the following year, and in 1994 and 1995 directed the Hollywood film *Johnny Mnemonic*.

In 1990, Reagan's economic policies and the first Gulf War triggered a recession that dramatically affected the art market. In 1995, Longo pared down his practice, producing *Magellan*, a series of 366 small drawings made daily from media over the period of a (leap) year. This work provided him with an image lexicon that forms the foundation of his practice to date.

The fall of the Berlin Wall in 1989, 9/11 in 2001, and the Iraq War in 2003 profoundly affected Longo's outlook on the world at the turn of the millennium, just as the Vietnam War and Civil Rights movement had in his youth, and global politics, protests, and proxy wars have done subsequently. Focusing on charcoal as a medium, from 1999 to 2008 the artist embarked on a suite of drawings depicting Sigmund Freud's consultation room and apartment during the Nazi occupation of Vienna. This influenced multiple series of works collectively entitled *The Essentials*, conveying a contemporary version of the creation myth—waves, bombs, sharks, children sleeping, and roses— images of what he calls "surrogate archetypes," or "absolutes," that embody the collective unconscious.

From 2009 to 2011, Longo stopped working serially, creating instead a body of work entitled *The Mysteries*, which explored the iconography of emotive images, such

as pilot's helmets, women in burkas, tigers, sun-drenched forests, and rock concerts, as well as Albert Einstein's study on the day he died. These triggered his interest in the architecture of religion, resulting in three epically-scaled works of key monotheistic religious sites—Mecca, St. Peter's Basilica, and the Wailing Wall—together entitled *God Machines*.

In the last five years, the artist has amplified his focus on chronicling politicized current events, such as the Occupy movement, the Paris *Charlie Hebdo* shooting, American football players protesting, and riot police, working at a scale that captures the poignancy and, at times, perverse beauty, of a transient moment. In parallel, since 2006 he has returned to art history, to explore how artists have depicted the times in which they live through producing small "heritage" graphite drawings that render famous historical works in monochromatic detail. In 2014, he produced a body of work that focused on the output of the Abstract Expressionists, and a year later Picasso's *Guernica*. Most recently he has embarked on a series of drawings based on x-rays of famous paintings, to render the "truth" of an image beyond its surface appearance and hone his inquiry into revealing invisible layers of meaning. Longo lives and works in New York.

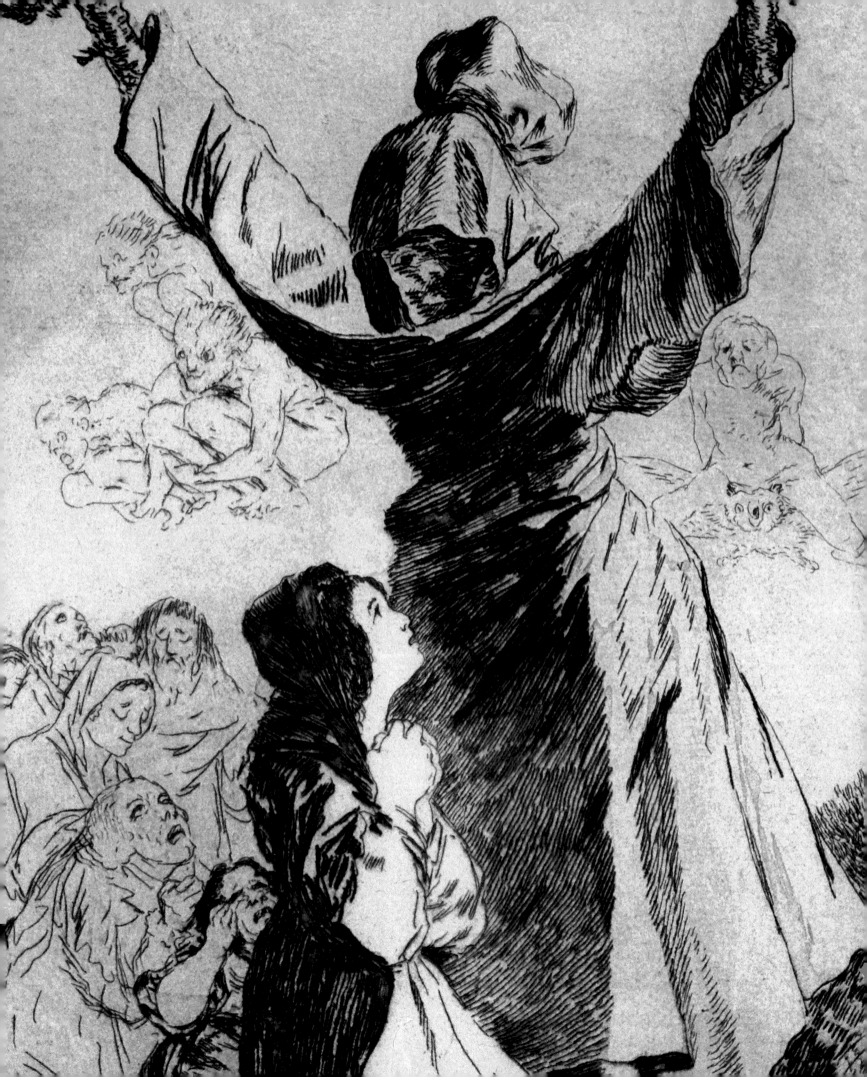

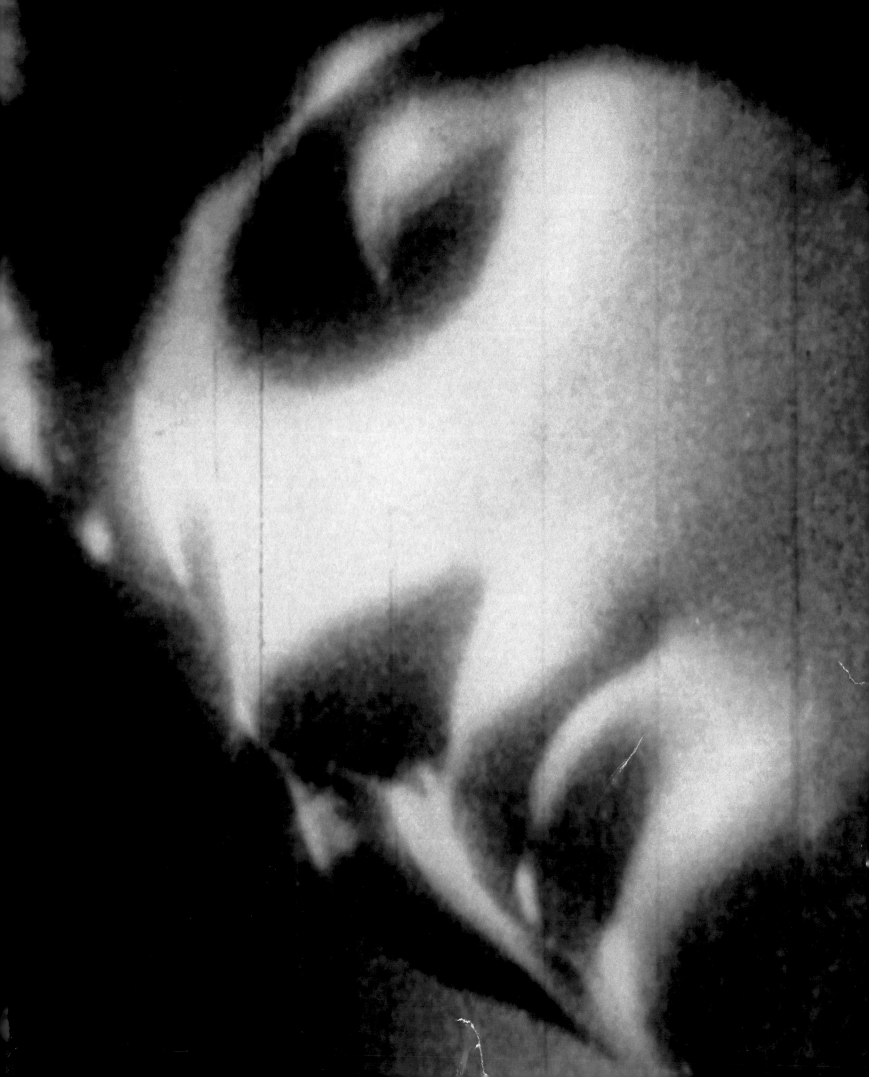

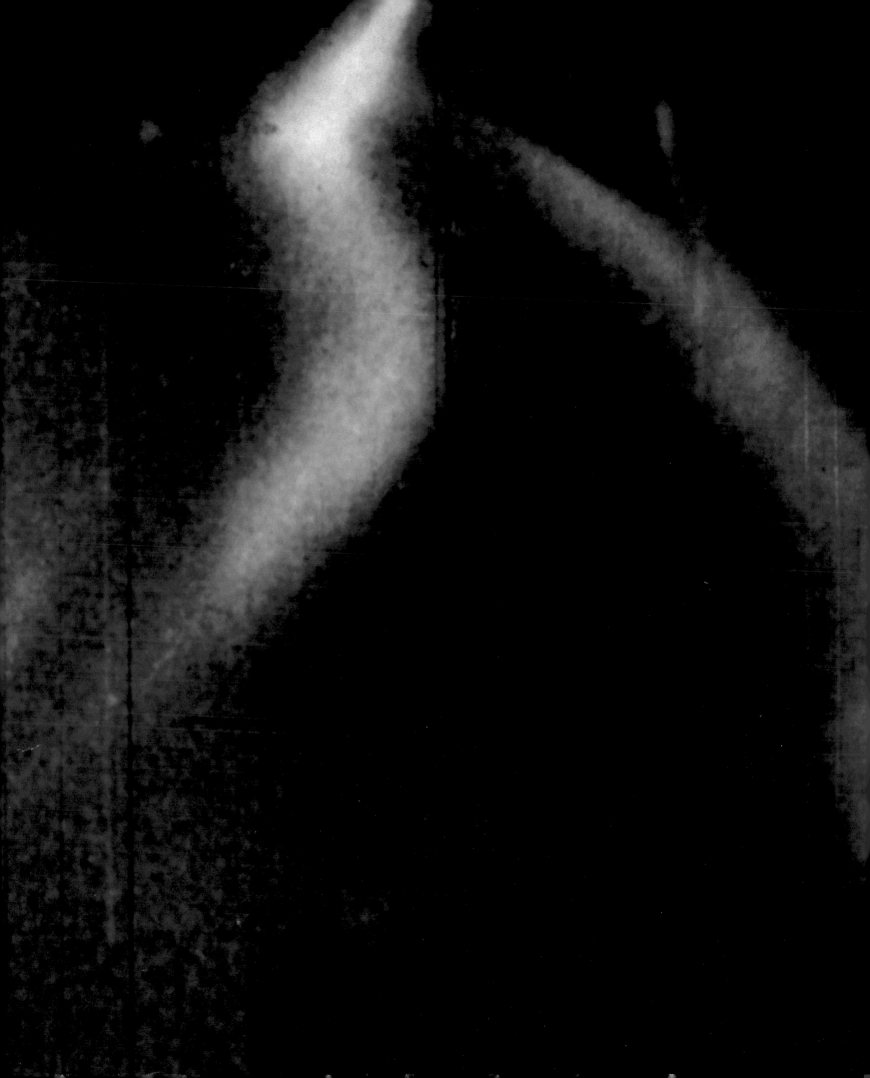

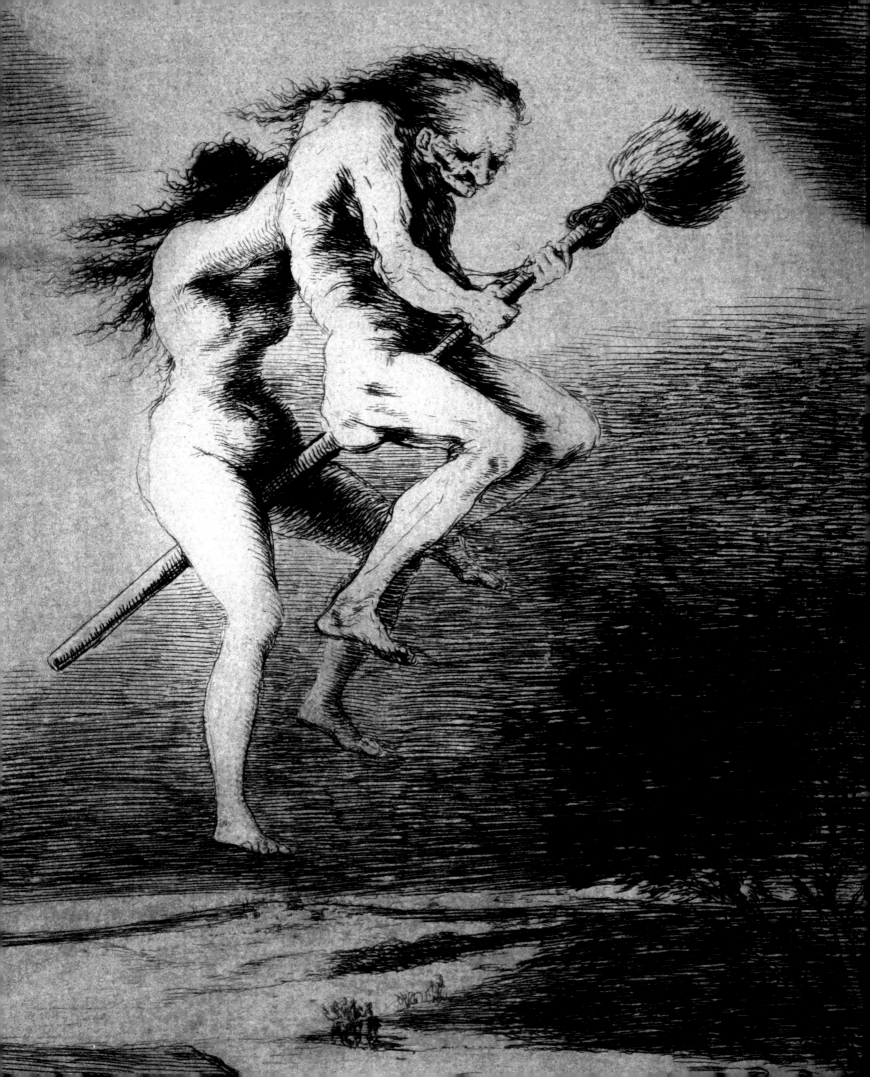

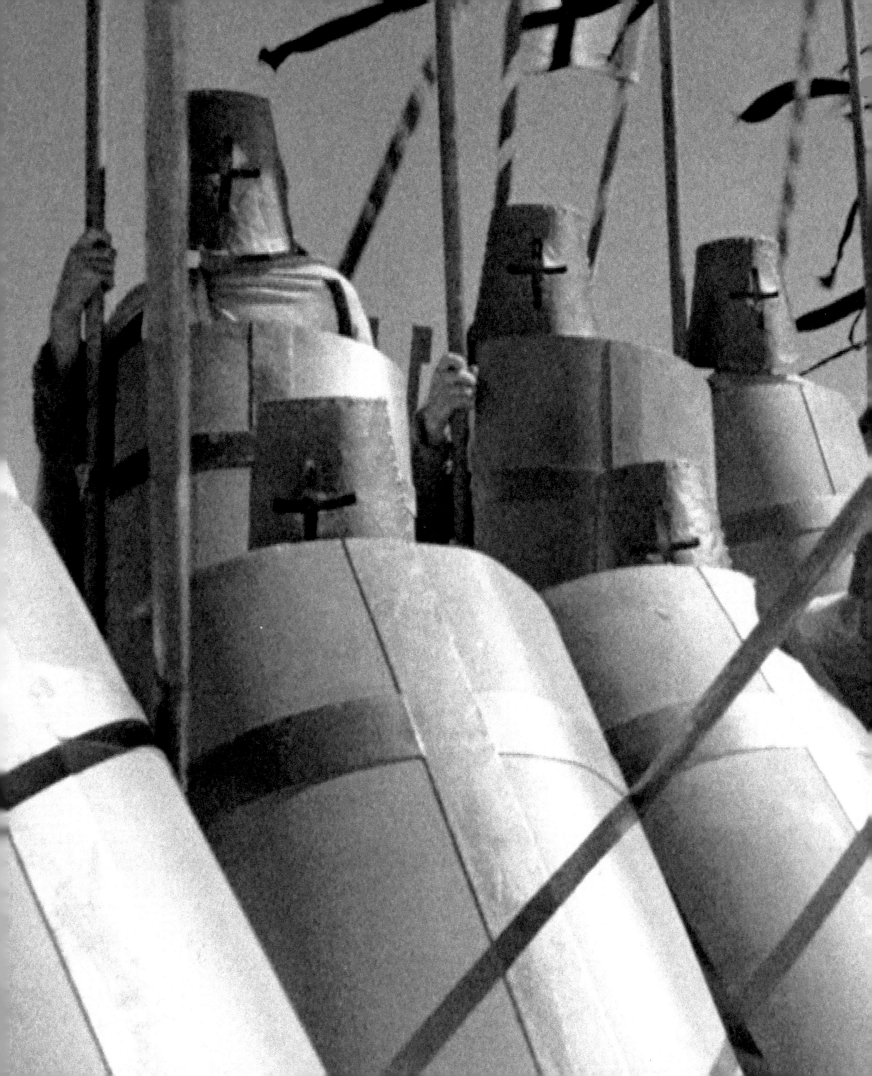

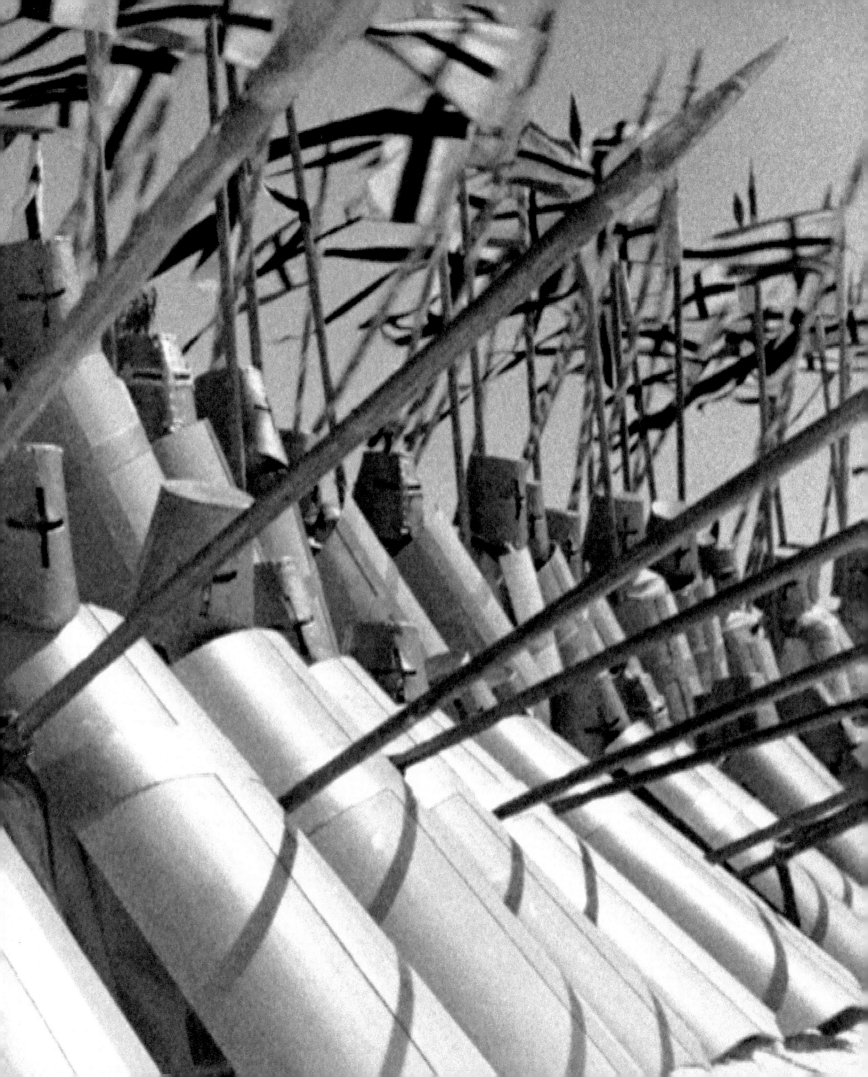

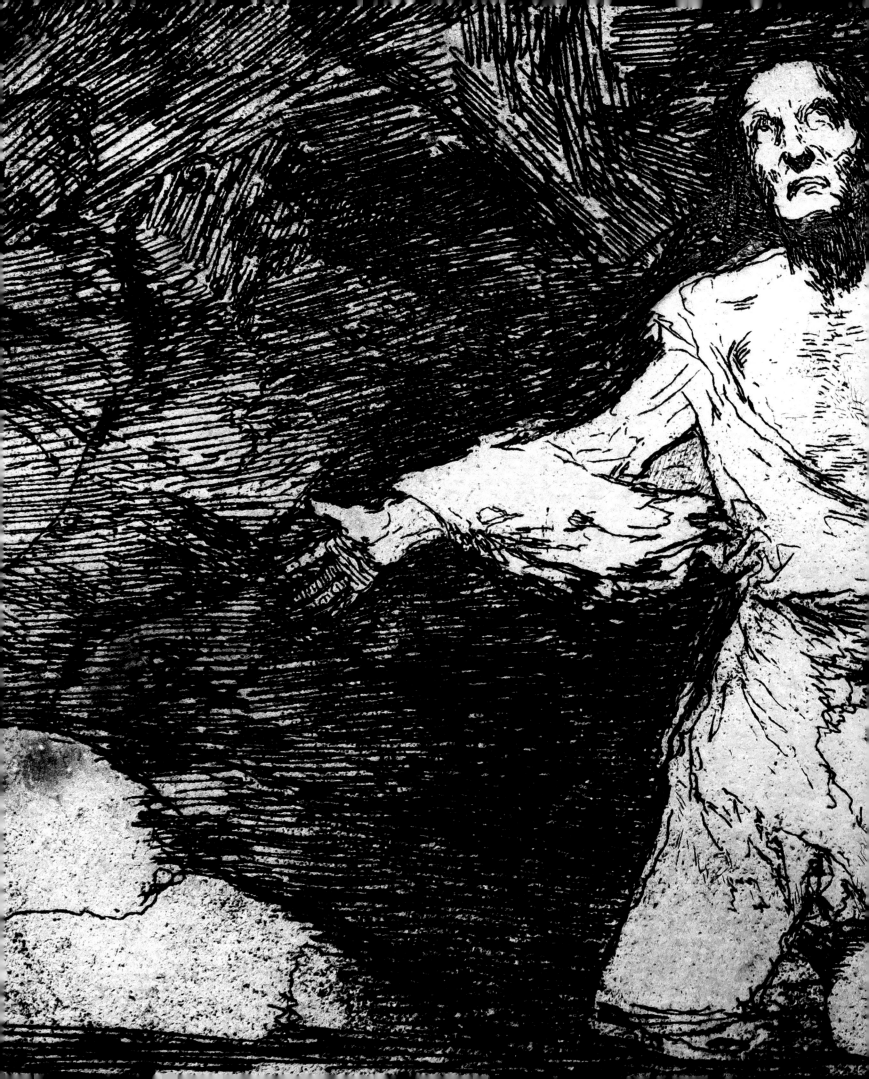

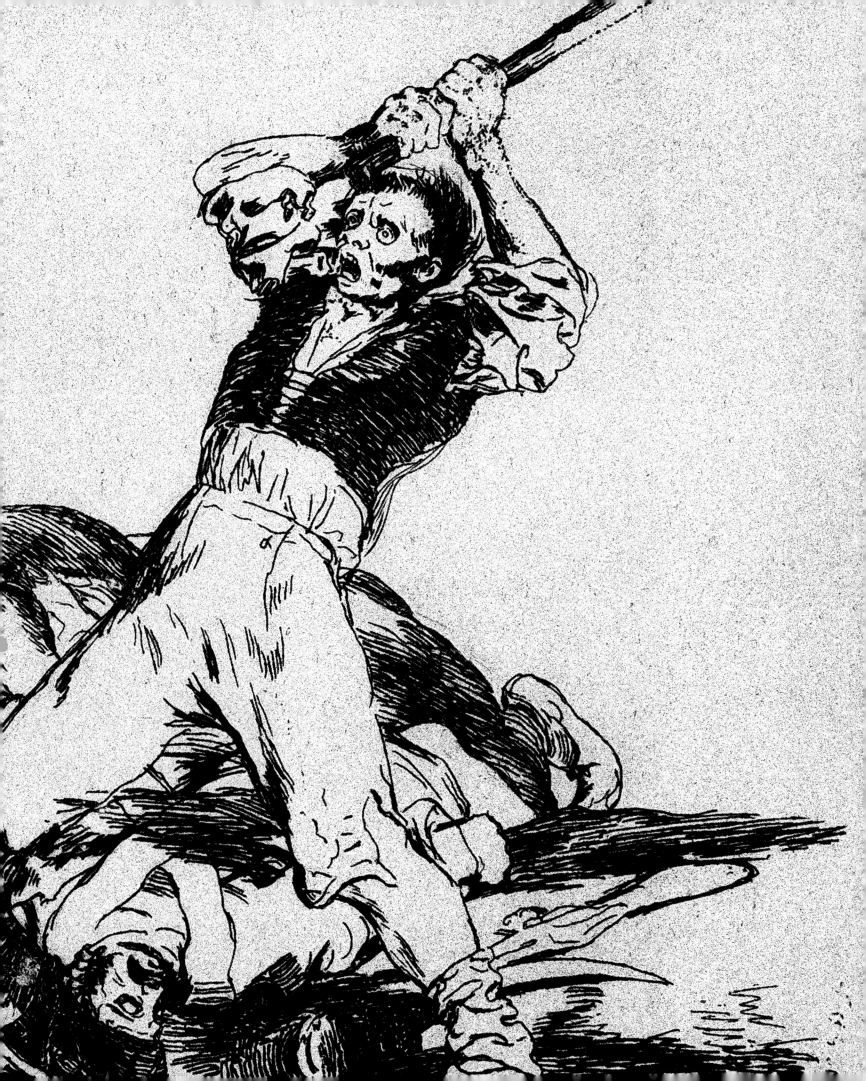

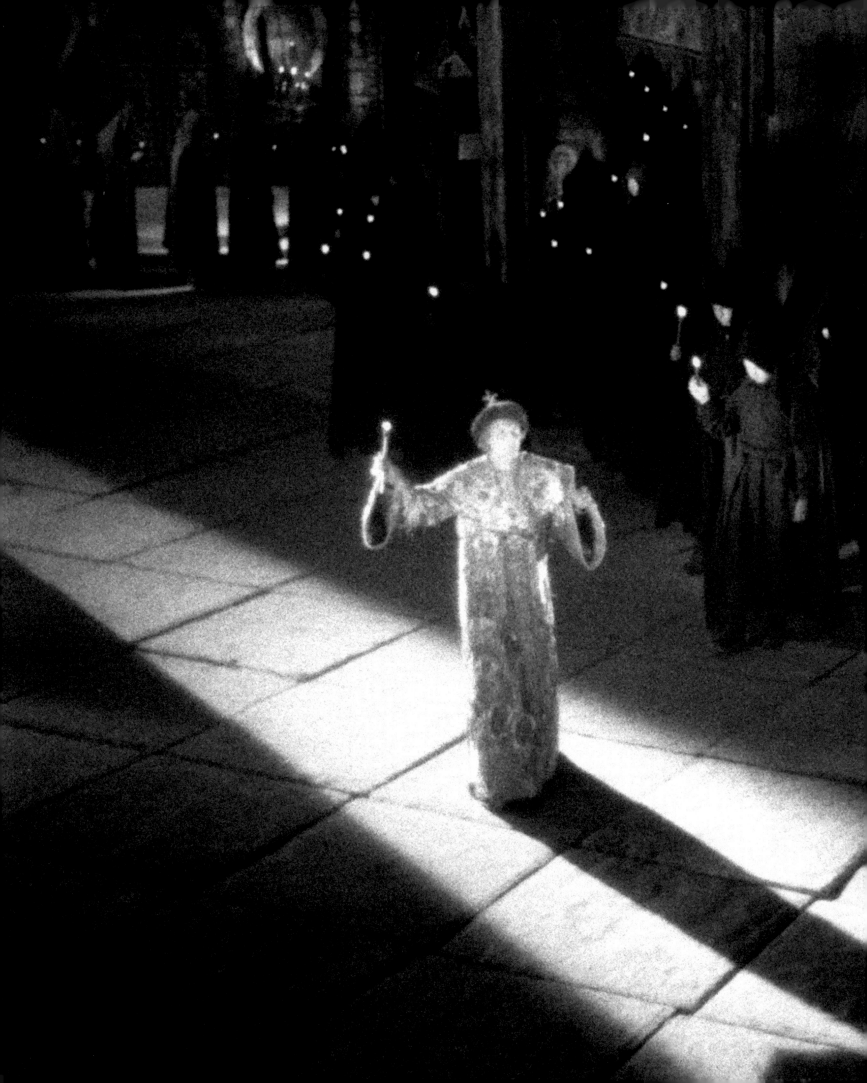

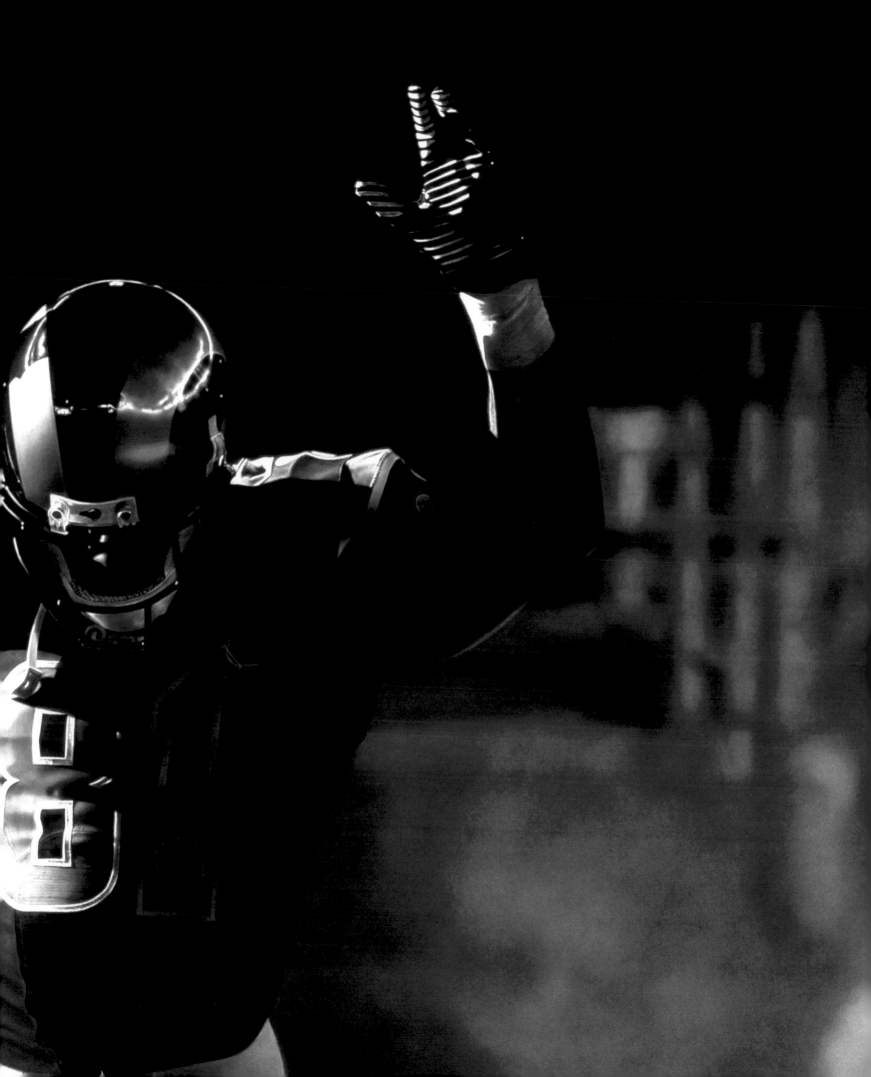

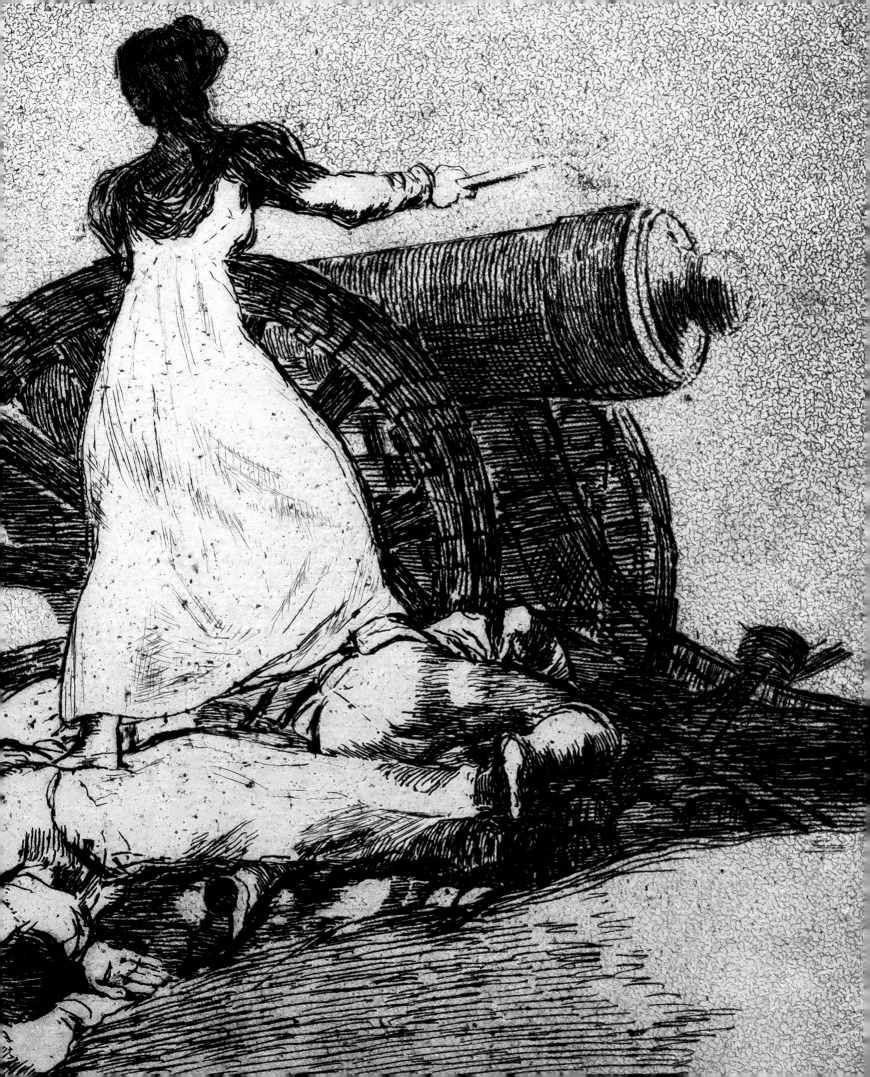

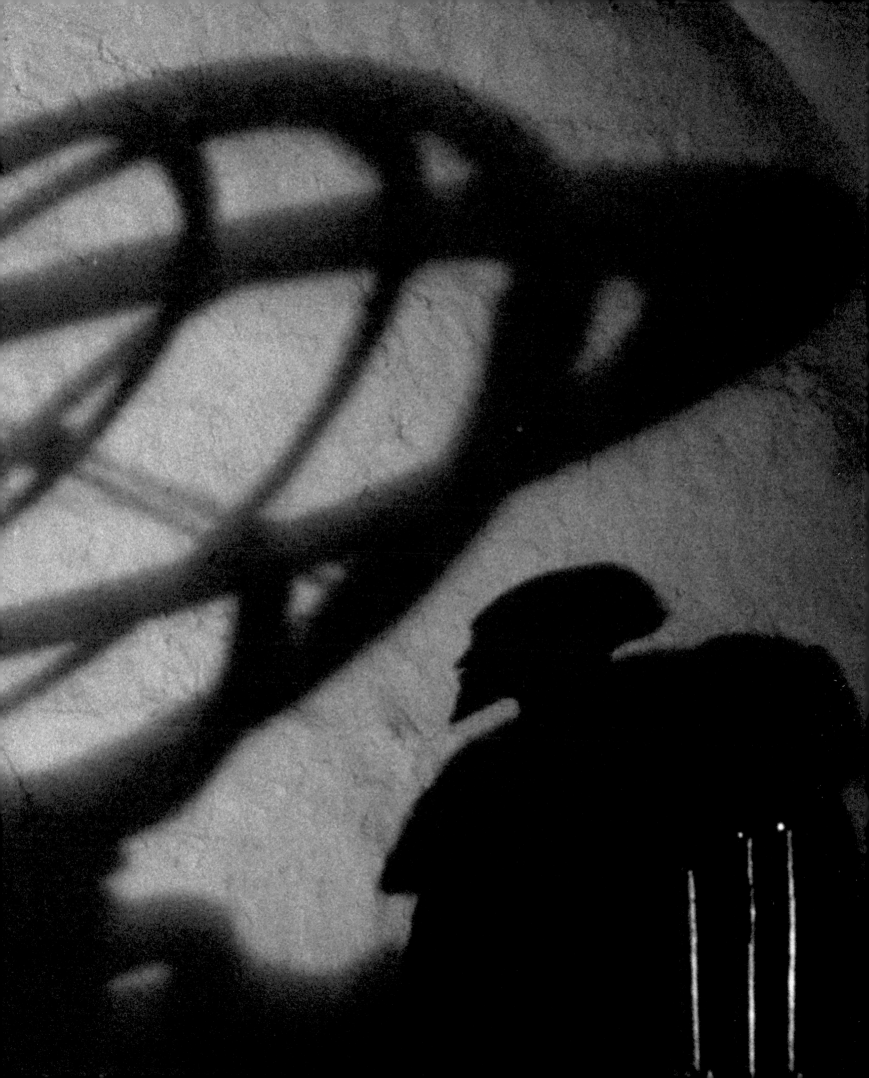

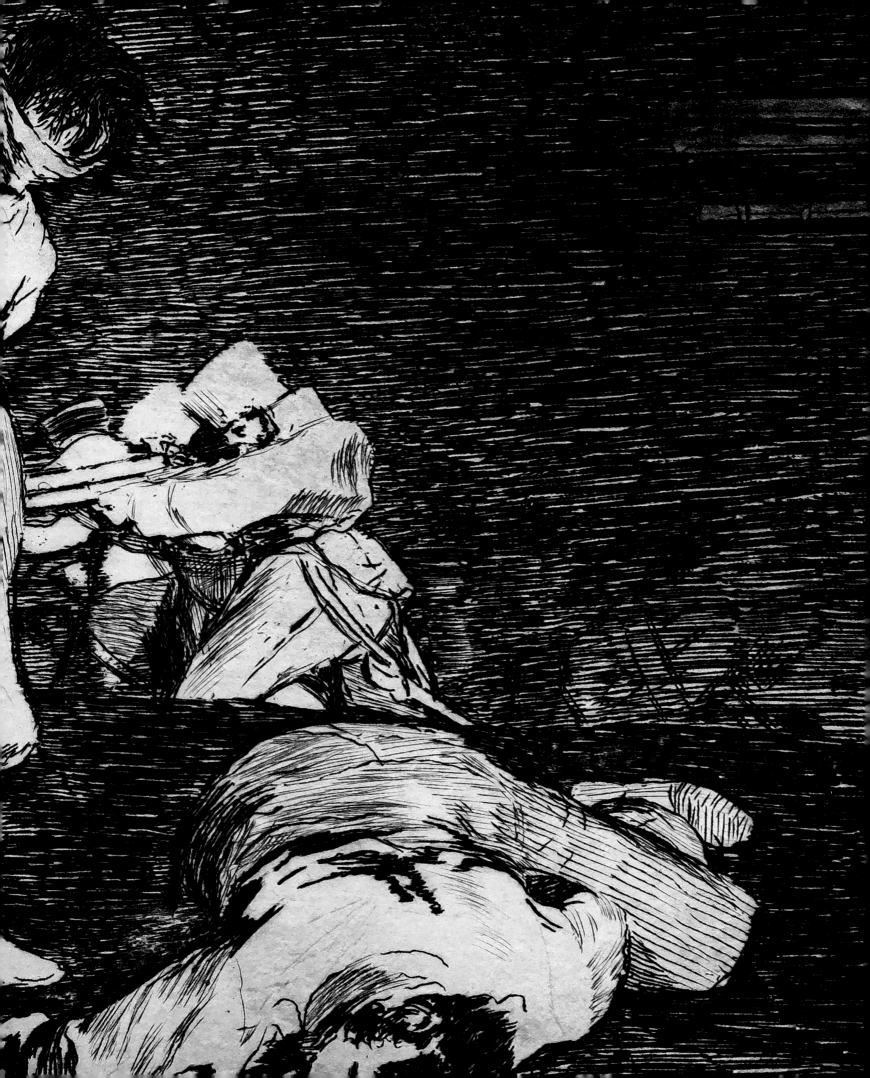

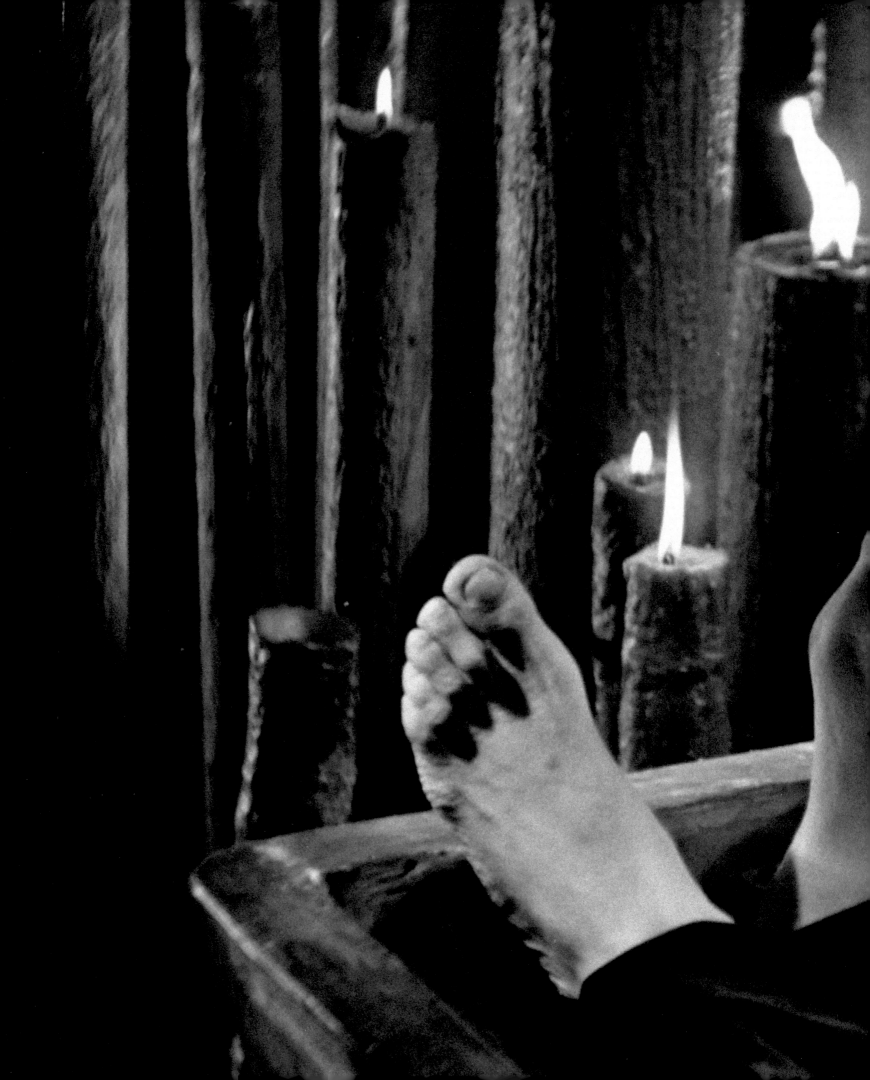

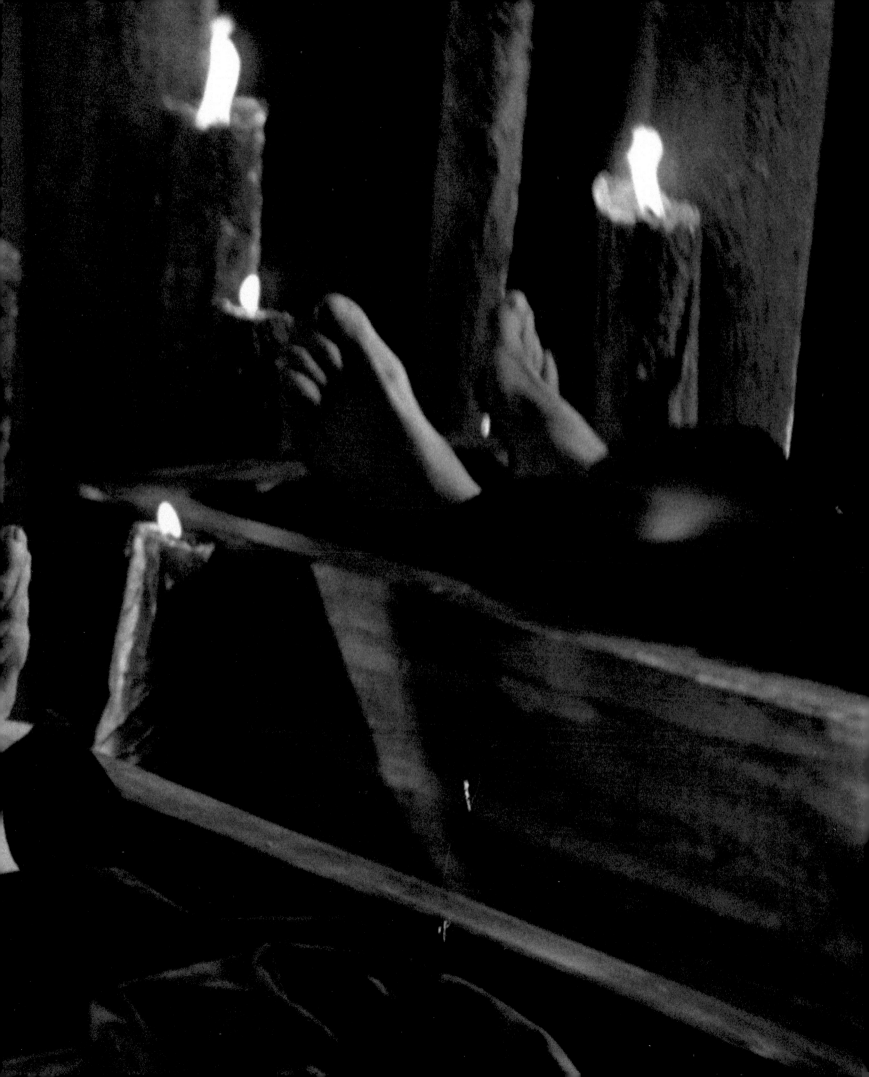

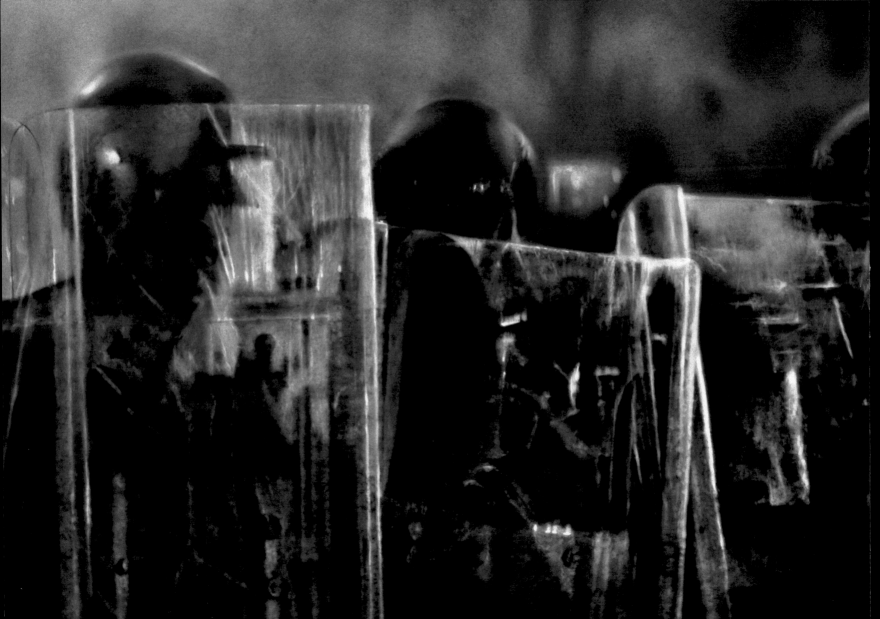

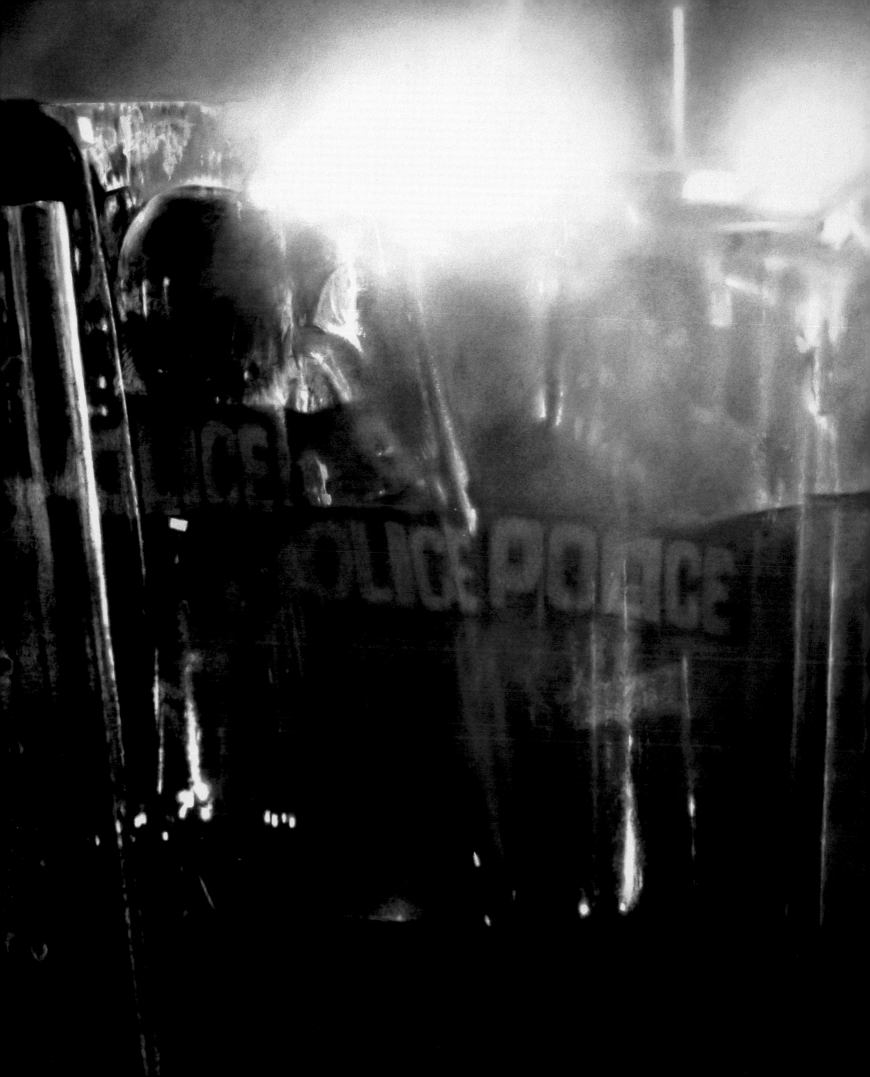

TIME TRAVELING

Robert Longo in conversation with Kate Fowle

Kate Fowle: One of the great things about developing this project with you has been the opportunity to observe you at work in your studio. Over the past few months I've particularly appreciated watching *Untitled (Pentecost)* (see facing page) come to life, emerging from the surface of the paper. How did the idea for that drawing come about?

Robert Longo: I've always really liked watching sci-fi movies with special effects, and I've enjoyed witnessing the evolution of special effects techniques over time. *Untitled (Pentecost)* is based on a still from a recent sci-fi film called *Pacific Rim*, which was made in 2013. It's not a great film, but I loved the idea of gigantic robots constantly fighting to save the world from aliens. The robots are controlled by two pilots who sit in their "heads." Actually, the robot that I drew is controlled by one guy, named Stacker Pentecost. I identified more with that situation.

KF: What do you mean?

RL: I find the idea of the little guy controlling the monstrous robot compelling. It seems like a Freudian reference to the id or the libido. One day I was surfing the Internet and this picture appeared and I thought, "Wow, that's it!" The image moved me. It reminded me of my large-scale church drawings from around 2010 (see facing page), and of a piece I made in 1982, *Now Everybody (for R. W. Fassbinder) I* (see page 102). This drawing is unlike any other that I'm making at the moment, yet as an image it captures something of our time, a representation of technology going berserk. In fact if it only represents a split second in the film.

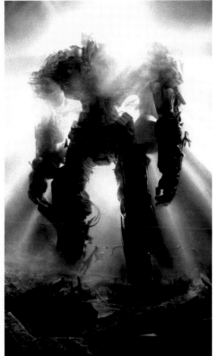

Robert Longo
Untitled (Pentecost)
(2016)
Triptych
Courtesy of the artist and Metro Pictures, New York

Robert Longo
Untitled (North Cathedral)
(2009)
Triptych
Courtesy of the artist and Metro Pictures, New York

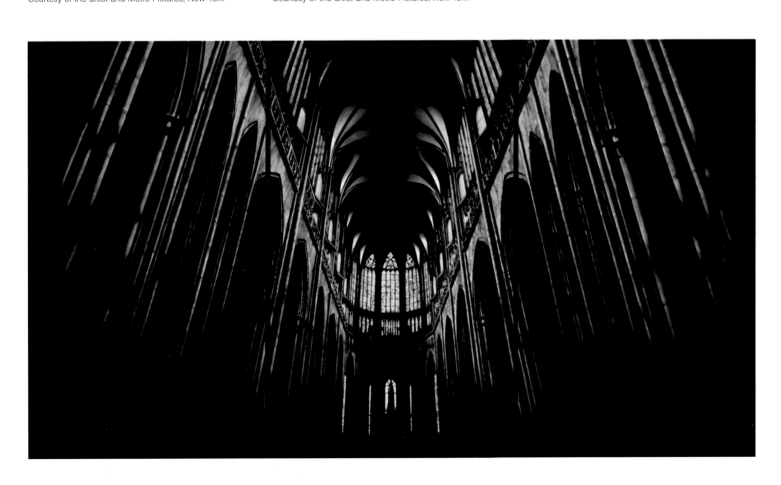

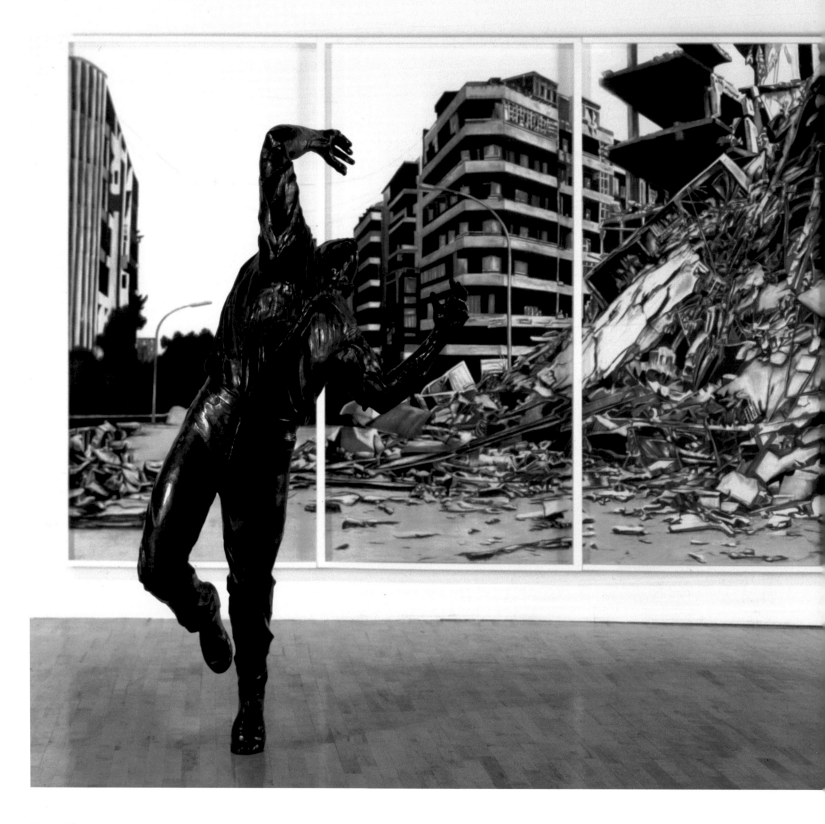

Robert Longo
Now Everybody (for R. W. Fassbinder) I
(1982–1983)
Installation view
Courtesy of the artist

KF: It's an apocalyptic image, but it seems to me that it is actually timeless: it could be in the past, present, or future. Would you say it's an archetypal image in that regard?

RL: Yes, that's partly the point. It was when I was making the series *Magellan* in 1996 that I first started going off on this tangent, inspired by the Jungian idea of the collective unconscious. I kept fantasizing about what images of the collective unconscious are today, when we are bombarded by so many pictures. Geoffrey O'Brien has written a brilliant book called T*he Phantom Empire: Movies in the Mind of the 20th Century*. It's about the impact of images, both moving and still, and how they quietly, profoundly, almost imperceptibly, affect us. With the amount of images we now see, how do we process the impact they have on us or deal with any that stay with us? I find that a seminal question.

KF: You once said that *Magellan* was about the "consequences" of images for the psyche.

RL: Some images I connect to on a deeply psychological level. But at the time of making *Magellan* in 1996 (see page 104)—which was the year after making the film *Johnny Mnemonic*—I realized I had become so pictorially anesthetized that images didn't mean anything to me anymore. I wasn't taking on any of their consequences.

I don't know why, but I started thinking about the avant-garde filmmaker Hollis Frampton and his last project, also titled *Magellan*, after the explorer who first circumnavigated the globe. It was intended to be a thirty-six-hour film cycle that would be shown in segments every day for a year and four days, but he never completed it. I decided to do a project where I chose one image a day for a year from the endless stream that came into my life—from magazines, newspapers, books, movies, and television—and to make a drawing from it. (There was no Google image search then; I didn't use the Internet as I do now.) There were images of rock concerts, murder scenes, sports events, animals, superheroes, plants, riot police, eyes, mouths, people mourning, people kissing, people being tortured, and more. I would make a picture become accountable for itself by absorbing it, both physically and psychically.

Drawing is a very specific way of analyzing something. You digest the image on a molecular level, which I find extraordinary. A photograph is recorded in an instant. A drawing takes months to make. That reference to time is important, as is the fact that my works are often composites. They are abstractions, in a way.

The irony is that, in hindsight, *Magellan* has become my image lexicon, the vocabulary for my subsequent work. It contains almost all the subject matter that I've investigated since making it. It's astonishing to realize that our world

Robert Longo
Magellan
Installation view
Metro Pictures, New York, 1996

has not changed much since I made that series. At the same time, the images I found in 1996 also reminded me of the ones I saw in magazines like *Life* when I was growing up.

KF: Would you say you were copying these images? Did you change them at all?

RL: I would select an image and crank up the contrast on a really old Xerox machine to get it to the dramatic pitch I wanted. So, there was a level of manipulation involved, but the pieces I was making were more "direct"—more like physical translations of images into drawings—than they are now.

KF: Because you no longer use the Xerox machine? Do you rely on computers more these days?

RL: Well, I still don't fully know how to use a computer, but the ability to search the Internet has proved important. The difference between appropriation, which

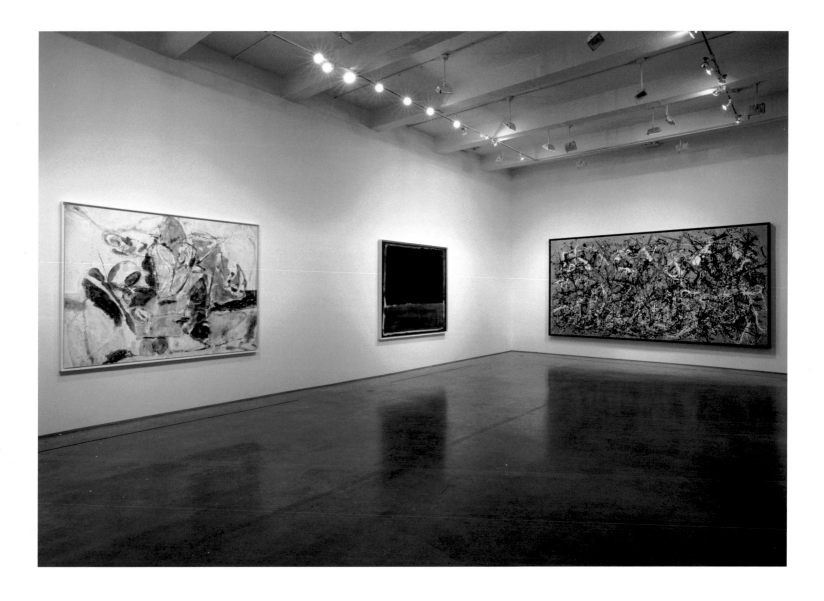

Robert Longo
Gang of Cosmos
Installation view
Metro Pictures, New York, 2014

is how my early work was described, and what I do now, is that in the past I would be fanning through, say, a magazine and I would find an image that activated something in me and then decide to use it in some way, to amplify it. Now I have ideas of specific images that I want to find and I look for them. I still watch television, scour newspapers and magazines, but I have this radar for images I want and I pursue them in many different ways, down to getting the rights for them from photographers, museums, artists, or producers.

Once I have the image, then I decide what I want to make of it. The works are by no means copies, rather they are highly sensitized, at times subjectively altered, translations. They often bear little relation to the original images, even though the drawings may appear photographic. Ultimately, in real life you would never be able to find the images I end up making.

KF: For the most part your works are black-and-white—or perhaps it's better to say that you predominantly work in charcoal on paper—which could be seen as a logical translation of some of the early photos you used from magazines

like *Life*, or the black-and-white TV images you grew up with. But now the images you cull are often color, and in the last few years you have even made works in response to paintings.

I'm thinking in particular about your *Gang of Cosmos* (see page 105) show at Metro Pictures in New York in 2014, for which you made charcoal drawings of twelve well-known Abstract Expressionist paintings by artists such as Jackson Pollock, Willem de Kooning, and Joan Mitchell.

RL: When you take a photograph or painting that is in color and translate it into black-and-white, it changes everything, particularly because the chemical translation is very different from the way the human eye translates something.

KF: Can you explain that further?

RL: We started by taking color photographs of the paintings. When translated into the grayscale of black-and-white, digitally or chemically, some of the colors in those photographs—dark red and dark blue, for example—look pretty much the same. The machine makes an arbitrary decision, but the human eye can detect a difference, even if it can't tell what the original color was. When I make a drawing, I make decisions which, theoretically, might alter the colors if they were retranslated using the computer.

KF: So, you make a decision based on how the retina receives information?

RL: Yes, I differentiate color tonally in charcoal, by hand and eye. And through this I have realized increasingly that the drawings are not black-and-white; working in charcoal really isn't about this.

KF: I remember when you were making the Joan Mitchell piece, *Untitled (After Mitchell, Ladybug, 1957)* (2013) (see facing page), you explained to me that in the process you understood how tall she was, and the fact that she was right-handed, where the composition started, and even her mood when she was making the work. In thinking about the slippage of past, present, and future in your own works, it struck me that this series amplifies how you time-travel and immerse yourself in an image and the way it is made, or what it is saying, to get it to speak from the past, in the present, and to resonate into the future.

RL: Totally, yes. I remember making the Mitchell piece with more than fifty photographs that we had taken in the museum all taped up on the wall around the drawing. It looked like a murder investigation board.

And what's so great about forensically studying the work is that you learn things like how long it takes to *draw* a brushstroke versus how long it takes to *make*

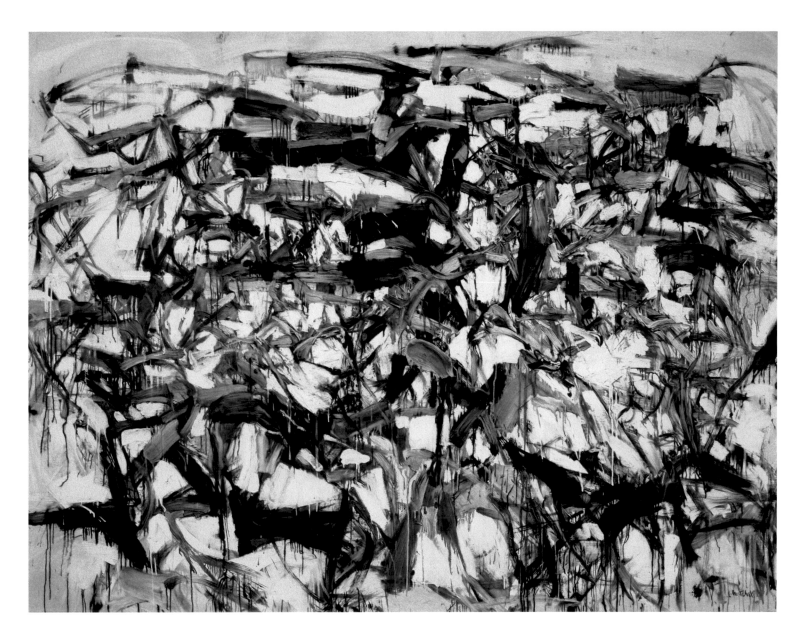

Robert Longo
Untitled (After Mitchell, Ladybug, 1957)
(2013)
Collection of Bob and Suzanne Cochran,
New York

a brushstroke. And you can tell by the weight of the paint, and by the way Mitchell takes a stroke across to the right, which hand she uses. I realized that she must have been a little bit shorter than I am and that she couldn't reach the top of the painting, so she made a couple of brushstrokes at the top just to fill it in. Most of the activity of the painting is basically around the guts and the heart, which I thought was quite amazing. You start to learn things about these paintings and about the people who made them, their outlook on life.

I talked to Paul Auster about Joan Mitchell—whom he met—and her violent relationship with Jean-Paul Riopelle, the French-Canadian painter. People talk about Jackson Pollock in terms of how violent his paintings were, but they are like ballet next to Mitchell's. She was more like the Sex Pistols in comparison. The level of violence in her paintings is like a knife fight.

KF: What made you want to focus on Abstract Expressionist artists for this series?

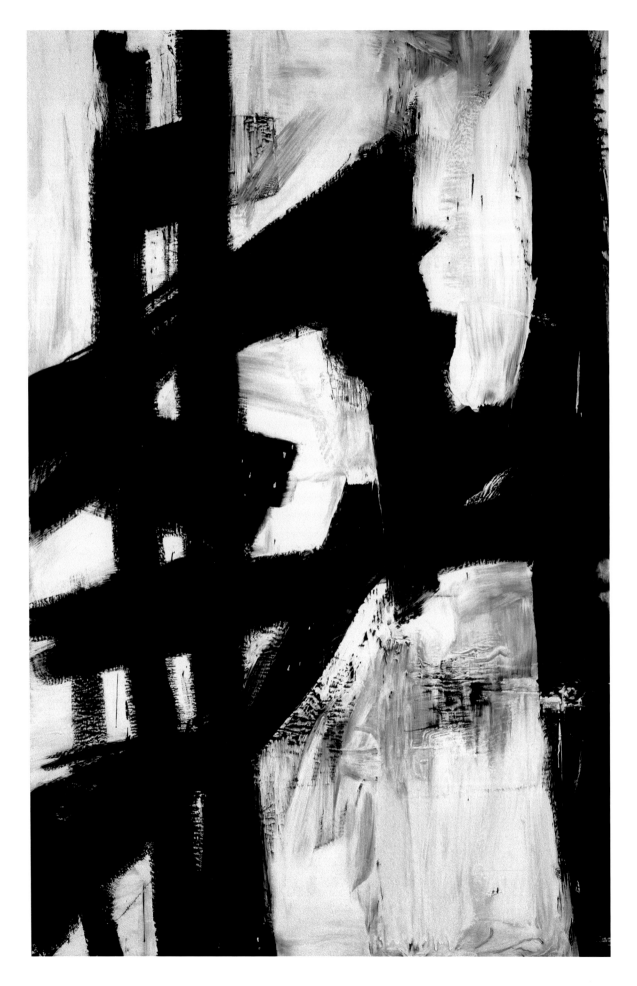

RL: There were a number of reasons, but the starting point was when I read a story about Willem de Kooning inviting Franz Kline over to his studio one night to show him this new toy he had, which was an opaque projector. I imagined them getting drunk and de Kooning saying, "See this little doodle I have here of this woman? I am going to take it and put it in my new toy." So, he projects it onto the wall and there's this big image. Then he says to Kline, encouragingly, "Why don't you do that too?"

At the time, Kline was making images of chairs and stuff like that on pages torn out of the telephone book. He enlarged one of these small works on a canvas, using the opaque projector, but the image was so much bigger than the canvas that what he ended up painting was abstracted. The experiment basically exploded into what Kline became. What hit me was that the Abstract Expressionists, with whom I had always felt a kinship, were working with projectors and representational images. I realized that there was a definite connection and I wanted to access that. The first work that I made was based on a Kline painting, *Mahoning* (1956) (see facing page). As I drew, it became so clear that the lines came from chairs. They weren't some aggressive, angry gesture. They were chairs! The fact that these forms are representational at their core fascinates me.

There is also a quote by Barnett Newman that I really like. He believed in myth and the unconscious as a driving force and said something like, Abstract Expressionists are "representational artists working abstractly." I always think that I am an abstract artist working representationally so it hit a chord. I also imagine what it was like trying to make art in the early 1950s, following World War II, after the world had tried to destroy itself and European ideas of art no longer had the same relevance. It must have been an incredibly exciting time to be an artist and to express something meaningful beyond all the rhetoric.

KF: You have recently started a series based on x-rays that were generated by the restoration departments of the Louvre and the Museum of Modern Art in New York, among other places. The subjects and artists are diverse—they range from Rembrandt's portrayals of Christ, to Van Gogh's paintings of his bedroom in Arles. What is the driving force behind the series?

RL: After I saw the x-rays of the "portraits" that Rembrandt made of Jesus (see page 110), I learned that he used young Jewish men living in Amsterdam as models. This discovery was intense, because the paintings conceal the fact that they were originally quite Semitic in appearance—unlike the subjects in the finished paintings. What I was seeing in the x-rays I studied was some other kind of truth: that Rembrandt had westernized his models, and by extension Christ, and made them European. It was also exciting that the x-rays accentuated the wood that Rembrandt painted on. When I first saw the grain of the walnut

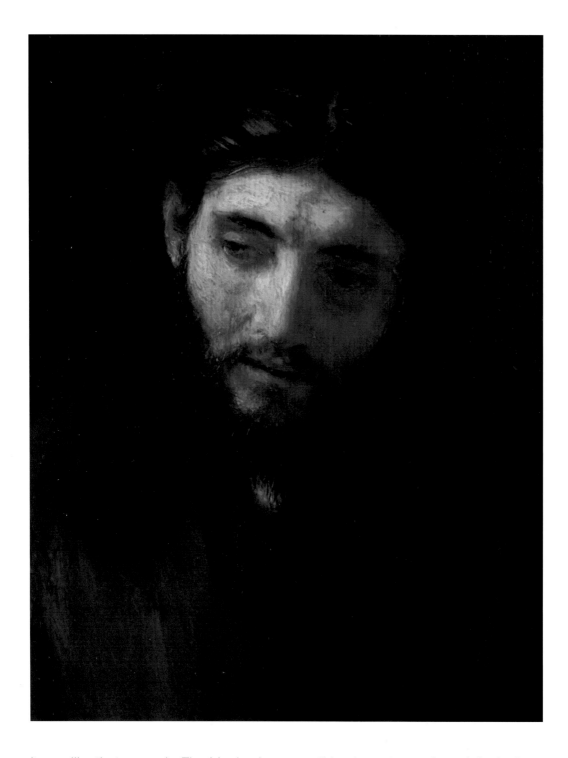

Rembrandt Harmensz. van Rijn
Head of Christ (c. 1648–1656)
Philadelphia Museum of Art, John G. Johnson
Collection

Robert Longo
*Untitled (X-Ray of Head of Christ,
c. 1648–1656, After Rembrandt)
(2015)*
Courtesy of the artist and Galerie Thaddaeus
Ropac, London · Paris · Salzburg

it was like that scene in *The Matrix* when everything turns to numbers. It looked as if electricity was flowing through it, and seemed so futuristic.

When I began this series based on x-rays, I revisited Walter Benjamin's "The Work of Art in the Age of Mechanical Reproduction," in which he evaluates the artwork's loss of aura through replication. This series was a way for me to reclaim the aura. At that same time, I came across a text by a poet who asserted that believing in God is to believe in the invisible. And I thought, "Wow, these x-rays actually enable you to see the invisible." That took me off on a whole other tangent in terms of how these works relate to others that I have made.

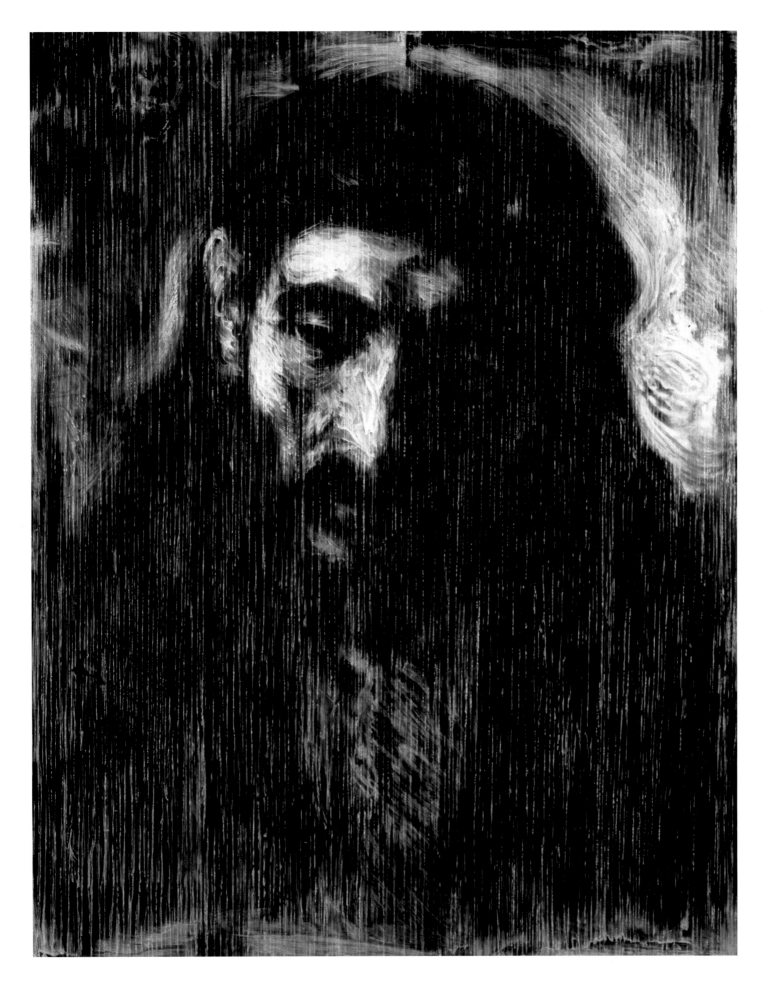

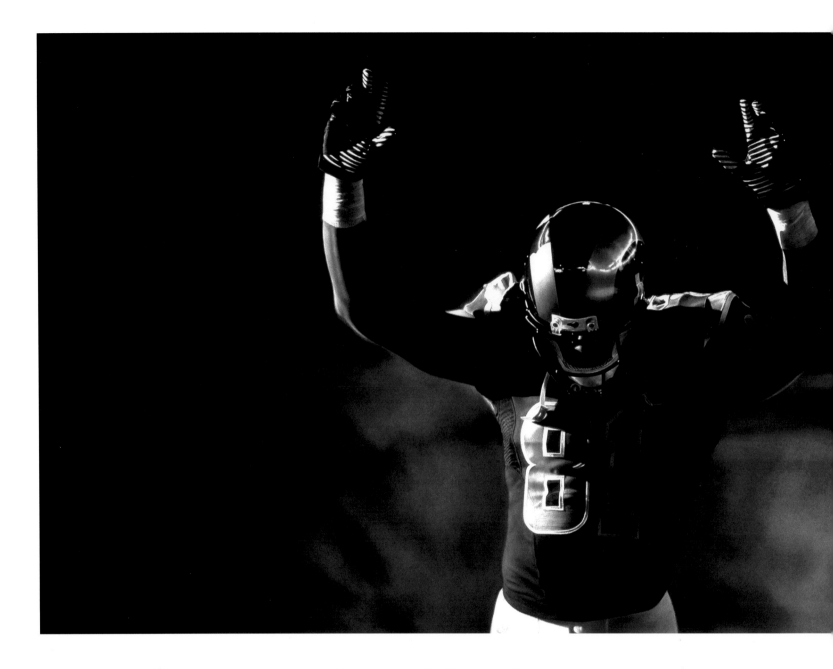

Robert Longo
Untitled (St. Louis Rams/ Hands Up) (2015)
Courtesy of the artist and Metro Pictures, New York

KF: That's interesting, because now you are working across quite different series simultaneously. As well as the x-rays, you are also making large-scale works that relate to current political issues. I'm thinking of the image of the police in the 2015 Baltimore riots, or the St. Louis Rams football players coming out onto the stadium field with their arms up in support of the Ferguson protests in 2014.

RL: Those images are also x-rays, in a way. Each drawing is an effort to see what's really there. I'm not by nature a political person, but I feel compelled to make this work. It starts with my choice of drawing as a medium, and particularly charcoal—to use dust to make images of the world in flux around us—rather than the "high art" forms of painting or sculpture. It's also integral to the way that I elevate drawing from its "secondary" status, by making it the scale of large paintings or film screens. Together, this imposing scale, combined with

the medium's inherent intimacy, represents a sincere attempt to slow down the image, to provoke the viewer to consume its full power. It goes back to *Magellan*, and the fact that when these images flash by you in newspapers and magazines you can't realize what they are truly saying. I want to really see them, and I want to identify what they reveal about our world right now.

KF: This impetus is what lies at the heart of *Proof*. It is firstly an exhibition that presents images that reflect the social, cultural, and political complexities of the time that they were made. But it is also a show that reveals resonances between artists—across centuries and continents—and, in particular, two artists that you have affinity with.

RL: As a kid, I frequently heard that phrase: "Those who don't know history are doomed to repeat it." Similarly, I understand the history of art as a series of rungs on an ever-extending ladder that each artist steps onto. As an artist, you aspire to establish a rung that future generations will have the chance to step onto, to help them climb higher. When I look at the work of great artists and really delve into their visual language, I am looking for help to get to the next level. When you are younger you think your life is about moving into the future. When you are older, you realize the future comes at you and it changes the past.

Getting inspiration from other artists is something that I think is common to Goya and Eisenstein, too. During the research for this show I learned from Naum Kleiman[1] that Eisenstein actually looked to Goya for inspiration in how to frame his shots. At the same time, he looked to Walt Disney. While Goya was influenced by Velázquez, Hogarth, and Rembrandt, but also turned to reproductions in pamphlets.

KF: When did your interest in Goya first start?

RL: In 1973, when I went to Europe to learn restoration and study art history. In the end, I realized I wasn't interested in being a conservator, so I quit and instead traveled around with my art history books, going to see all the "greatest hits" in Western Europe. One of the high points was visiting the Prado in Madrid. I didn't know that much about Goya then, but I vividly remember seeing *The Second of May 1808* (1814), which depicted the invading Mamelukes (who were part of Napoleon's French army) attacking rioting Spanish citizens, and *The Third of May 1808* (1814–1815) (see pages 116–117), which is an incredible painting of the execution of the rebels. It's been said that these two paintings are the first to depict revolution on every level.[2]

Together they were like cinema for me. They gave me a whole new experience of painting. Then when I saw *A Procession of Flagellants* (1812–1819) and

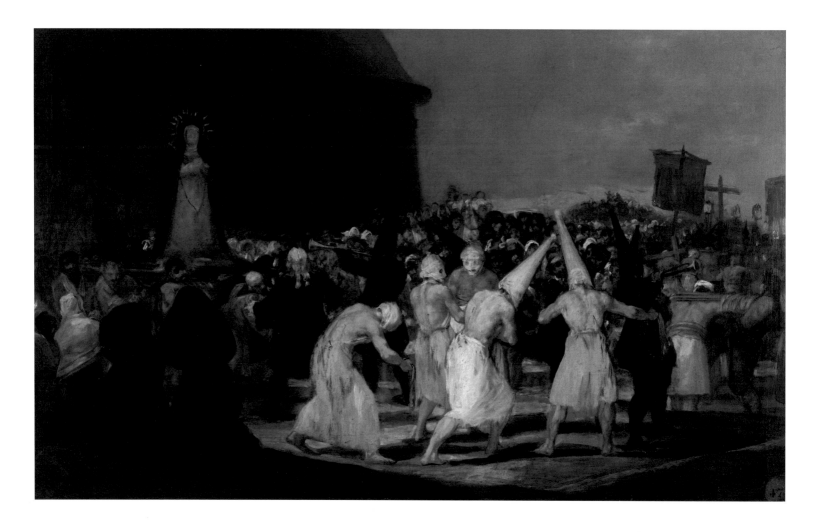

Saturn Devouring His Son (1820–1823) (above and facing page), I was blown away by the barbarity of the images. I remember there was also a painting of Christ that was quite exquisite, very stark, much like Velázquez. And although I wasn't much taken by Goya's court paintings, it was interesting for me to imagine how the man that could draw such horrendous images from his imagination could paint privileged people from real life. Although the way he made them look quite ugly seemed pretty subversive to me. Then I saw the etchings and my response was: "Holy shit! This is dark stuff!" But they also seemed like storyboards for a movie.

Since then I've investigated his work and life quite a bit. I joke about how I've been lots of different artists in my life—from the one who made *Men in the Cities*, to the one who made the giant *Combine* montages, to the performance guy, to the charcoal guy—and when I think about Goya's career it wasn't much different. He moved between making the cartoons for pretty lame royal tapestries, serving kings and rich people, and making his etchings and the Black Paintings. It was Goya who made me understand that, as artists, we're lots of different artists.

KF: Your relationship with Eisenstein seems quite different, both in terms of the way you talk about his work and in how you relate to his biography. It's clear that Eisenstein's ideas about "montage" are an inspiration, particularly in the 1980s.

Francisco Goya
A Procession of Flagellants
(1812–1819)
Museo de la Real Academia de Bellas Artes de San Fernando, Madrid

Francisco Goya
Saturn Devouring His Son
(1820–1823)
Museo del Prado, Madrid

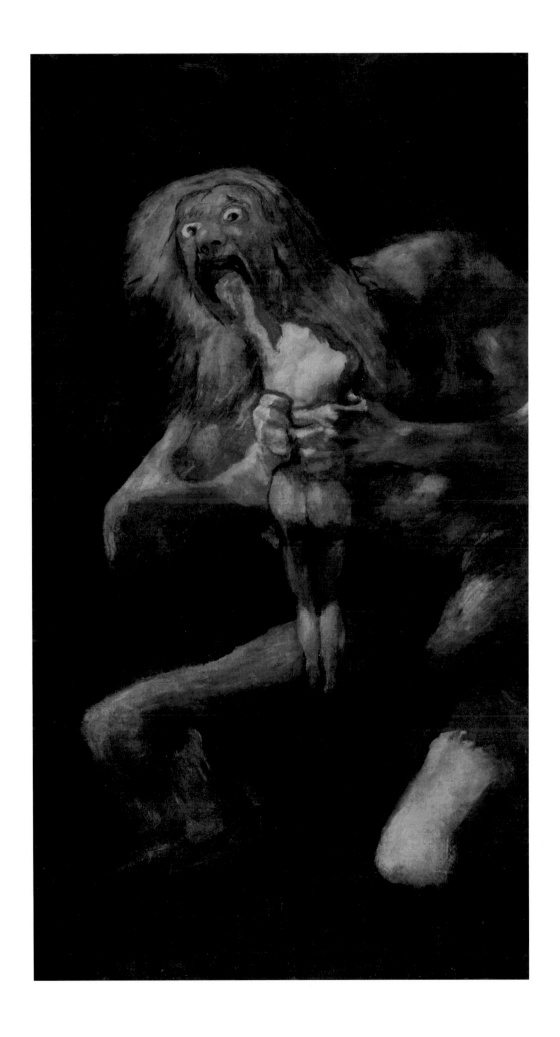

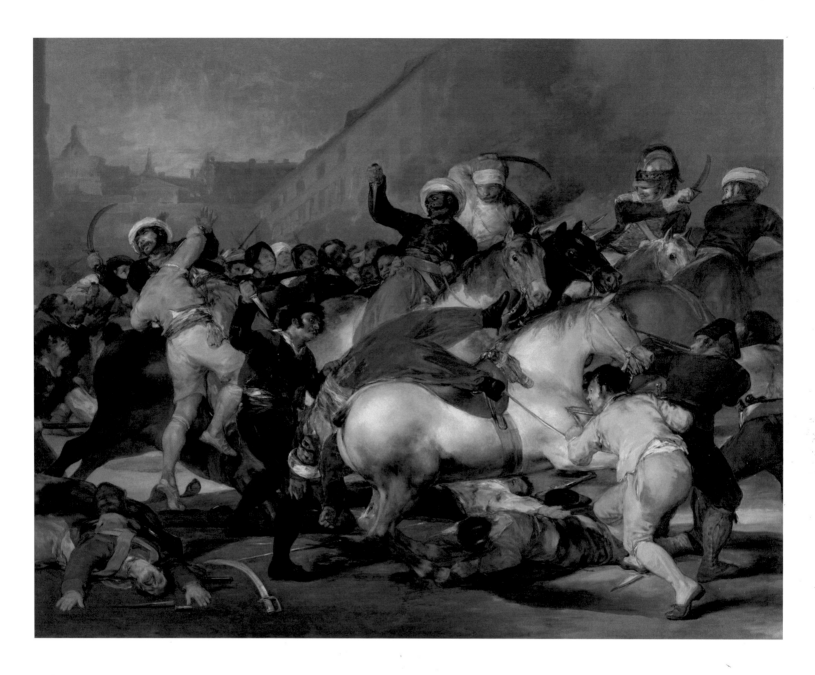

Francisco Goya
The Second of May 1808
(1814)
Museo del Prado, Madrid

In fact, when writing about you, Hal Foster cites Eisenstein's approach to film as a parallel to your practice.[3] But you discovered Eisenstein at a different stage of your development than Goya, didn't you?

RL: Yes, it was a bit later. I didn't know Eisenstein existed until I was at college in Buffalo in 1975. That was the first time I ever saw an Eisenstein film, on the Media Studies program, and then the fact that I was working for Paul Sharits got me into poststructuralist filmmaking.

I always intended the works in my *Men in the Cities* series (1979–1983) (see page 118) to be seen in sequences, like Eadweard Muybridge's photographic studies of motion, but they kept getting sold individually. My response to that was to make the *Combines* series in the 1980s (see pages 119 and 120–121). You couldn't subtract any of the separate elements from these works. I always joked they were

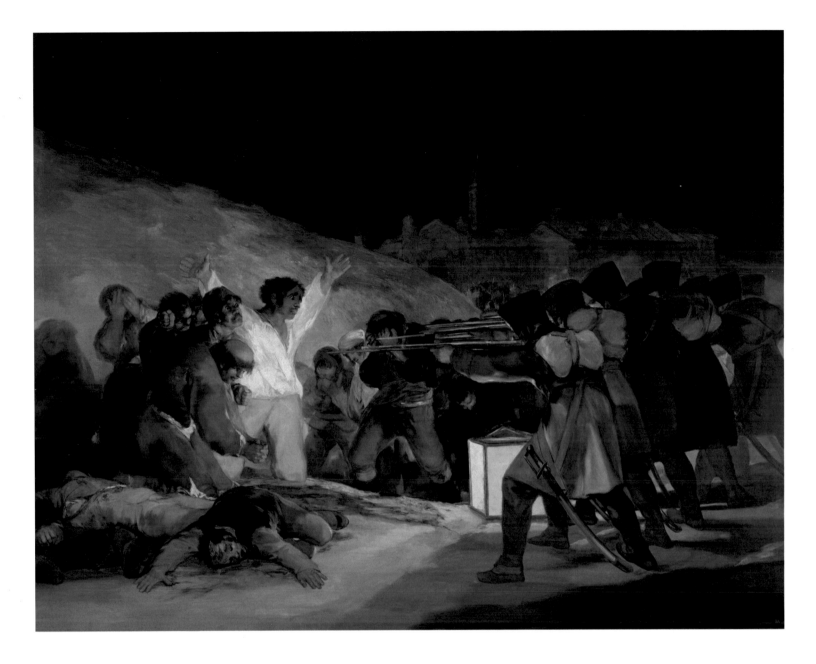

Francisco Goya
*The Third of May 1808
in Madrid* (1814–1815)
Museo del Prado, Madrid

like frozen movies. It was like taking excerpts of a film and making them physical on the wall. The doctrine behind those works is Eisenstein's essay on montage.

I wasn't looking at the content of Eisenstein's films so much as drawing on his thinking and processes. The political aspect never properly registered with me at the time. I experienced them in a post-hippie America where that "revolution stuff" seemed cool, but I did not appreciate how complicated the films are in terms of their relationship to propaganda and the tightrope Eisenstein walked in relation to Stalin, his patron, because of his radical practices. More recently I have been interested in the actual images he created.

KF: It seems to me that one of the important connections that ties the three of you together as artists is that you were all born in countries that were experiencing periods of optimism and confidence socially and politically—Spain during the

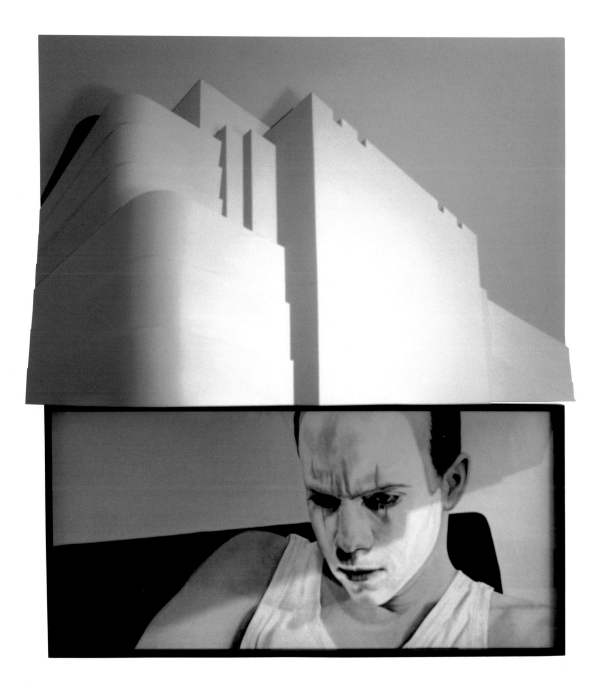

Enlightenment, Russia during the early days of communism, and the United States post World War II. But then you all came of age during transitions into uncertainty: the French Revolution, Stalinism, and the Vietnam War.

RL: Yes, these facts are important beyond personal biography, because they make a profound difference to the context of your work and the decisions as to how you will even make art. I think coming of age in the 1970s was critical for me. I grew up with America as the "good guys," with John Wayne and big Cadillacs that looked like jet airplanes. Then the Vietnam War happened, my draft number was 11, and all of a sudden America went from being a great nation to being the evil empire. I remember this change first registering in me at the end of high school in 1970, when the Kent State rally happened and a friend got killed.[4] That's where my sense of outrage started. It was also the beginning of my particular

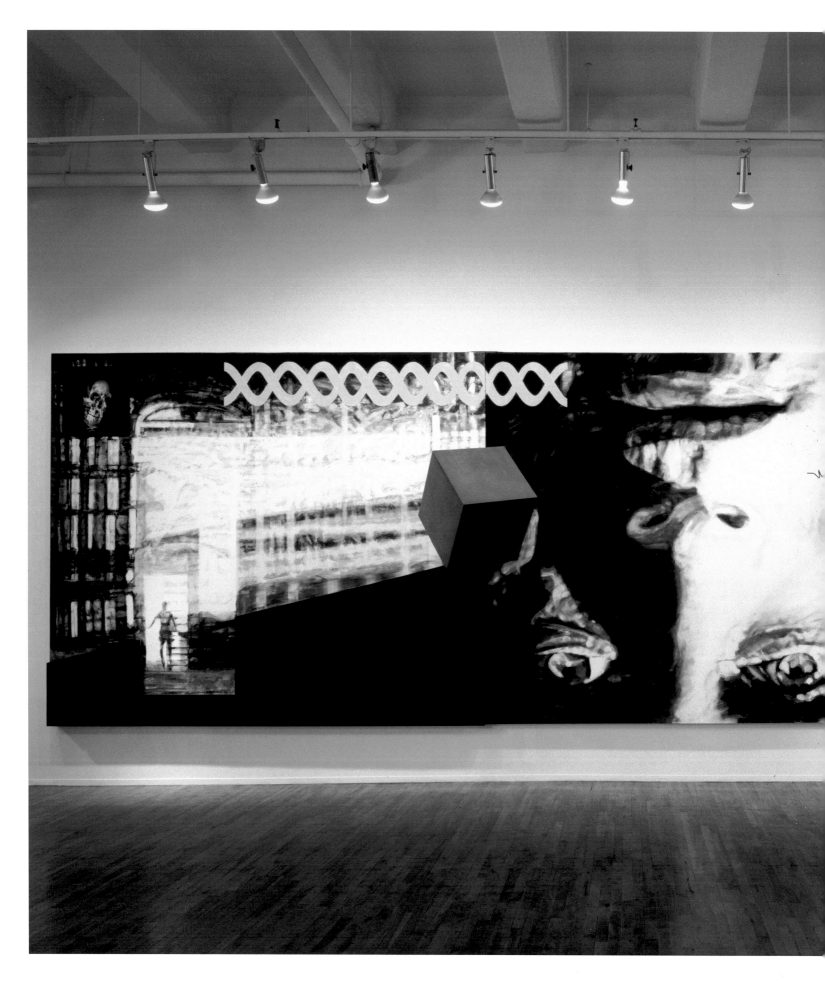

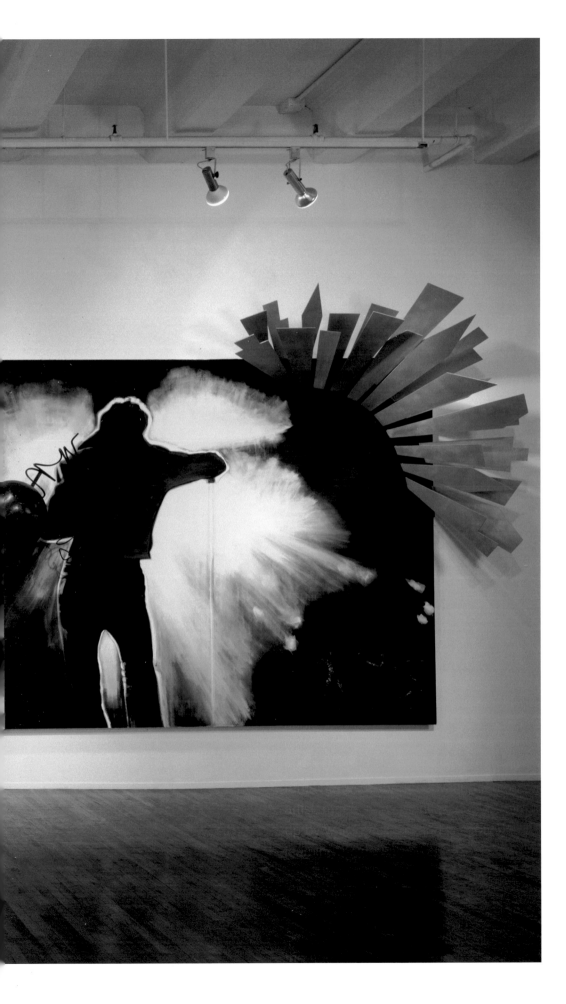

Robert Longo
Lenny Bleeds: Comet in a Bomber
(1986)
Courtesy of the artist

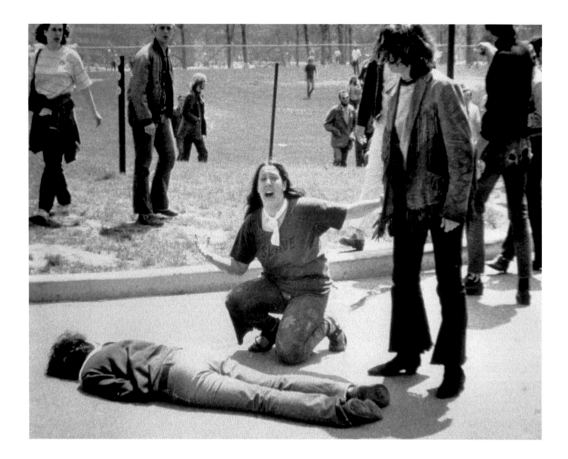

John Filo
*Mary Ann Vecchio screams
as she kneels over the body
of Jeffrey Miller during an anti-war
demonstration at Kent State University,
Ohio, May 4, 1970*
Photo © John Filo/Getty Images

relationship with press photos. There is this famous image, which won a Pulitzer, by the photographer John Filo, that captures my friend Jeffrey lying shot dead on the tarmac. I remember looking at it over and over, trying to take in the enormity of the image.

But apart from the impact of the period as I grew up, there is also this thing that has happened over time, which has to do with disappointment.

KF: Disappointment?

RL: Yes. Napoleon's exploits were disappointing, for example, after all the potential of liberty and equality that catalyzed the French Revolution. Spain must have been a big disappointment to Goya for failing to fully embrace the lessons of the Enlightenment. For Eisenstein, the disappointment was to live through the energy and potential of the 1917 Russian Revolution and then to experience firsthand how Stalin turned communism into totalitarianism. As for me, growing up in the 1950s "home of the brave, the land of the free," and witnessing the fight for Civil Rights, I was disappointed by the devolution into mass killings in the name of democracy, and the rise of corporate power, just for starters.

KF: So, the potential of revolution turned to disillusionment?

RL: And oppression. King Ferdinand IV reintroduced the Spanish Inquisition, Stalin purged freedom and creativity, and Reagan introduced so-called traditional values, which are what? Owning slaves?! And which really meant the rise of sexism and racism again. Not to mention his "trickle-down economics," which unleashed corporate power. Reagan's attitudes then were like Trump's now.

KF: Apart from responding to social and political shifts, all three of you also engage with the potential of new technologies. You're using the Internet, as we have already discussed, but you're also pushing technology in terms of scale with the paper sizes you are using and the intricate use of interlocking frames, to create drawings of proportions that are way beyond what was possible in the past. Similarly, Eisenstein was at the forefront of shifting the capabilities of film, and Goya pushed the parameters of aquatint and lithography when they were considered inconsequential mediums.

RL: Yes, but I think perhaps scale and speed are important across all the works in the show. For me, to be able to take drawing to a scale that represents what I intuit about the subject matter removes the "study" aspect from the technique and subverts the medium. For Goya, to make etchings that could be reproduced, to work small at a time when the painter to the king was supposed to paint big and make unique, exclusive images, is an equivalent subversion. For Eisenstein, changing the speed of actions, introducing montage, was also about scale in a different way. It made small gestures feel more important and undercut the traditional linearity of narrative.

I already talked about how I understand the ways in which I have tried to slow down my work, or the experience of it, for myself and for audiences. In developing this show, this consideration has also been important for me in thinking about how to present Eisenstein and Goya. To literally slow Eisenstein's films down abstracts the narratives, so you can see his image-making. With Goya, to focus on a grouping of fifty etchings, selected from around two hundred potential works, also gives people the chance to really look and see the enormity of what he achieved. For me, the installation and slowing down the process of how we consume art is about paying respect and about giving people the chance to see works in a way they haven't before.

Your selection of my drawings also changes how I see my own work. I broke down Eisenstein's narratives and Goya's sequences and you have broken down some of my series, which completely shifts how you see each piece individually and in relation to my entire body of work. It creates new associations.

KF: Yes. I think it's important that we have made a three-person show, with each artist having a dedicated space, and presented in a way that offers a different

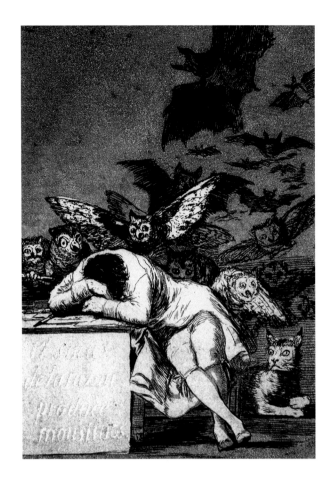

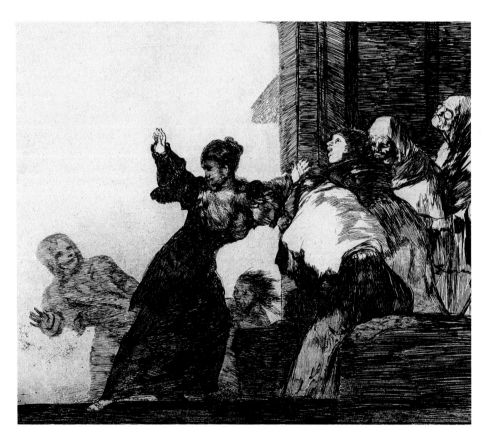

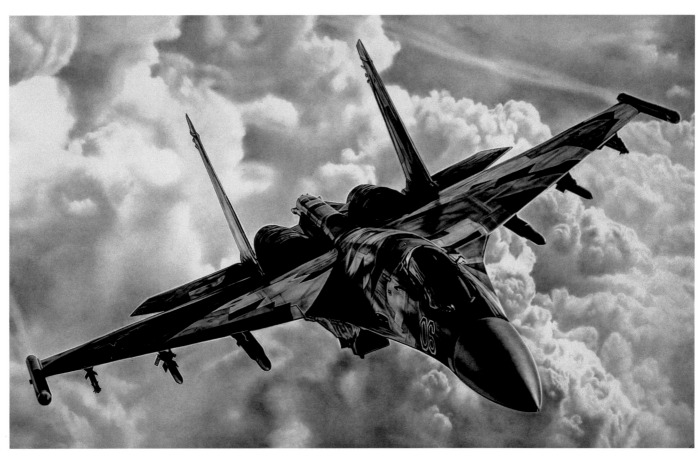

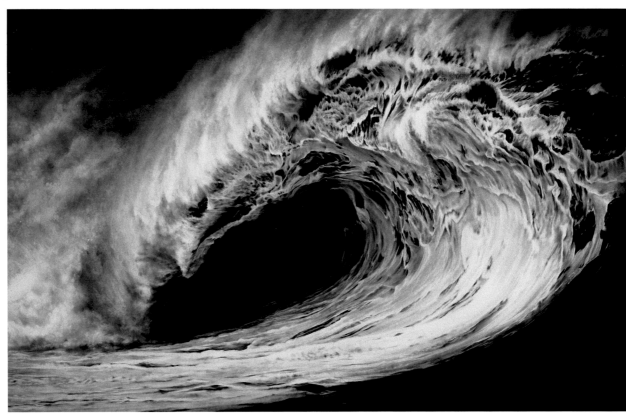

perspective on the individual bodies of work, at the same time as creating connections between the three. But there is also another approach we have taken—which is to create a series of triptychs that juxtapose one work from Goya, Eisenstein, and you in each grouping. The fact that the images in these triptychs are all presented at the same scale, irrespective of their original sizes, emphasizes correlations between visual compositions, or gestures, revealing the archetypal nature of the images (see pages 124–125 for two examples and 2–7, 15–37, 65–99, 130–147, 152–169, 174–191, 196–212).

RL: I would say that all the images are "surrogates" of ancient archetypes. They are contemporary to their day, but echo classical archetypes.

In addition to these two approaches, drawing is also an important connector. In some respects, it is the foundation, because it's that "from the eye to the hand" thing, that molecular level of processing through the body. You can see thinking actually occurring in drawing, in the way a line varies in thickness. That's why I wanted to include Eisenstein's drawings of his films, to show a different angle on his thought processes. When I looked through them in the archive I became incredibly aware of how he used his lock-down camera, of the composition of each frame, of how deliberate and precise his images were. Goya filled many sketchbooks with drawings, but I was interested in his etchings because they are like carvings. They are truly extreme in every sense.

KF: Let's talk about the title of the show: *Proof*. We played around with many other words and phrases before that, relating to the idea of witnessing, or chronicles, or evidence, but in the end they were too heavy-handed and didn't introduce the emotive or non-rational aspects of your practice, which are central to the project.

RL: I think the word "proof" conjures up an object, or at least the objectification of an idea.

KF: So, the work is the proof?

RL: On one level, yes. It's a physical manifestation of experience, thoughts, observations, reactions, intuitions, premonitions, expectations, and experiments. These images are not "images" per se. Goya's pictures of bullfighting are not just about bullfighting, and Eisenstein's *Alexander Nevsky* is not a historical drama. Just like my charcoal drawings of jets are not images of jets in the end. There's something else going on.

KF: The personal perspective fuses with the social and political implications of the rendered image.

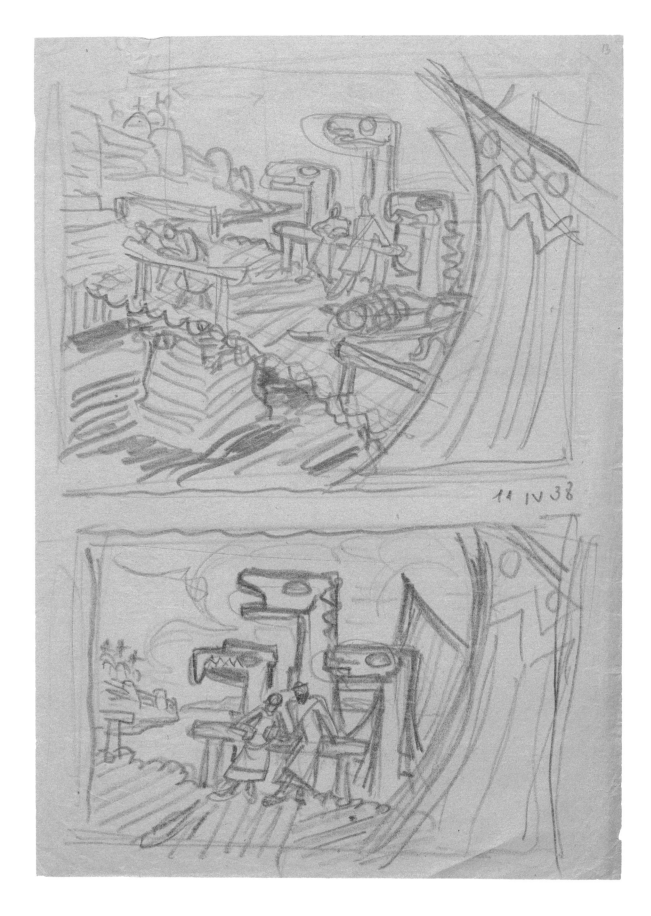

Sergei Eisenstein
Sketch for the film
Ivan the Terrible (1942)
Russian State Archive
of Literature and Art (RGALI),
Moscow

Murió la Verdad.

Francisco Goya
Truth has died, plate 79
from *The Disasters of War*
(1810–1820)
State Central Museum of Contemporary
History of Russia, Moscow

Francisco Goya
Will she live again?, plate 80
from *The Disasters of War*
(1810–1820)
State Central Museum of Contemporary
History of Russia, Moscow

Si resucitará?

RL: Yes. When I think of proof, the word "truth" again comes to mind. But the thing about trying to find truth is that it's intangible.

KF: So perhaps "proof"—in both senses of the word—is as close as you can get to it? It's a test of truth, a trial run, as well as a subjective objectification of it. "The truth" can't actually be manifest, it can only be perceived.

RL: And there is a lot of proof needed in order to get anywhere close to feeling that you are near the truth. The process of searching and questioning, I guess, is the point. While I don't see myself in the same league as Goya and Eisenstein, we are all searchers in one way or another. This is why the last two aquatints in Goya's *Disasters of War* series, *Truth has died* (1815–1820) and *Will she live again?* (1815–1820) (see facing page), offer a kind of closure to the exhibition. The latter seems like a fitting and relentless question that we need to ask ourselves, regardless of the place or time we are born into as artists.

1 Naum Kleiman (b. 1937) is a cinema historian, film critic, and Eisenstein specialist, who was formerly director of the State Central Cinema Museum, Moscow and the Eisenstein Center, Moscow.

2 "This is the first great picture which can be called revolutionary in every sense of the word—in style, in subject and in intention … Almost all the painters who have treated such themes have been illustrators first and artists second. Instead of allowing their feelings about an event to form a corresponding pictorial symbol in their minds, they have tried to reconstruct events, as remembered by witnesses, according to pictorial possibilities. The result is an accumulation of formulas. But in *The Third of May* not a single stroke is done according to formula. At every point Goya's flash-lit eye and his responsive hand have been at one with his indignation." Kenneth Clark, *Looking at Pictures* (New York: Holt, Rinehart and Winston, 1960), 130.

3 See Hal Foster, "Contemporary Art and Spectacle," in *Recodings: Art, Spectacle, Cultural Politics* (Seattle: Bay Press, 1985), 75–98. First published as "The Art of Spectacle" in *Art in America*, April 1983.

4 On May 4, 1970, national guardsmen fired on a crowd demonstrating against the Vietnam War at Kent State University, Kent, Ohio. Four students were killed and nine wounded.

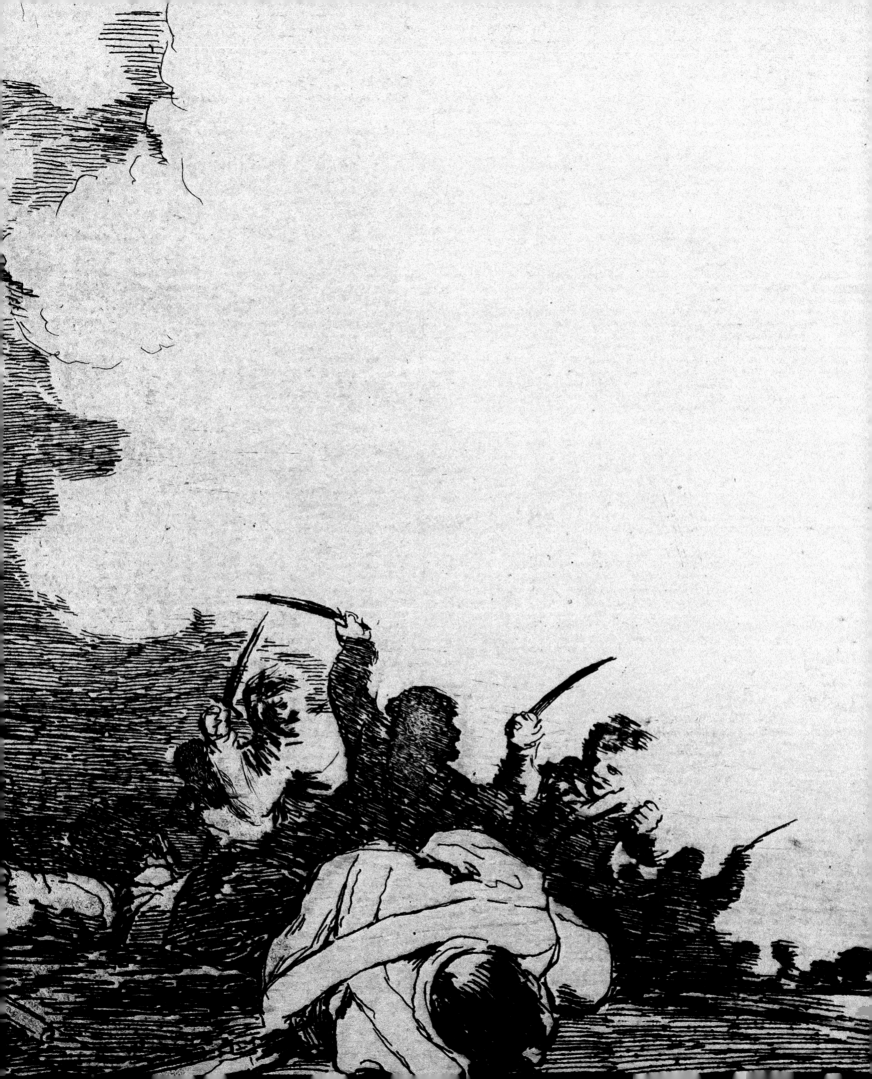

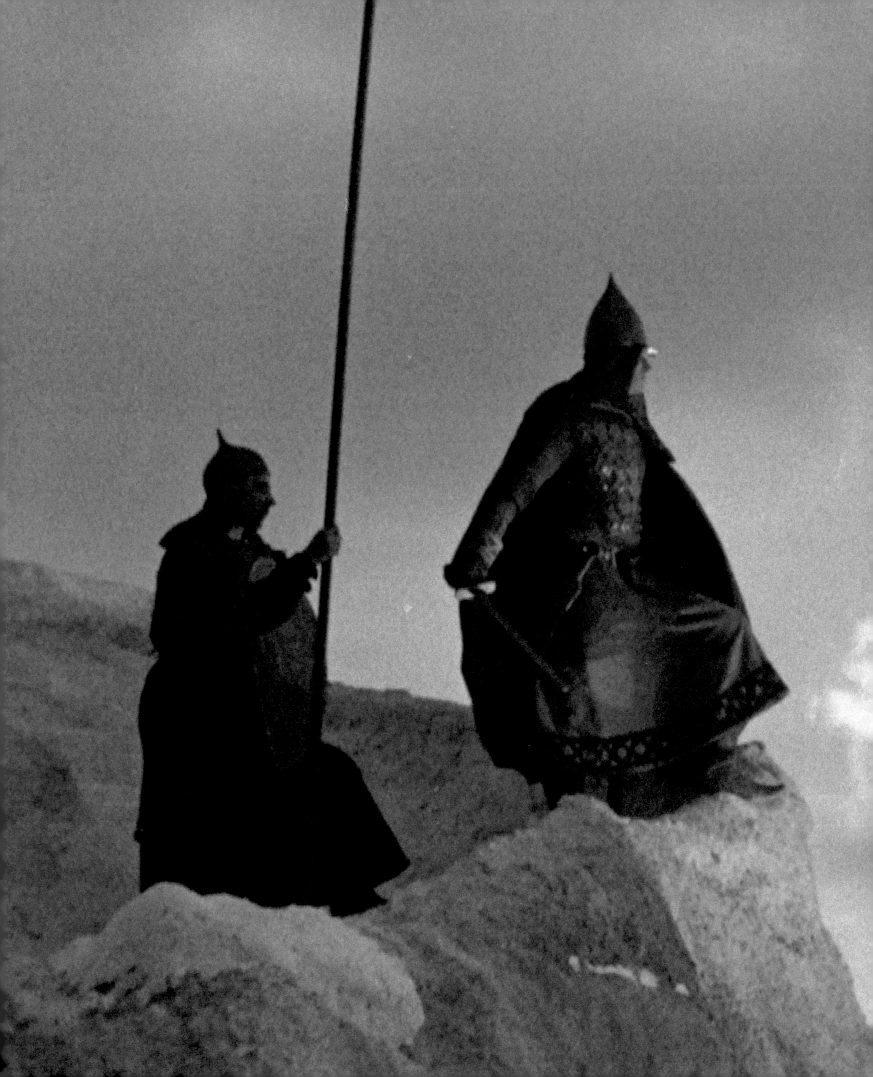

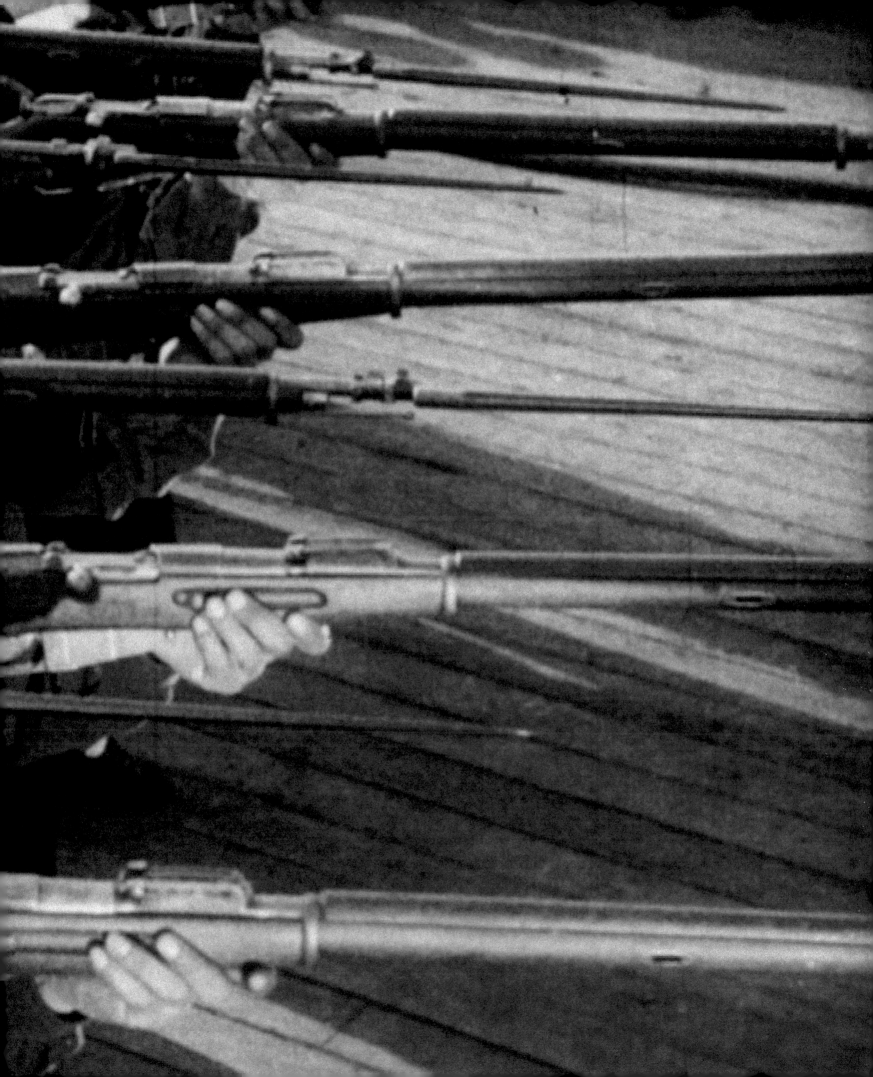

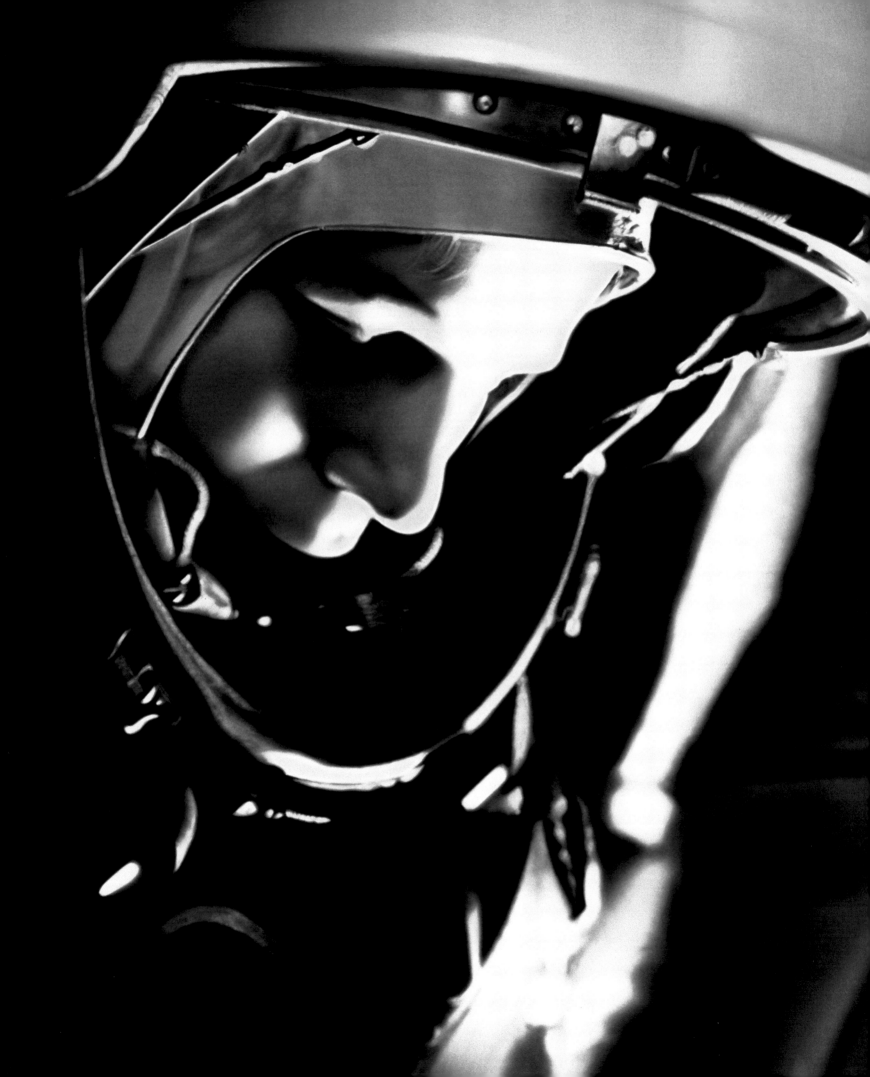

WHEN LIFE IMITATES ART

Nancy Spector

The question of whether art imitates life or life imitates art has never been answered satisfactorily, though it has been pondered for ages, from Aristophanes to Oscar Wilde to Adam Curtis. The latter's BBC documentary *Hypernormalization* (2016) frighteningly posits the idea that our contemporary reality is merely a fabrication, artfully constructed by a confluence of corporate greed, political opportunism, radical fundamentalism, technological innovation, and avant-garde performance. For those of us versed in recent art history, this improbable conflation came into razor-sharp focus with an AP news photograph graphically depicting the assassination of the Russian ambassador to Turkey on December 19, 2016 in Ankara (see facing page). The impeccably dressed gunman—with black suit and thin tie—is shown in a defiant pose with finger in the air and legs spread wide. Peel away the body lying dead on the ground next to him and the pristine setting—ironically the interior of a contemporary art center—and this silhouetted figure could have been one of Robert Longo's lithe, contorted models from his *Men in the Cities* series. The resemblance is uncanny.

Produced throughout the 1980s, the drawings comprising *Men in the Cities* came to epitomize the hypocrisy of the Reagan era (1981–1989) in America. The graphite images function as visual mixed metaphors: the fashionable, svelte figures they depict are either dancing or dying; punk rockers or bankers; victims or assailants. In their ambiguity, Longo's subjects invoke the contradiction at the heart of the conservative Right's message. Republican testaments to "traditional" family values were essentially coded injunctions against people of color, the poor, the queer, and the disenfranchised. Reagan's vision of America was anachronistic at best— a false nostalgia for a time that never really existed. Even though Longo premised the original figure in this series on a death scene from Rainer Werner Fassbinder's

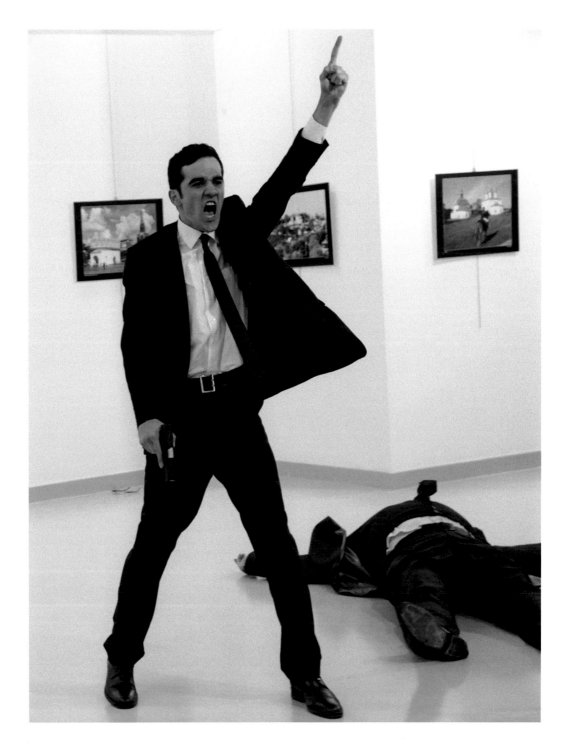

take on the gangster film, *The American Soldier* (1970), the work spoke so specifically to its time that it became an icon for it. But now, nearly forty years later, the Turkish assassination photo has yanked Longo's twisted figures into the present, brought them to life, and made them newly relevant. Suddenly, in retrospect, they become prescient—haunting harbingers of a future yet to come. Longo speaks of the Cassandra Effect in reference to this work,[1] acknowledging that we now understand how seeds for the divisive, political reality in which we find ourselves were sown during the late 1970s and 1980s when a nefarious web of privilege, prejudice, and fear began to coalesce around the world, fueled by cyberspace and the flows of capital.

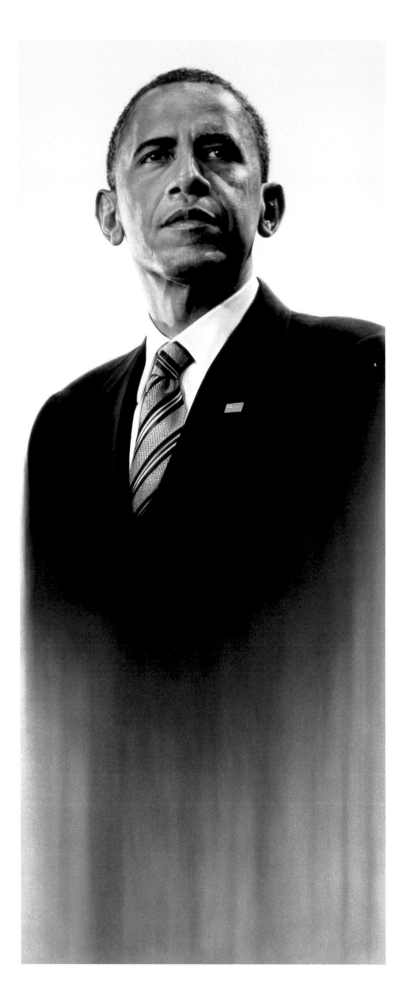

Robert Longo
Untitled (President Obama),
(2012)
Courtesy of the artist and Capitain
Petzel, Berlin

The subtext of *Proof* is that great art speaks to its own time, providing indelible imagery that encapsulates the deepest implications of social, cultural, or political upheavals. Longo has singled out Francisco Goya and Sergei Eisenstein in this exhibition for bearing witness and giving form to cataclysmic shifts in their respective societies. But as Longo has proven, great art can also predict the future. We are relentlessly reminded of this today with the sudden popularity of literary classics like Aldous Huxley's novel *Brave New World* (1932), George Orwell's *1984* (1949), and Margaret Atwood's *The Handmaid's Tale* (1985), which boldly envision aspects of the new regime in Washington and its dystopic ramifications. With this knowledge, Longo is very discerning in his choice of subjects. At the very end of 1999, amidst the pervasive fears of a technological apocalypse—which in retrospect seems to have been nothing more than displaced dread at the visible passage of time—Longo began working exclusively with charcoal, one of the most ancient of mediums.[2] While he has always drawn as part of a multidisciplinary practice, charcoal unleashed a visual imaginary in his work that so poignantly reflects upon the ethical challenges of our era. An exquisitely rendered, grisaille image of the American flag, expanded to monumental proportions, becomes a chilling cipher for injustice when juxtaposed with a drawing of a burning cross or a battalion of police in riot gear in Ferguson. A close-up portrayal of a single bullet hole in a shattered windowpane, conceived on an outsized scale, represents Longo's response to the brutal murder of editors and cartoonists in the office of *Charlie Hedbo*, the French satirical journal that dared to lampoon the fundamentalist strictures of Sharia law[3] (see page 193). Disaster lurks behind so much of Longo's imagery: hydrogen bomb blasts, revolvers, tidal waves, melting glaciers, and the open jaws of killer sharks. Even a stately portrait of President Obama now screams of his absence, and the absence of sanity and grace in the White House.

Longo's majestic charcoal drawings emulate the scale of history paintings, though their sources are often found photographs culled from the daily news. With their profoundly mimetic quality, they oscillate between the visual precision of print journalism and the hallucinatory imagery of dreams. Born from an alchemy of dust, of burnt residue, the drawings are built layer by layer over time. They are deliberately tedious to make, as if the artist, who is acutely aware of their predictive capacities, attempts to slow the whole process down. Given the current political situation in the United States, with government officials promising a "deconstruction of the administrative state,"[4] and the very real threats to the Earth's climate, it seems best to keep the future at bay.

[1] In conversation with the artist, February 15, 2017.

[2] Cave paintings done with charcoal dating back 35, 400 years have been discovered in Indonesia. http://www.smithsonianmag.com/history/journey-oldest-cave-paintings-world-180957685.

[3] Longo has pointed out the profound implications of this terrorist attack—the targeted victims were artists. Free expression is a danger to any form of authoritarian leadership.

[4] This is from a promise made by White House Chief Strategist Stephen K. Bannon at the Conservative Political Action Conference on February 23, 2017.

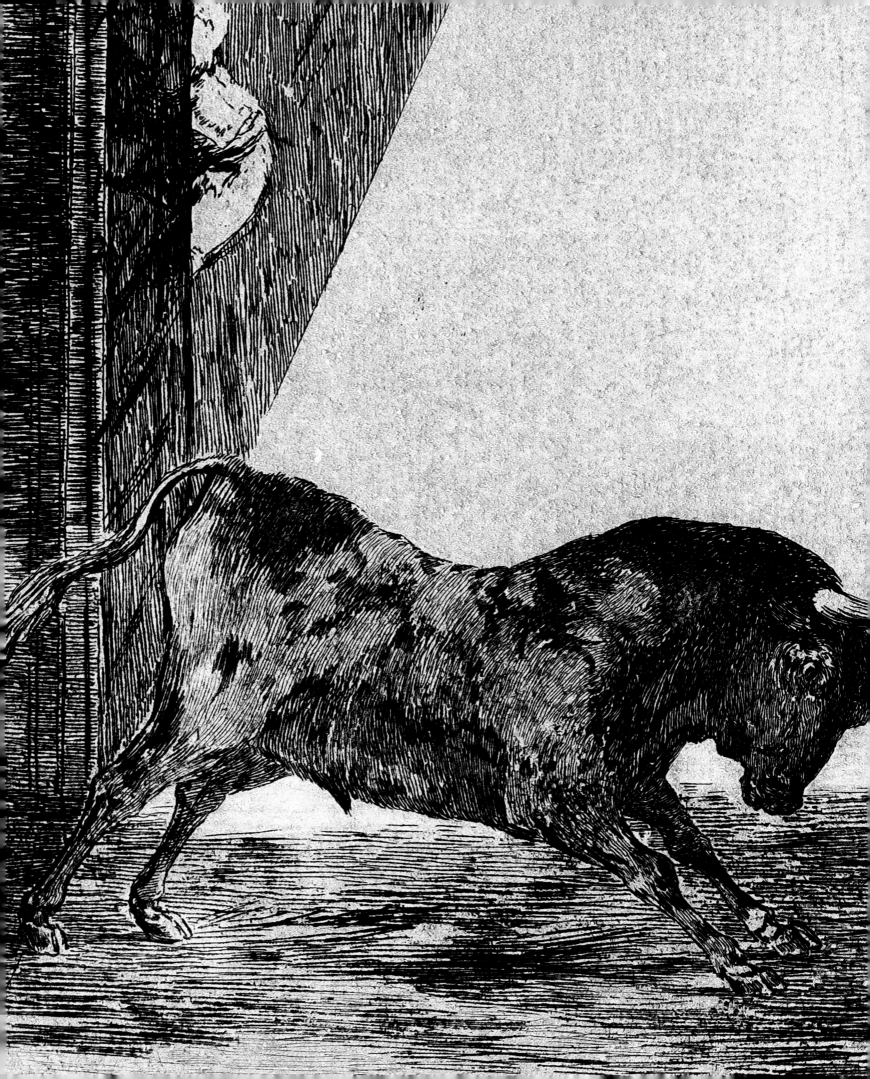

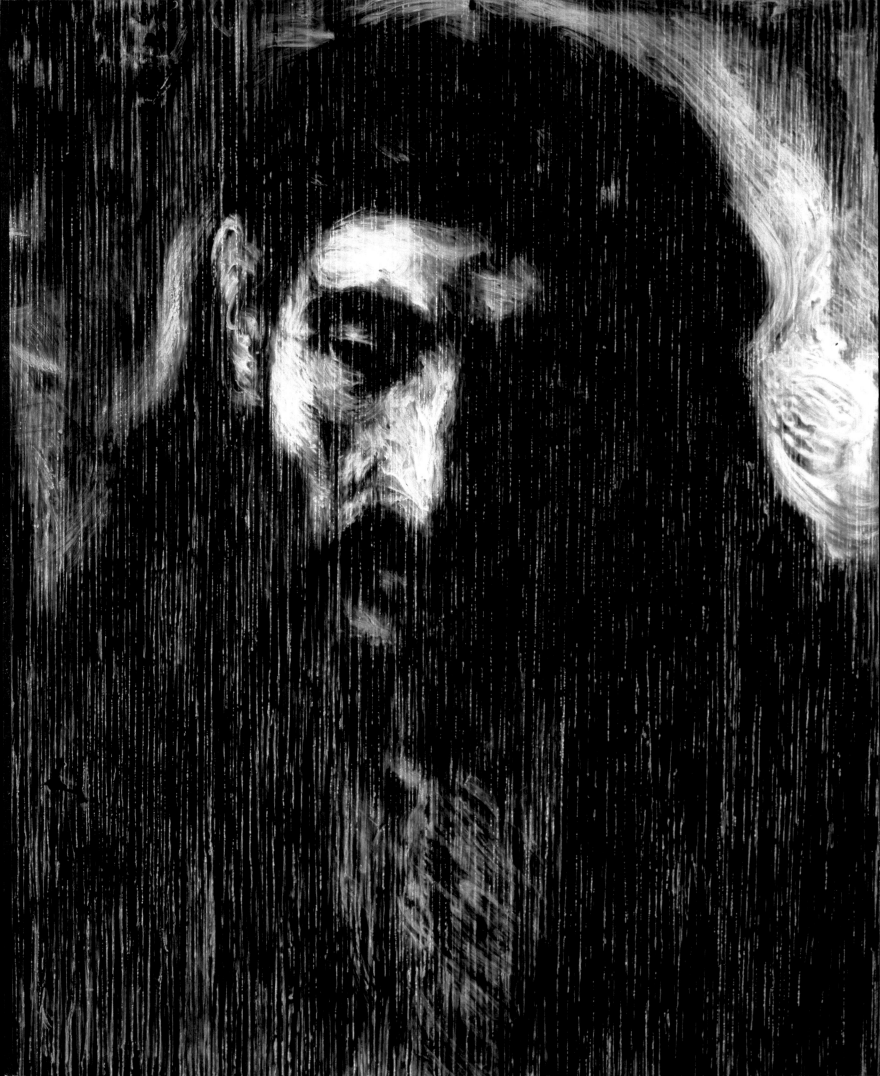

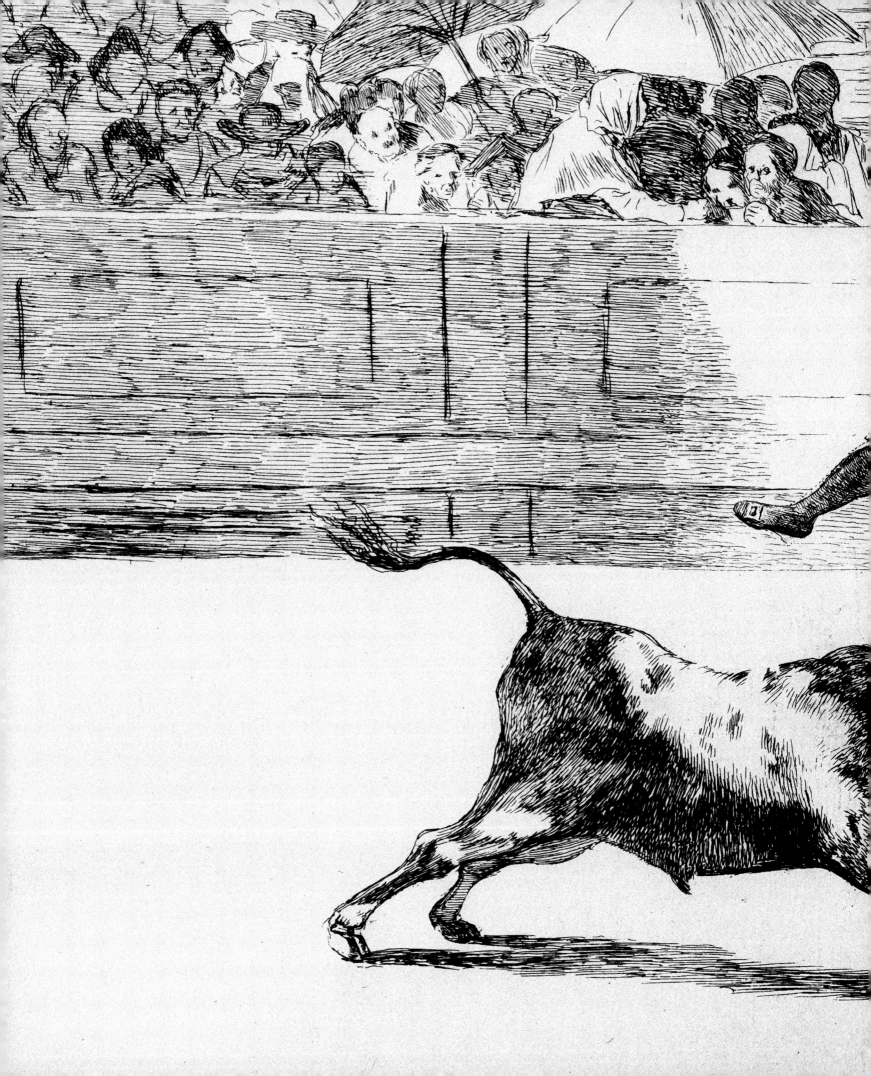

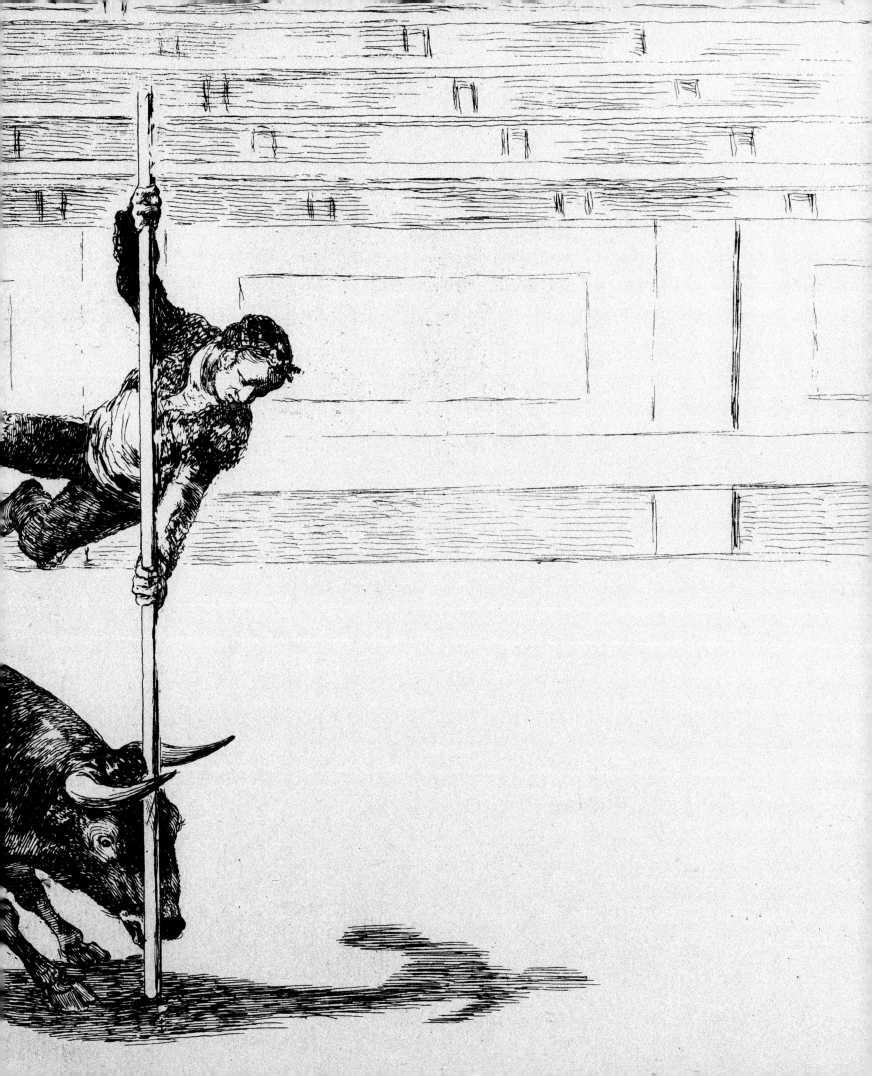

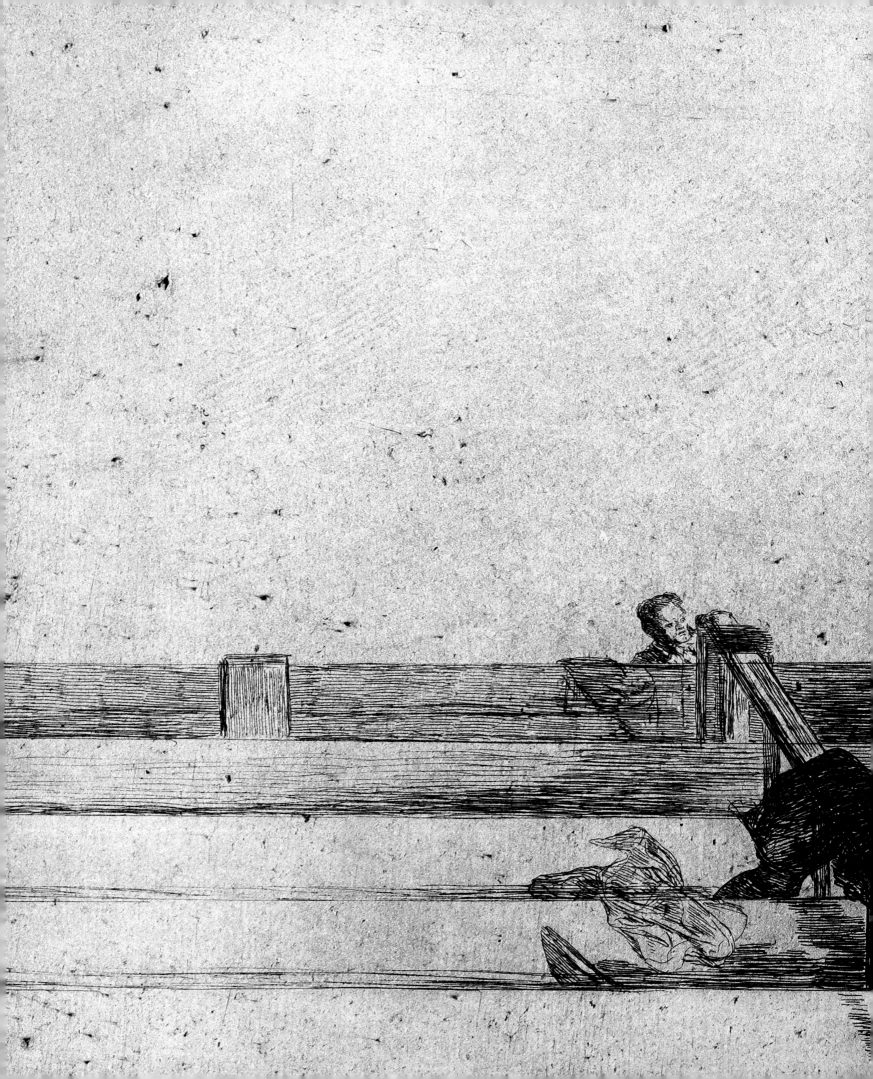

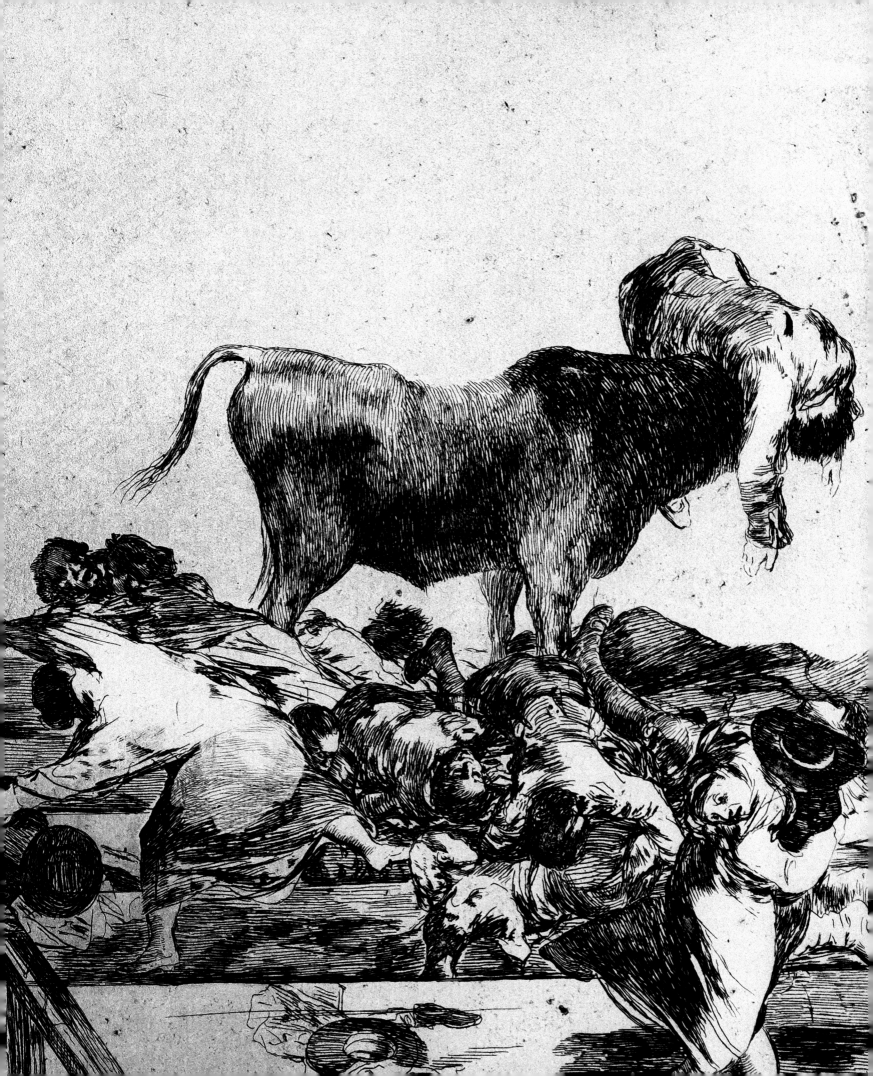

THE BERMUDA TRIANGLE: GOYA, EISENSTEIN, AND LONGO
(An Artist's Commentary)

Vadim Zakharov

It's not easy for an artist to write about another artist. Many factors must be taken into account. First and foremost, professional ethics. Secondly, the existence of—and understanding of—a general cultural context. Thirdly and fourthly, the age factor and a long-standing familiarity with each other's work. However, the most important factor is an interest in the other person's art. I'll begin with everything at once.

I first saw Robert Longo's work in the mid-1980s. His black-and-white dancing figures remained in my head for some reason, although my interests were quite remote from them at the time. This was followed by a long intermission, or so it seemed. Nevertheless, looking through the artist's website, I discovered to my surprise that many of his works seem familiar: *Black Flags* (1988), *Crosses* (1992), *Bodyhammers and Death Star* (1993), *Monsters* (2000), *The Sickness of Reason* (2003), *Beginning of the World* (2007), and *Perfect Gods* (2007). It turned out that all these images had been stored in my subconscious. They did not weigh down on it in a heavy or obtrusive manner, but penetrated invisibly without any censorship by consciousness. How could this happen? I was surprised, to be honest. After all, many of the images created by artists which circulate in our minds are subject to reflection in one way or another. Over the years, a label becomes attached to each of them: "It works," "I'm tired of it," or "Please, don't show it to me again!!!" Today Leonardo's *Mona Lisa*—printed in millions of copies—Malevich's *Black Square*, Duchamp's *Fountain*, and the works of Warhol, Lichtenstein, and Beuys make one nauseous. A characteristic feature of Longo's images is that they quickly penetrate our subconscious and then act slowly and imperceptibly. Each image becomes impressed on your mind like inside a camera (it is no coincidence that all his work is linked to photography),

and each imprint instantly hits its target. Nevertheless, a moment later the image becomes blurred, turning into another, or many others, and mixing with new or old, forgotten images that were already present in our mind. It's like a psychedelic experience: a powerful eruption of images and meanings that consciousness is unable to stop. Longo's images are a powerful catalyst for the explosion of associations. Moreover, he situates this explosion in reality rather than in the minds of cultivated drug addicts: a method one might call "protracted cultural explosion." His works have an epicenter, located in *Bodyhammers and Death Star*. From there, they spread out like waves in all directions, touching upon everything from crying children to planets, from works by well-known artists to shark jaws, from the banal to the philosophical, from the sacred to mass culture, and from the artist to the musician and the director. It's as if Longo has not made any individual works for a long time, and that which he produces is the result of waves that he generated, which continuously move in all directions as if in slow motion. His numerous "Untitled" works with a continuation in parentheses (Mecca, Eisenstein's Desk, Russian SU 30 Jet Fighter, Cosmonaut Tereshkova) or those with titles, that begin with the word "After" (Goya, Delacroix, Caravaggio, Pollock, Dante, Malevich, Jasper Johns), or even *X-Ray of Bathsheba after Rembrandt*, show that the "Longo wave" has reached these works and transformed them into charcoal dust that the artist uses to reproduce them, shorn of titles, and in black-and-white.

I don't know whether anyone has already noted that Longo's incisive method of working can be ruthless, despite his seemingly playful treatment of mass media images. Works made with charcoal (burnt material, ash) create a space of death. But as charcoal contains a lot of energy, it leads to new transformations. The recreated images have different properties: they are immaterial and come from another world. Thus, they easily penetrate our minds and remain there. Another important aspect of Longo's work lies in the absence of boundaries between his images. His *Roses (Ophelia)* and *Jaws (Perfect Gods)* are of the same order. Despite being totally different in meaning, content, and the place they occupy in our lives, these images do not contradict each other: they are both beautiful and terrible. The "charcoal immateriality" of Longo's work reconciles opposites, creating a narrative of simultaneous attraction and repulsion.

Proof continues Longo's "annihilation wave." The sole difference is that he no longer feels the need to annihilate the works of other artists by passing them through his charcoal furnace. He selects works by other artists that address the themes of death and horror. How else can you describe Goya's engravings from the series *The Disasters of War, Tauromaquia*, and, of course, *Los Caprichos*? Or Eisenstein's film—and associated drawings—telling the story of Ivan the Terrible, one of the bloodiest tsars in Russia's history, for which the director received the Stalin Prize. His other films, *Strike, October, Battleship Potemkin*, and especially *Alexander Nevsky*, are full of lofty artistic propaganda for a new

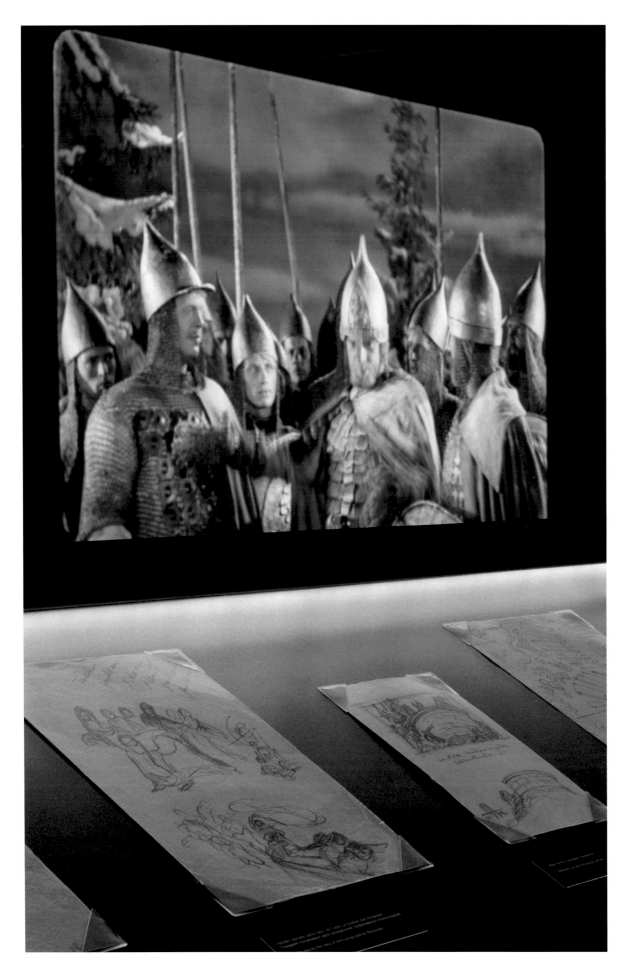

Installation view, *Proof,*
Eisenstein films and
drawings,
Garage Museum
of Contemporary Art,
2016–2017

world that became a totalitarian regime which destroyed millions of Russians. Today, the great propaganda artists of the Soviet period must bear responsibility for serving the needs of murderous regimes. I believe that Longo understands this. In *Proof*, he projects Eisenstein's films in slow motion, turning them into stills that clearly demonstrate the range of propaganda used by the great director. Longo removes the obsessive propaganda, lies, and revolutionary pathos and highlights the mechanism of human frenzy.

An exhibition of the work of three artists such as Goya, Eisenstein, and Longo is unusual. This combination creates a kind of Bermuda Triangle, giving the viewer the sense that they can move from the exhibition space into unknown territory. Longo is co-curator of the exhibition, and constructs this triangular mousetrap on purpose. His means of attracting attention is precisely constructed. The viewer immediately becomes immersed in the interaction of these names. The machine of exploding associations is launched, and the wave instantaneously hits its target: viewers find themselves in an altered state of consciousness. The process of moving from one artist to another changes their perception. Passing from Eisenstein's drawings through Goya to Longo, one sees the figure of a Soviet director who was hideously constricted by the totalitarian system, yet broke all possible boundaries. Eisenstein draws the other two artists toward him through the horror of totalitarianism and death. His drawings for the film *Ivan the Terrible* (of limited interest as artworks, it should be said) produce a strange resonance between the Stalinist and post-Soviet periods, shedding light on important stages of Russian history. This is underlined by the fact that the exhibition opened in Moscow, emphasizing how Longo hits the mark with his choice of Eisenstein's films and drawings.

The Russian director is at the center of the exhibition. To be more precise, he is the Soviet-Russian filter through which we look at the American artist Robert Longo and the Spanish artist Francisco Goya. Naturally, this configuration will change should the exhibition be shown in the United States or Spain. The stress will shift automatically: it is part of Longo's method as a curator, creating space for new interpretations of Longo the artist. The more one thinks about Longo's methods, the more one is surprised by the multilayered nature of his work, combined with the deadening Pop Art flatness of his images. But as soon as one understands that this intentional American flatness is nothing but an illusion, then everything begins to spin in a curious dance that goes back to the depths of the cultural subconscious.

P.S. Longo and Eisenstein also meet as directors, but this nuance is not addressed in *Proof*. What an absurd parallel could be created by projecting Longo's *Johnny Mnemonic*—starring Keanu Reeves—and Eisenstein's *Ivan the Terrible* onto a single wall as a diptych.

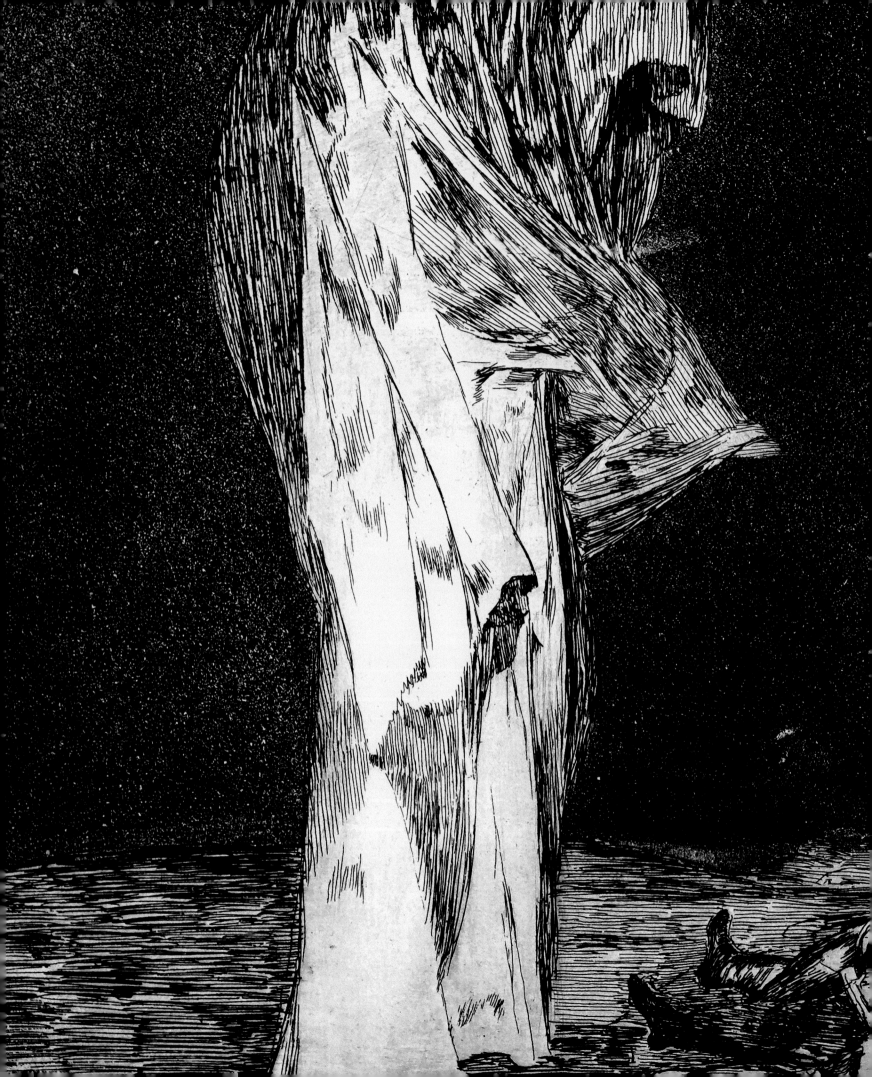

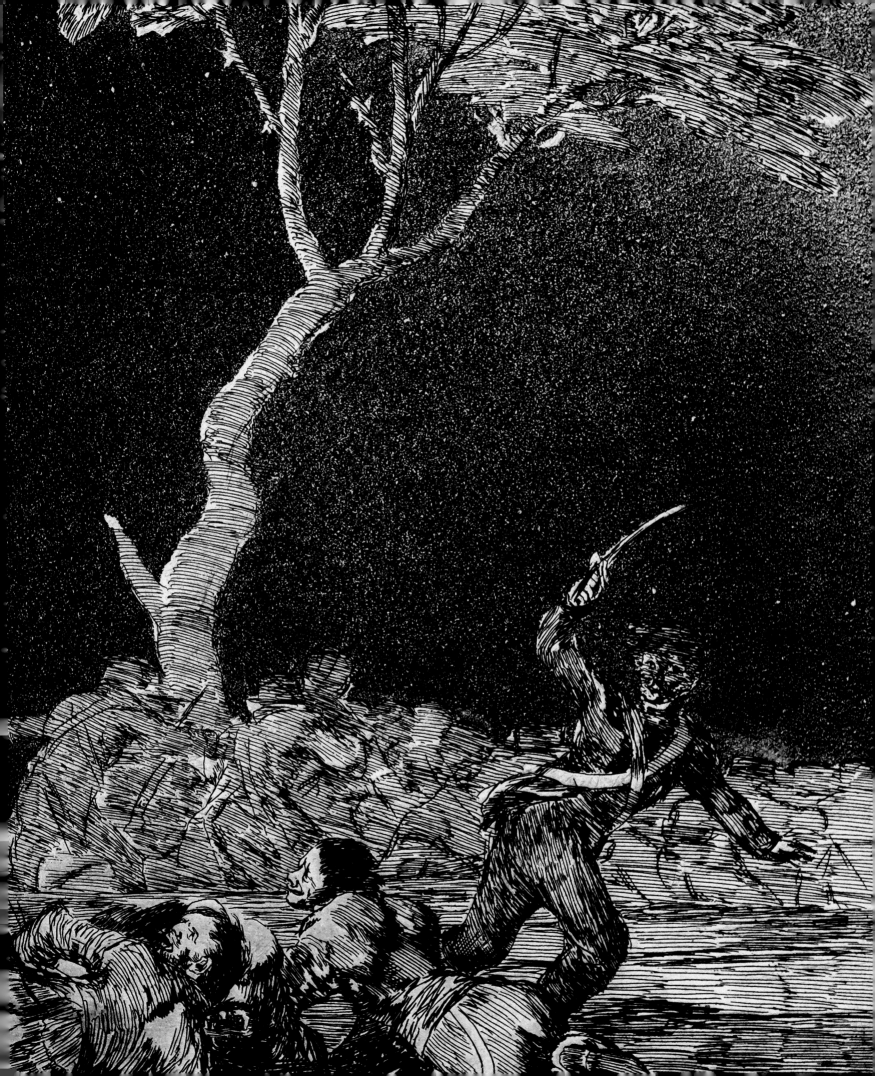

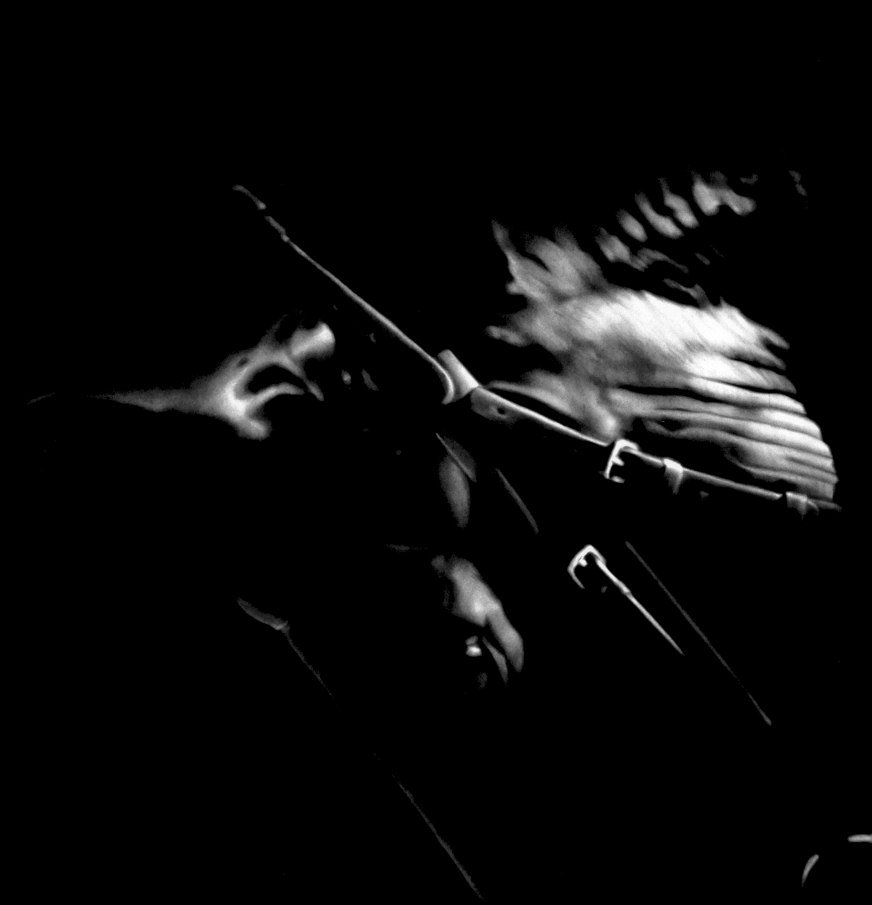

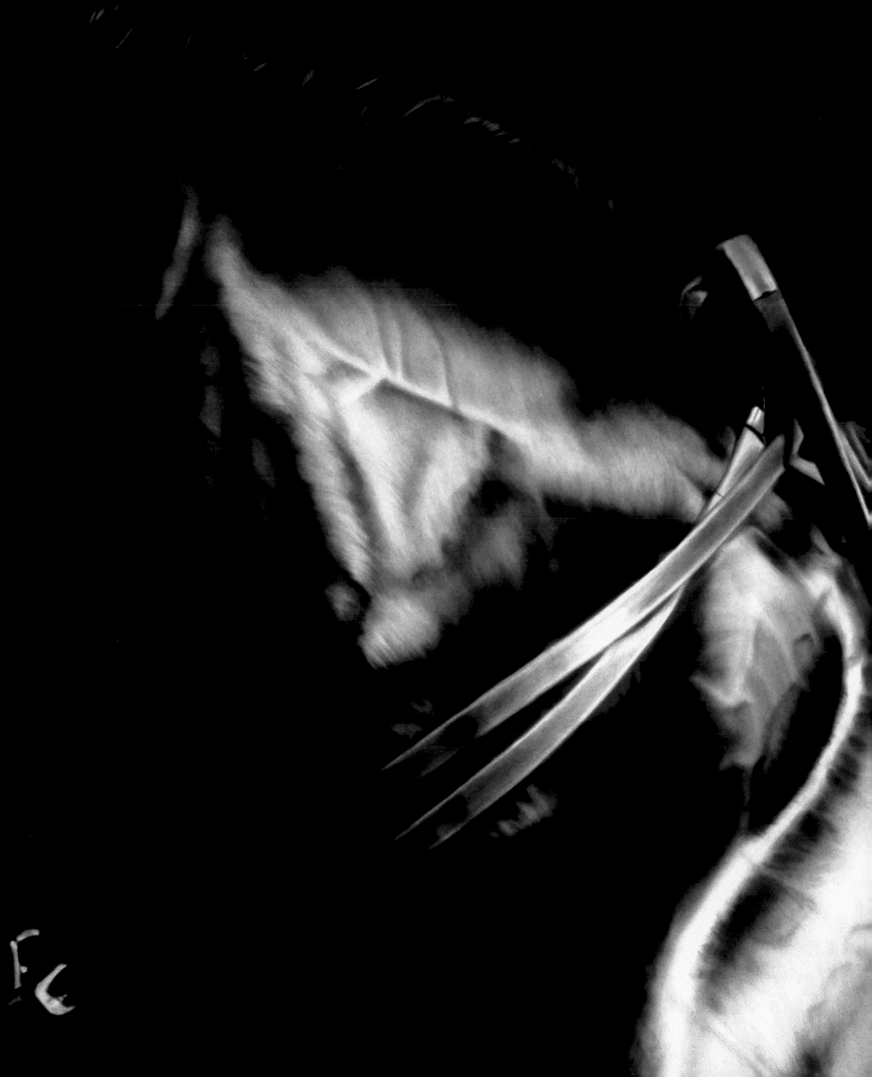

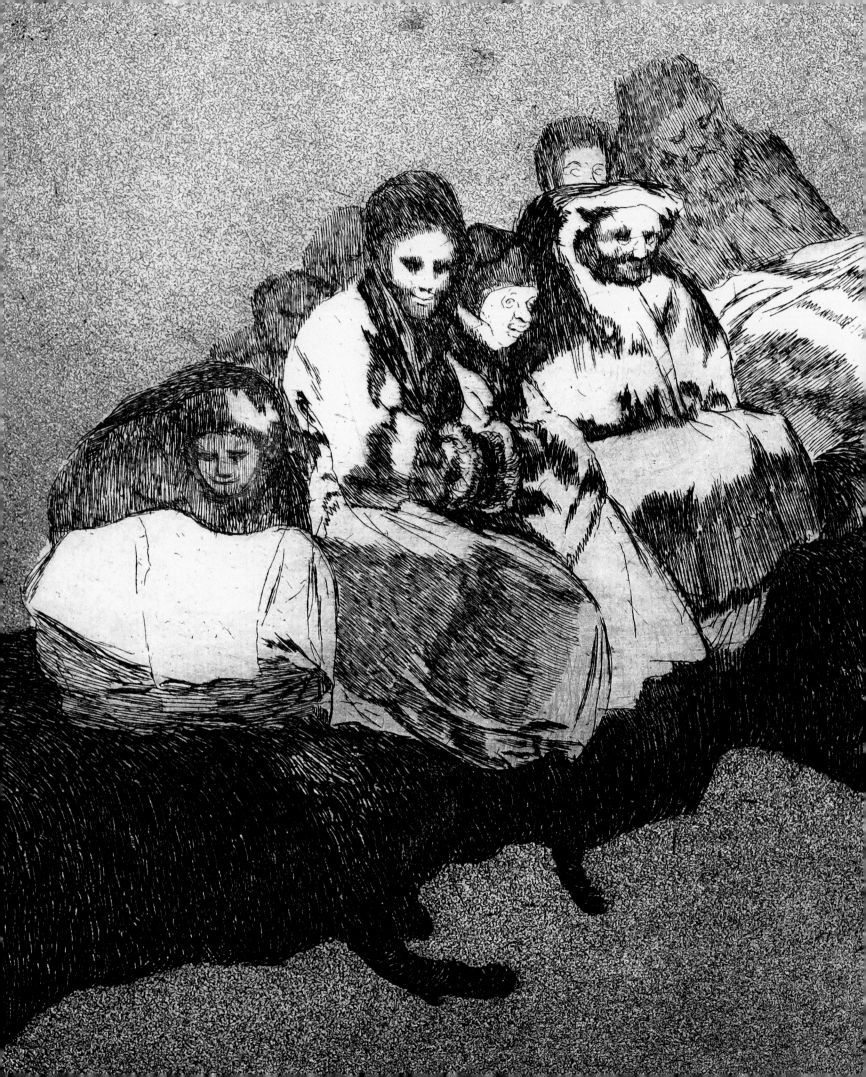

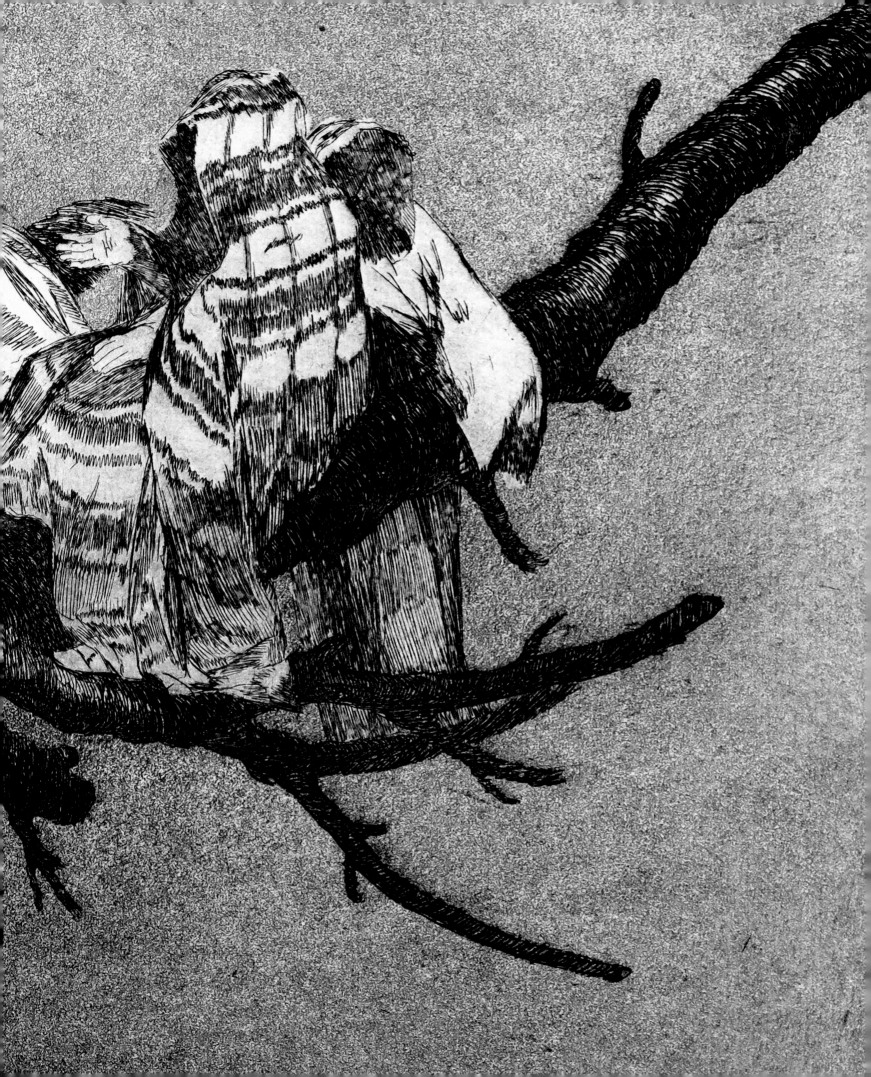

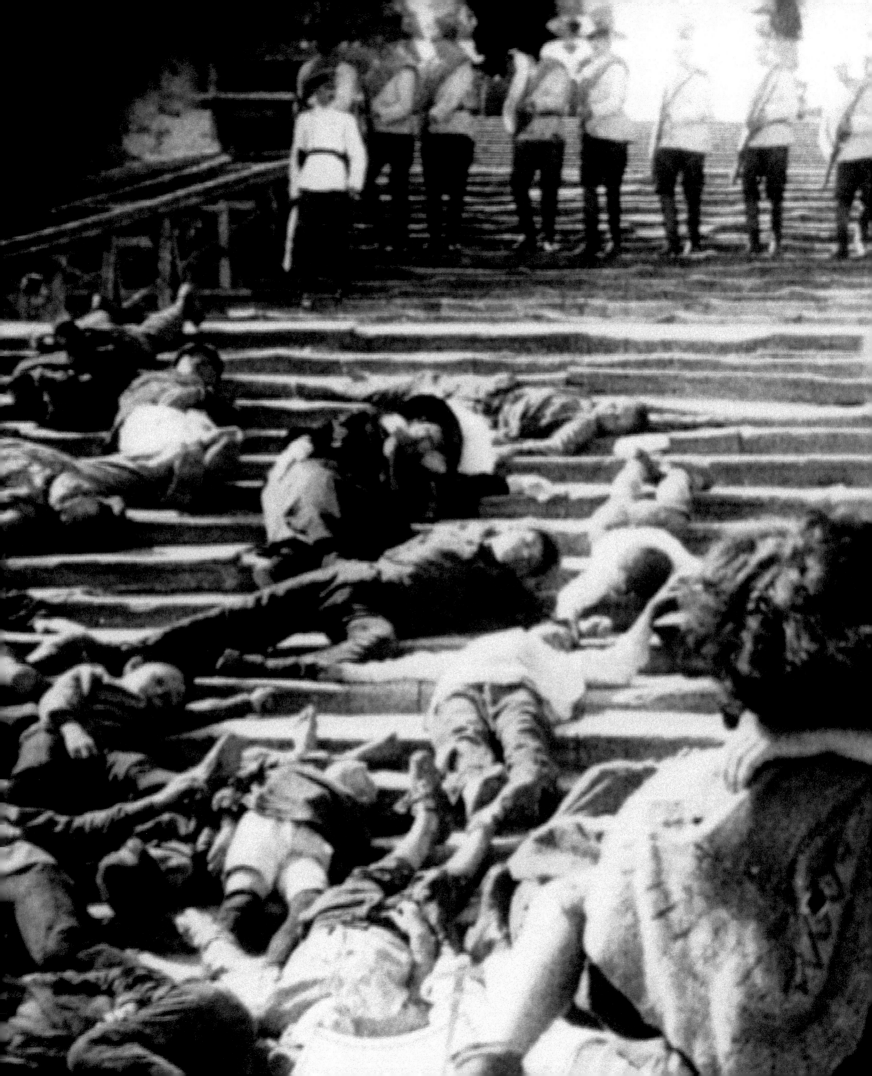

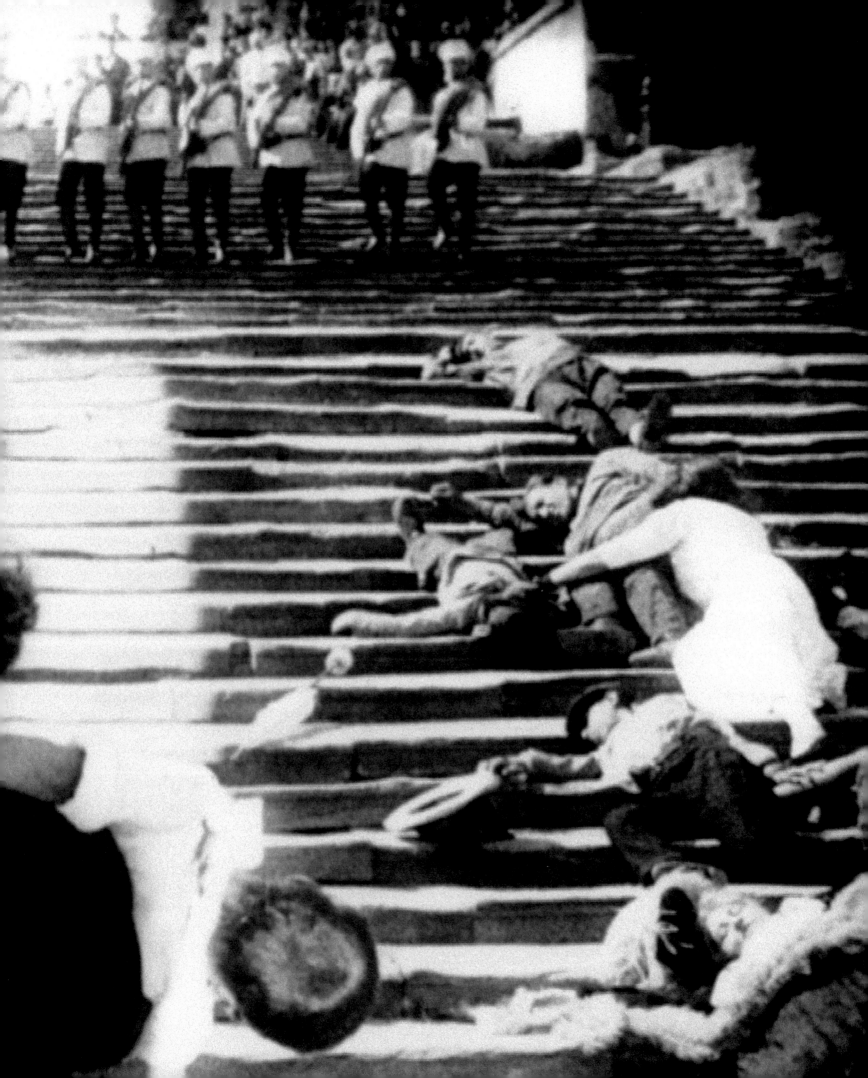

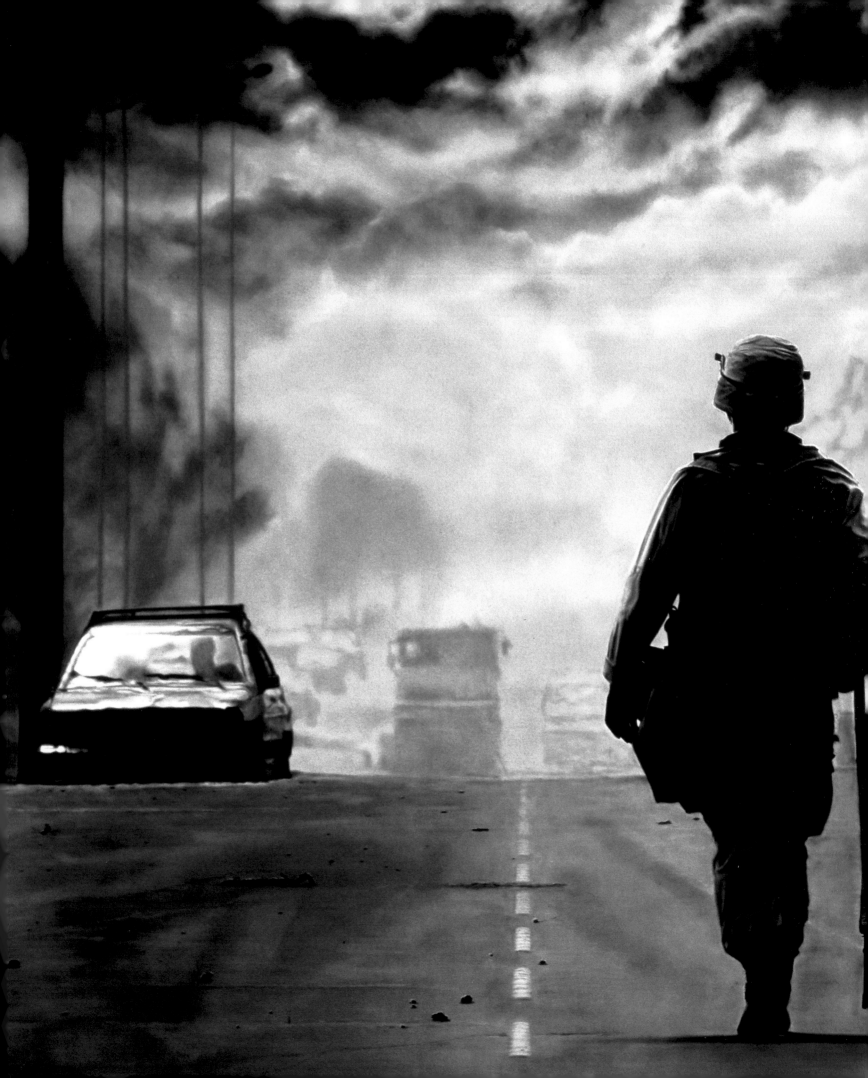

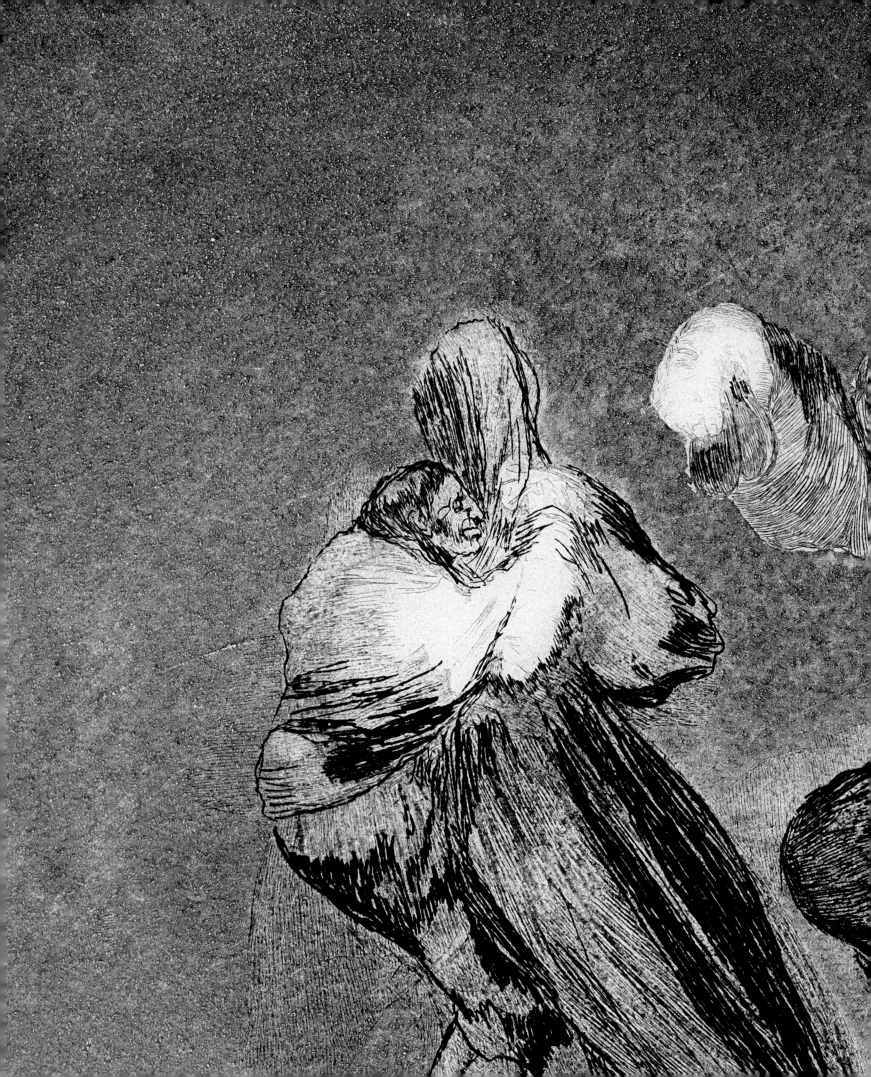

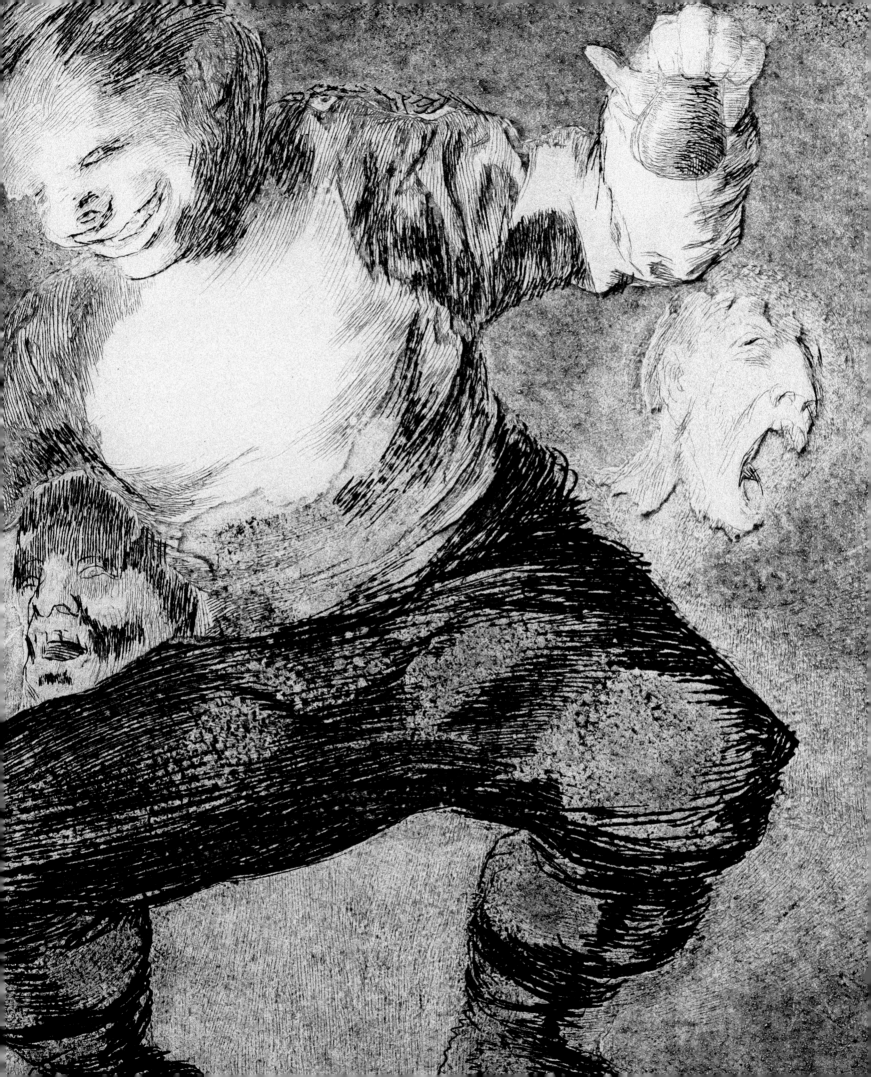

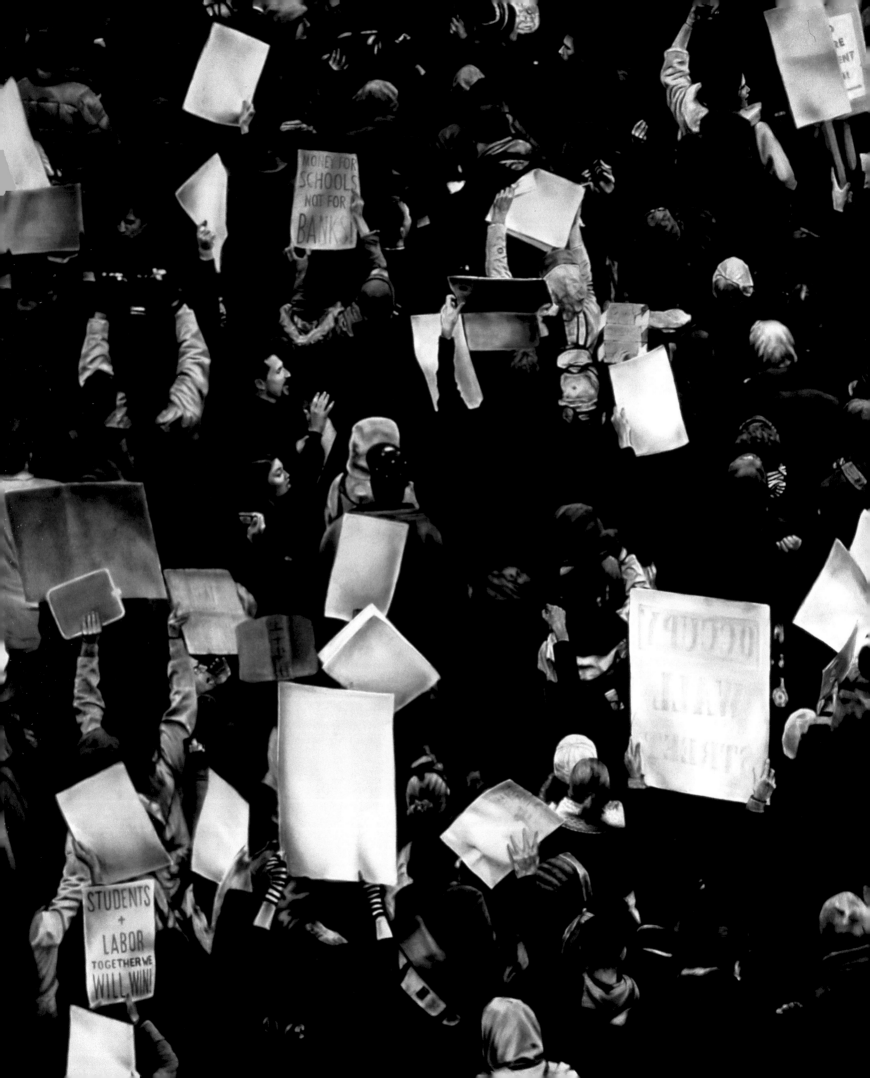

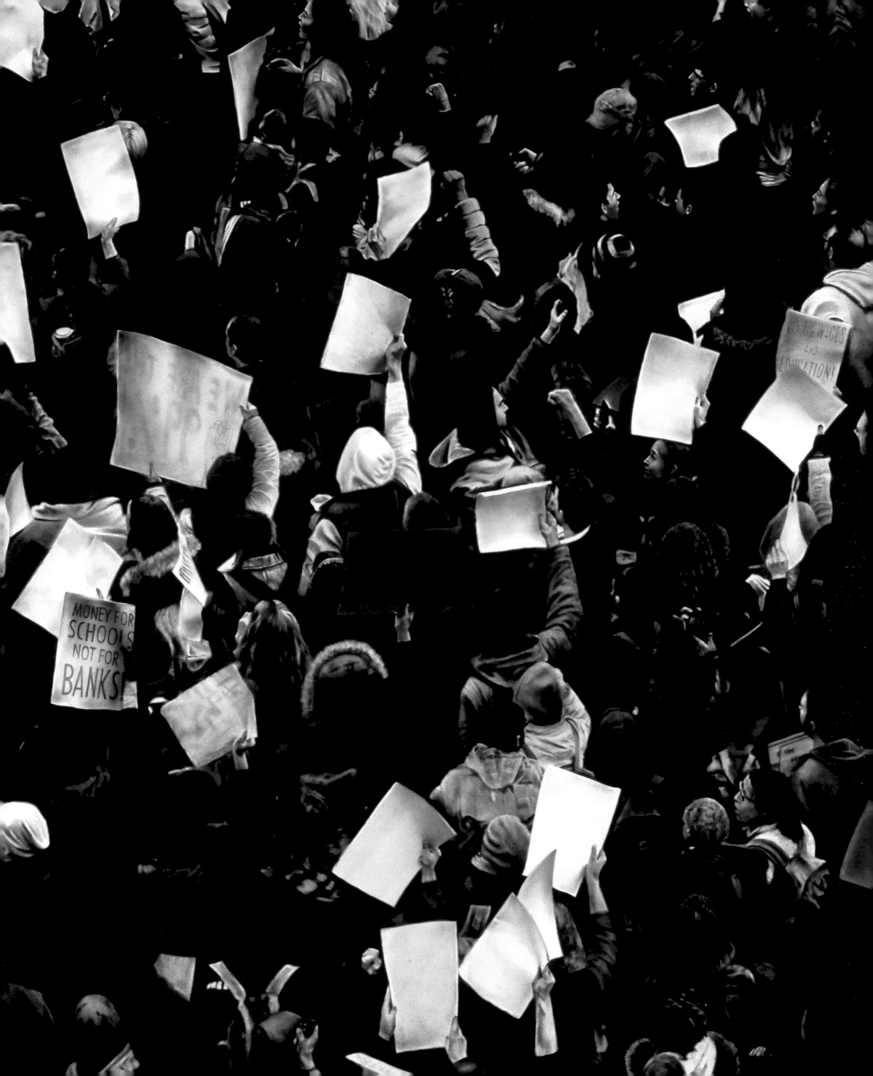

THE COST OF TRUTH

Chris Hedges

Can we capture the reality of combat in images? I think not. We can capture the effects of war. We can freeze the snapshots of terror, as Goya does, giving a voice to war's victims, but because these snapshots and images are devoid of the smells, the noise—the cacophony of war is deafening and disorientating— the constant confusion, and, above all the fear, all attempts to portray the reality of battle are sterile. There are ways to tell the truth about war. But the routes into war's madness come by exploring the after effects of war or the mechanisms of death rather than its high-octane moment of impact.

In combat, you desperately tried to figure out where the firing was coming from and how to respond. You were only aware of the tiny circle of your immediate surroundings. Fear made you think and respond with another part of your brain. You did things before you articulated or were aware of what you are doing. When the adrenaline rush subsided, when the hallucinogenic landscape of combat was replaced, you wondered if you actually did what you remembered. Was it real? Did it happen? Was that me?

Once combat ceased, soldiers, sometimes while looting through the pockets of the dead, talked among themselves to formulate a coherent narrative. They pieced together their individual experiences to make sense of what happened. It was the transformation of combat into a story, one with a beginning, a middle, and an end. At that moment, the reality of combat evaporated. The road to mythology had begun.

I once saw an Iraqi soldier in the 1991 Gulf War who had lost both his legs after stepping on a land mine. It took him six hours to bleed to death in the sand.

If someone had set up a camera and filmed from the moment of explosion until his death, and if a theater or television audience had been made to sit through the long and gruesome scene, you could begin to grapple with some of the reality of combat. But even then, it would be devoid of much that made it so hard to absorb. Death often takes time. It is disgusting and revolting. It stinks. It makes you turn away. There is the technological capacity to, in real time, to show us what combat does to human bodies. But, as in all past wars, censorship and self-censorship keeps the most brutal images of combat from public view. If we saw war for what it is, if we could somehow smell it, hear it, and taste in on our lips, if our bodies shook with fear, even terror, if we had to endure the numbness and trauma of the experience, we would not be able to justify war. Those who come home from war to speak its awful truth are ignored by the public, which prefers to bask in war's myth. So the witnesses stop talking. Many lose themselves in drink and opiates or commit suicide. The myth is never defeated. All states and all militaries mask war's reality. War is a primary instrument of power. Artists who seek to explore truth, especially the truth about war and the state are, therefore, mortal enemies. Artists in wartime engage in a precarious dance, seeking to push up against rigid limitations imposed by the state or being pressured into silence.

It is best, as Robert Longo often does, to concentrate on the residue of war and the instruments of war, rather than attempting to portray the momentary high of combat and rush of violence. Longo's picture of the bullet hole from the *Charlie Hebdo* shooting, or of the police in Baltimore, are examples of his search for back windows into the reality of violence. This is the only effective technique for explaining war. Even anti-war films, when they portray images of violence, are overpowered by those images. They unleash, despite their intent, the dark, godlike lust within all of us for power.

There are no just wars. Violence infects all participants with the same poison. The Islamic State and Al Qaeda are as contaminated by the death instinct—what

Sigmund Freud called Thanatos—as the US Marine Corps. War is the ultimate expression of death. It not only celebrates death, but it destroys all systems that have the capacity to support life—familial, political, social, economic, cultural, religious, and environmental. It seeks, as we have done in Iraq and Afghanistan, to create an ecosystem that is only conducive to slaughter, that perpetuates itself by turning human beings into objects and often into corpses.

The films, novels, photographs, and pictures that say something important about war have few or no scenes of violence. Rather, they explore the necrophilia that lies at the heart of war, its seductive even erotic fascination. They expose the obscene hollowness of words such as glory, duty, and honor. They make palpable the allure of death that is part of war's contagion. They chronicle war's sacrifice of the weak and the vulnerable. They tell the stories of those whom history erases from its pages and ignores. They make plain war's sickness.

The Czechoslovak film *The Cremator*, directed by Juraj Herz, centers around a cremator in a morgue in 1930s Prague during the Nazi occupation. It captures the unsettling miasma of death and the sexual decadence that comes with it, which is always part of war. The cremator, Karl Kopfrkingl, believes he is liberating the souls of the dead. He sees himself, in a mystical way, as a giver of life rather than death. His dark obsession intertwines itself brilliantly with the death instinct at the heart of fascism. The film was banned after its premier in 1969 and was not seen again until the collapse of the communist regime in 1989.

In René Clément's 1952 French film *Forbidden Games* there is only one brief war scene, at the opening of the film, when refugees fleeing Paris in 1940 during the Battle of France are strafed by German warplanes. The parents and little dog of a five-year-old girl, Paulette, are killed. The girl is traumatized. She struggles to comprehend that her parents are laying inert underground. A peasant family that has a ten-year-old son, Michel, takes her in. The two children construct a cemetery where they bury Paulette's dog and other animals. The children mark the graves with crosses stolen from a local graveyard, one belonging to Michel's brother. The film illustrates what war does to children, to culture, and to civilization.

Elsa Morante's *History: A Novel* focuses on the powerless victims of war, especially women and children. Morante sets the novel during World War II in Italy. She follows the plight of a schoolteacher who, raped by a German soldier, raises the child born of the rape against the backdrop of war. War, for most of those caught in its maw, is about sexual violence, terror, fear, hunger, bombing raids, crime, cattle cars filled with human beings, secret police, and gaping wounds that cause unbearable agony and death.

Sergei Eisenstein's *Alexander Nevsky* was designed to serve the myth of war and echo back the cant of Soviet ideology. It was, like Lawrence Olivier's 1944

film of Henry V, a historical epic that mythologized not only the past, but also the present. Eisenstein adapted history, as Olivier did, to address a current political reality. Winston Churchill instructed Olivier, as Stalin instructed Eisenstein, to use a historical epic to boost morale. This led Olivier to cut parts of William Shakespeare's play such as Henry's threat to let his troops rape and pillage Harfleur, his beheading of the three English traitors, and the hanging of Bardolph. Eisenstein, seeking to demonize the Nazis, also distorted history, at one point proposing putting swastikas on the helmets of the invaders, although the film chronicles the attempted thirteenth-century invasion of Novgorod by the Teutonic Knights. The church, reflecting the anti-clericalism of Stalinism, is condemned as a force for fascism in the film—the knights' bishop's miter is adorned with swastikas. The Russian nobility is portrayed as feckless and cowardly. Nevsky was an allegory for Stalin. The film, initially a success, was withdrawn from circulation with the signing of the Molotov-Ribbentrop Pact in August 1939. Once Hitler invaded the Soviet Union in June 1941, however, the film reappeared in theaters to serve the anti-German message that was back in vogue.

Eisenstein, like all artists, struggled under Stalinism. His film *Ivan The Terrible, Part II* was not released until 1958 and the incomplete version of *Ivan The Terrible, Part III* was confiscated and much of it destroyed. Eisenstein was closely watched by loyal Stalinists, including Pyotr Pavlenko who served as a film "consultant" during the making of *Alexander Nevsky*, to make sure his work reflected the ideology of the state. Eisenstein sought truth, as much of it as could be expressed, within the narrow confines of state control. When he attempted to reach too far to express this truth, the wrath of the state censored or destroyed his work. Stalinism was an extreme example of state repression, but all states in wartime seek to domesticate artists and use them to peddle the myth of war. It is distressing that so few artists resist.

Artists have a vital role to play in war, especially in the age of the endless wars America wages in the Middle East. Too often, because of state pressure, money, or a desire for adulation, artists surrender their talents to justify and glorify war. They become propagandists. They ignore the cries of war's victims. They fictionalize war's terrible reality. They demonize the "enemy." They produce not art, but historical epic or patriotic kitsch. This is why so much of what is produced during wartime is swiftly forgotten.

This wartime work served a cause and a false ideal, not truth. The war makers effectively destroy their own culture before destroying the culture of the enemy. Those who attempt to defend their culture, to expose the lies used to stoke militarism, to remain faithful to their call as artists, become outcasts. Truth has a cost. This is especially the case when the Pandora's box of war is opened. But if this truth is not told, war is never understood.

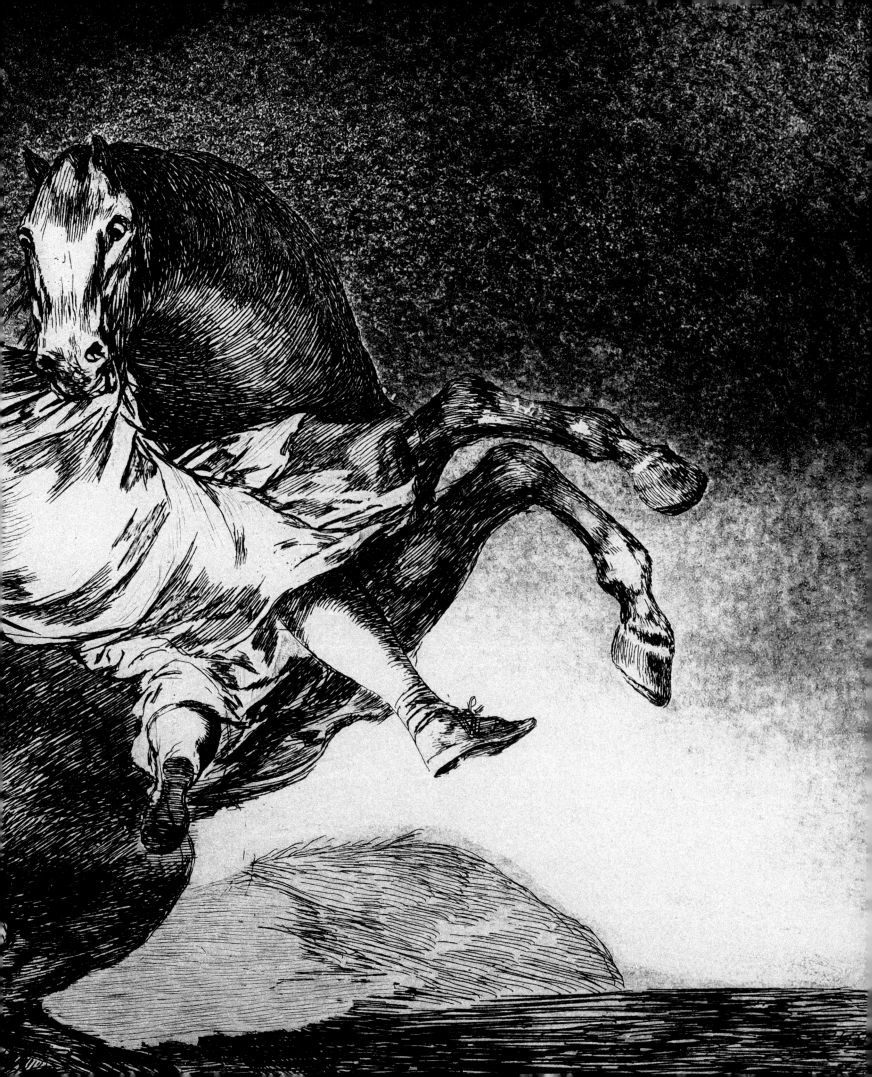

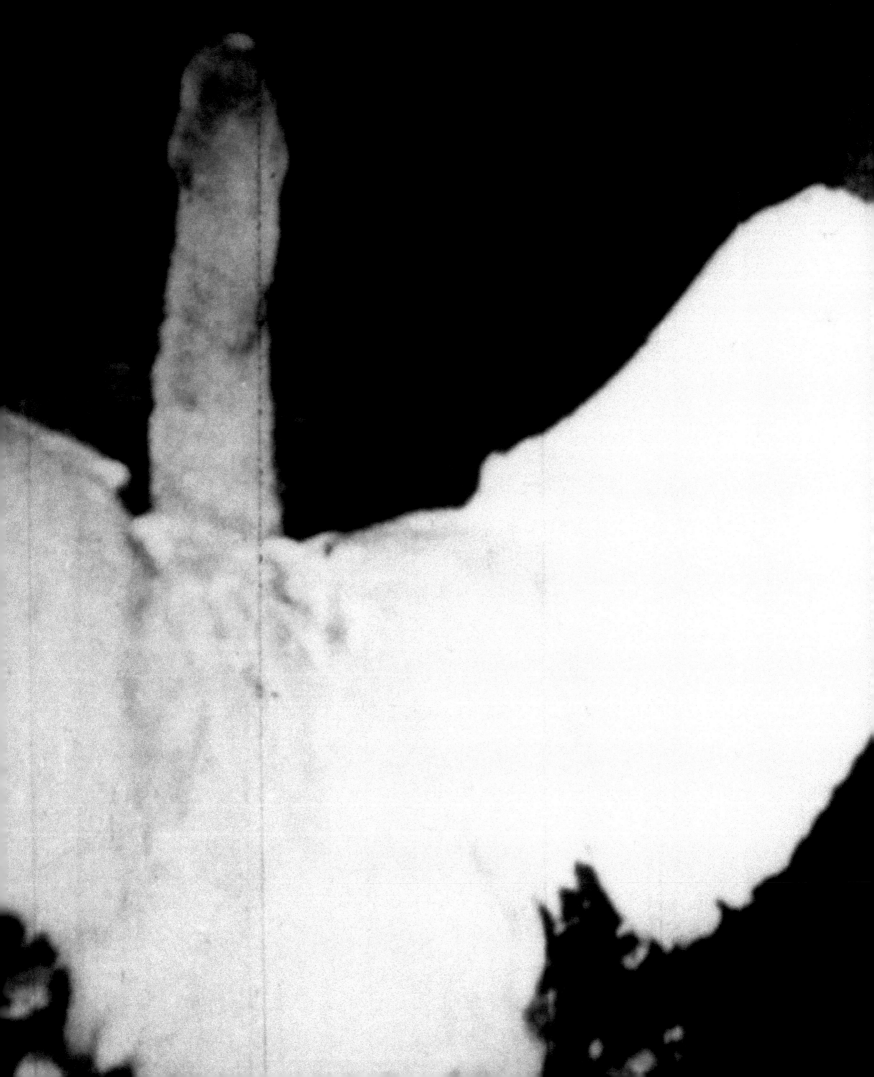

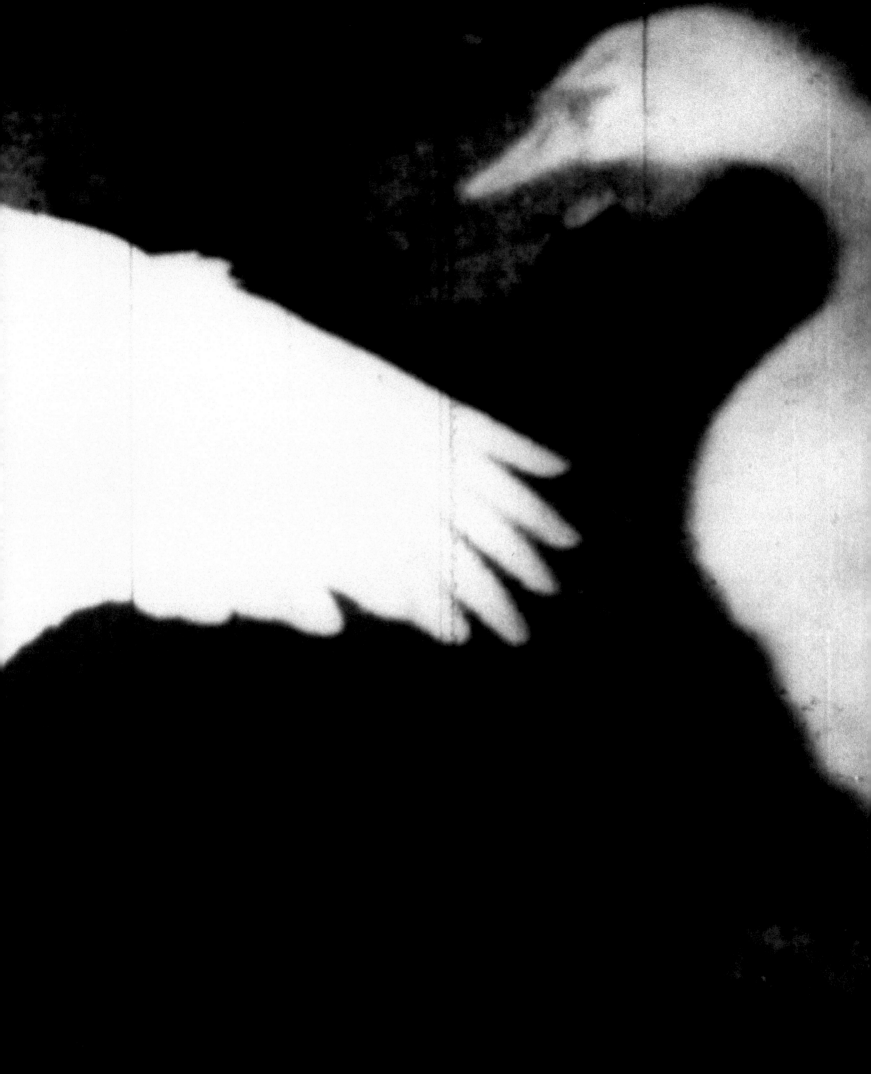

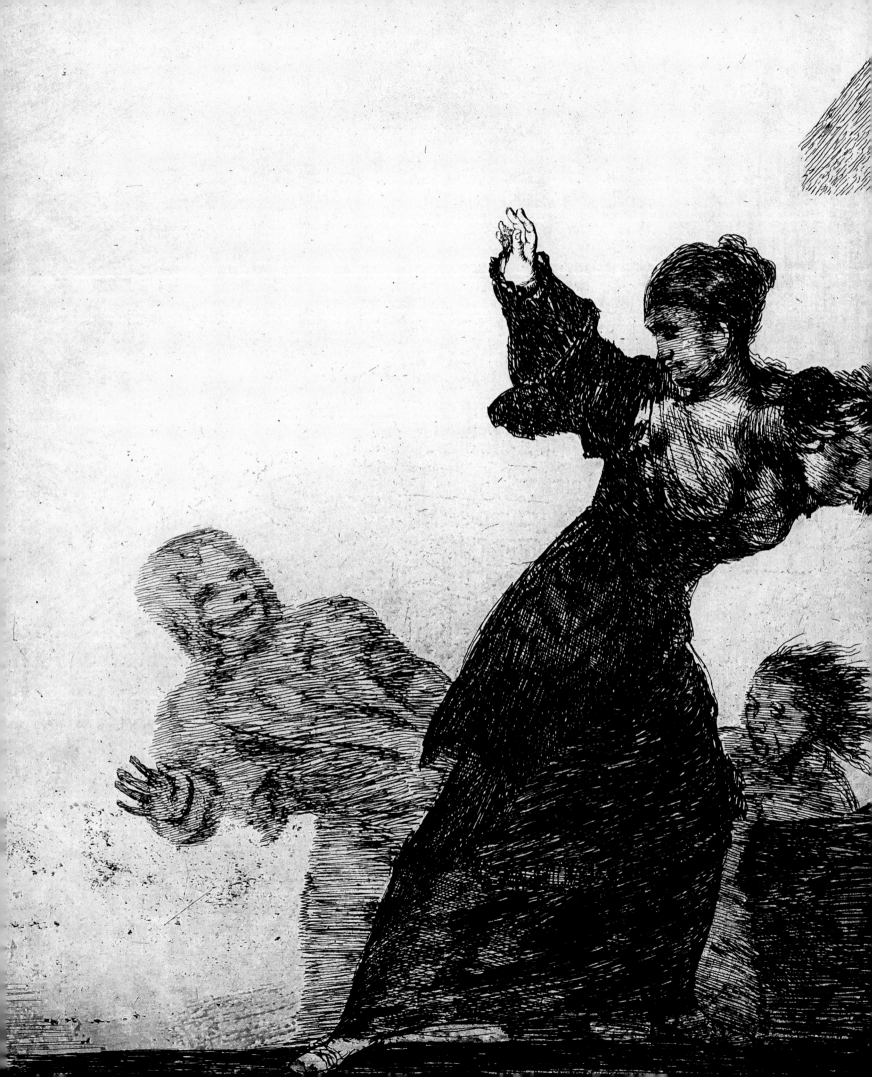

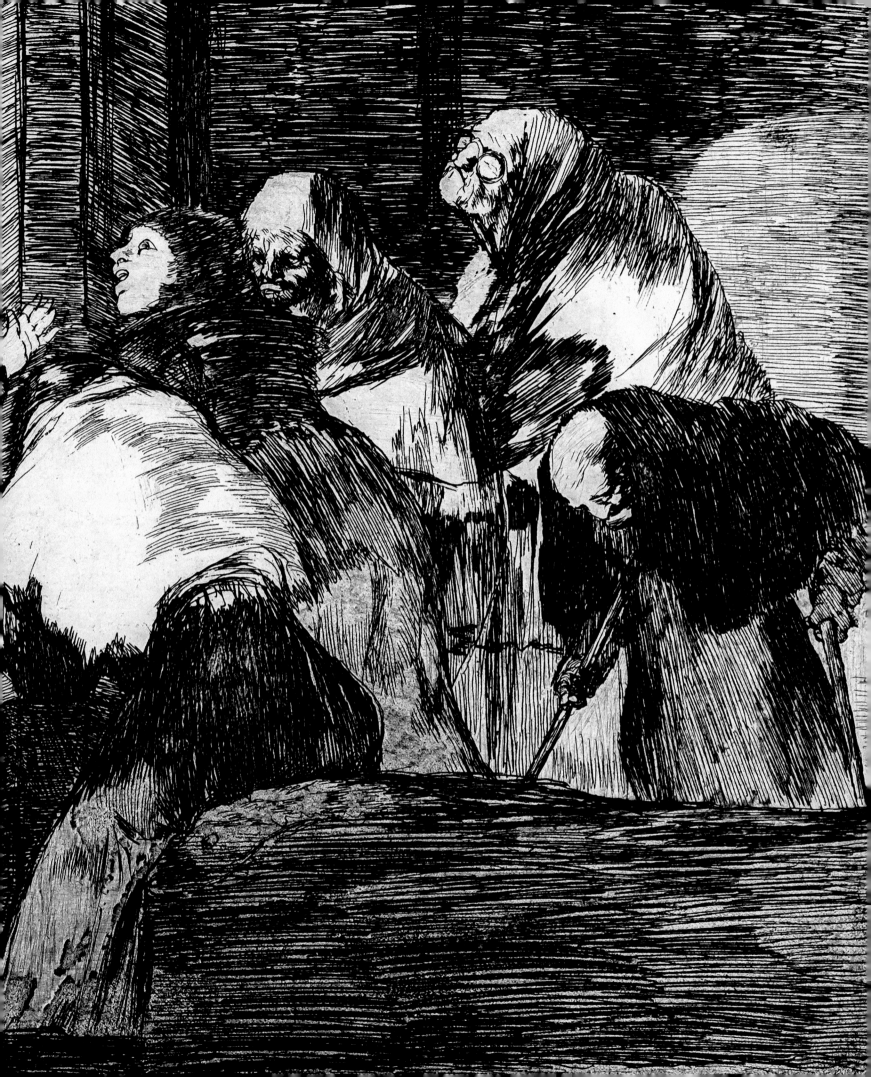

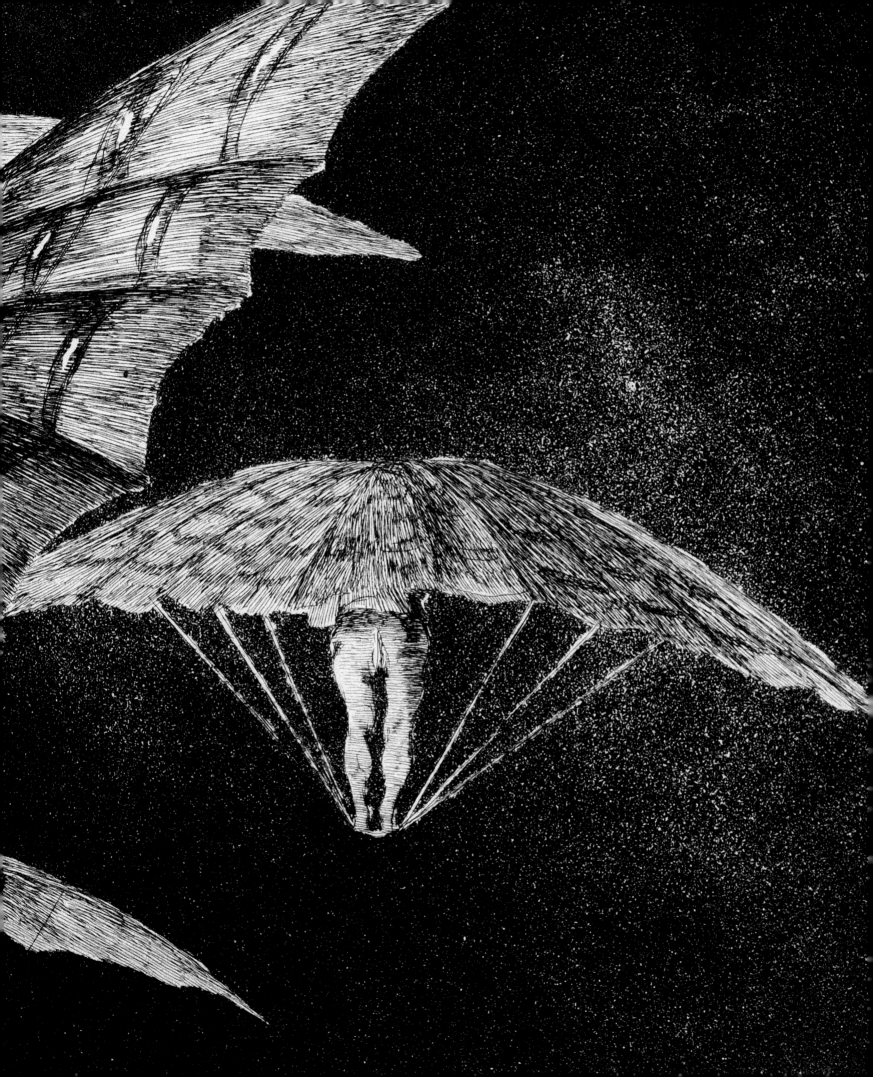

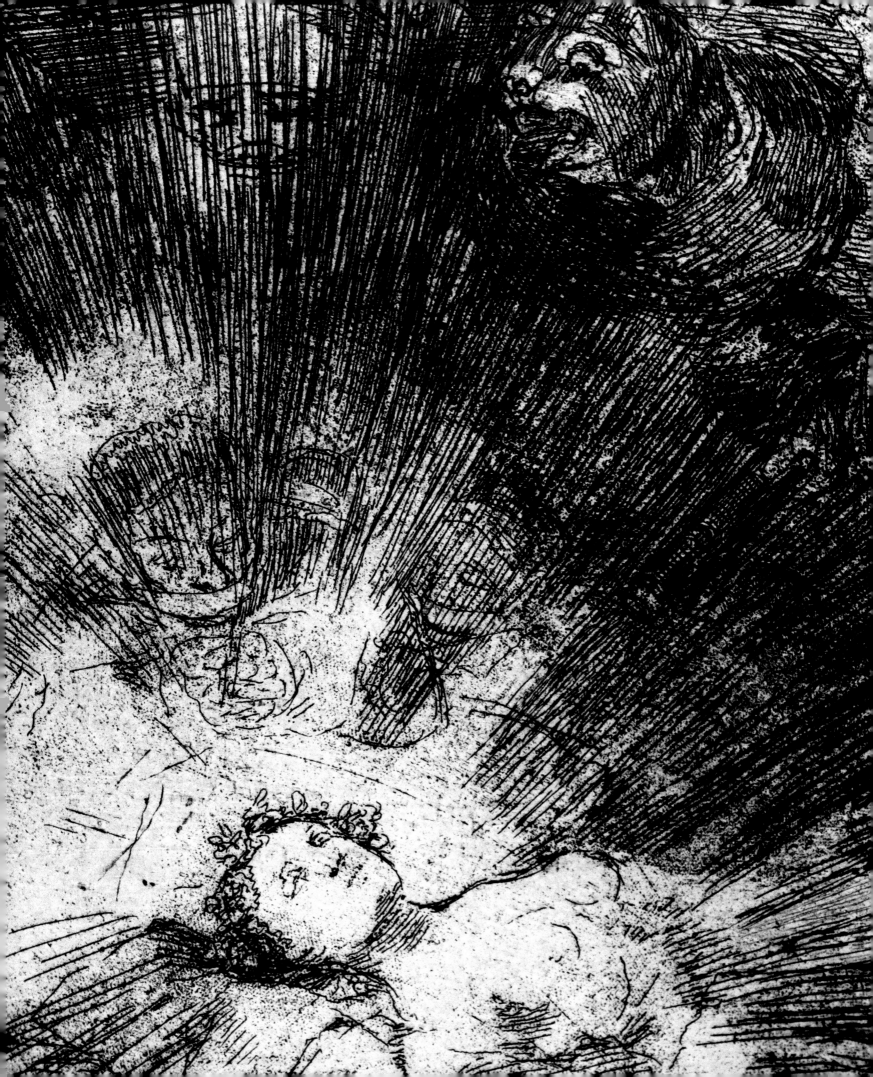

WORKS IN THE EXHIBITION

FRANCISCO JOSÉ
DE GOYA Y LUCIENTES

Los Caprichos (The Caprices) (1797–1798)

They carried her off!
Plate 8
Etching and aquatint on paper, 38 × 28.3 cm
(14⅞ × 11⅛ inches)
State Central Museum of Contemporary History
of Russia, Moscow
Inv. 15285/32-8

These specks of dust
Plate 23
Etching and aquatint on paper, 38 × 28.3 cm
(14⅞ × 11⅛ inches)
State Central Museum of Contemporary
History of Russia, Moscow
Inv. 15285/32-23

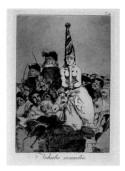

There was no help
Plate 24
Etching and aquatint on paper, 38 × 28.3 cm
(14⅞ × 11⅛ inches)
State Central Museum of Contemporary History
of Russia, Moscow
Inv. 15285/32-24

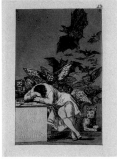

The sleep of reason produces monsters
Plate 43
Etching and aquatint on paper, 38 × 28.3 cm
(14⅞ × 11⅛ inches)
State Central Museum of Contemporary History
of Russia, Moscow
Inv. 15285/32-43

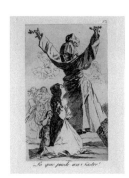

What a tailor can do!
Plate 52
Etching and aquatint on paper, 38 × 28.3 cm
(14⅞ × 11⅛ inches)
State Central Museum of Contemporary History
of Russia, Moscow
Inv. 15285/32-52

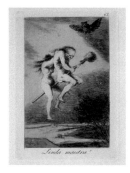

Pretty teacher
Plate 68
Etching and aquatint on paper, 38 × 28.3 cm
(14⅞ × 11⅛ inches)
State Central Museum of Contemporary History
of Russia, Moscow
Inv. 15285/32-68

Los Desastres de la Guerra (The Disasters of War) (1810–1820)

*Gloomy premonitions
of what must come to pass*
Plate 1
Etching and aquatint on paper, 27 × 37 cm
(10⅝ × 14½ inches)
State Central Museum of Contemporary History
of Russia, Moscow
Inv. 15285/33-1

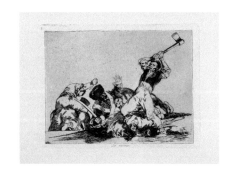

The same
Plate 3
Etching and aquatint on paper, 27 × 37 cm
(10⅝ × 14½ inches)
State Central Museum of Contemporary History
of Russia, Moscow
Inv. 15285/33-3

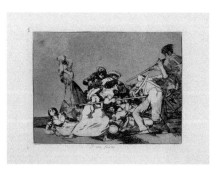

And they fight like wild beasts
Plate 5
Etching and aquatint on paper, 27 × 37 cm
(10⅝ × 14½ inches)
State Central Museum of Contemporary History
of Russia, Moscow
Inv. 15285/33-5

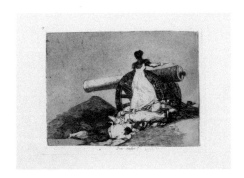

What courage!
Plate 7
Etching and aquatint on paper, 27 × 37 cm
(10⅝ × 14½ inches)
State Central Museum of Contemporary History
of Russia, Moscow
Inv. 15285/33-7

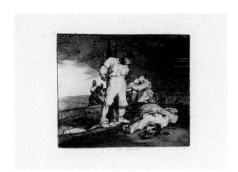

And it cannot be helped
Plate 15
Etching and aquatint on paper, 27 × 37 cm
(10⅝ × 14½ inches)
State Central Museum of Contemporary History
of Russia, Moscow
Inv. 15285/33-15

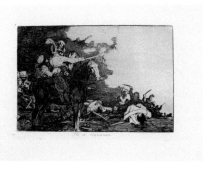

They cannot agree
Plate 17
Etching and aquatint on paper, 27 × 37 cm
(10⅝ × 14½ inches)
State Central Museum of Contemporary History
of Russia, Moscow
Inv. 15285/33-17

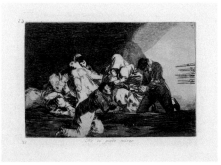

One can't look
Plate 26
Etching and aquatint on paper, 27 × 37 cm
(10⅝ × 14½ inches)
State Central Museum of Contemporary History
of Russia, Moscow
Inv. 15285/33-26

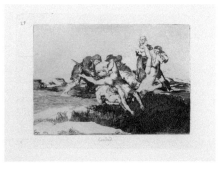

Charity
Plate 27
Etching and aqualint on paper, 27 × 37 cm
(10⅝ × 14½ inches)
State Central Museum of Contemporary History
of Russia, Moscow
Inv. 15285/33-27

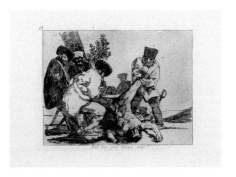

What more can be done?
Plate 33
Etching and aquatint on paper, 27 × 37 cm
(10⅝ × 14½ inches)
State Central Museum of Contemporary History
of Russia, Moscow
Inv. 15285/33-33

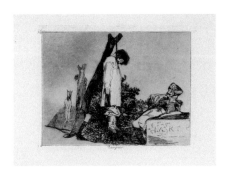

Also it is not known
Plate 36
Etching and aquatint on paper, 27 × 37 cm
(10⅝ × 14½ inches)
State Central Museum of Contemporary History
of Russia, Moscow
Inv. 15285/33-36

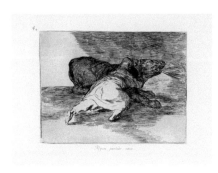

He gets something out of it
Plate 40
Etching and aquatint on paper, 27 × 37 cm
(10⅝ × 14½ inches)
State Central Museum of Contemporary History
of Russia, Moscow
Inv. 15285/33-40

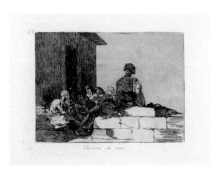

Appeals are in vain
Plate 54
Etching and aquatint on paper, 27 × 37 cm
(10⅝ × 14½ inches)
State Central Museum of Contemporary History
of Russia, Moscow
Inv. 15285/33-54

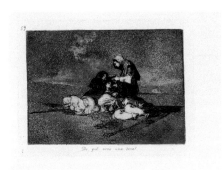

What is the use of a cup?
Plate 59
Etching and aquatint on paper, 27 × 37 cm
(10⅝ × 14½ inches)
State Central Museum of Contemporary History
of Russia, Moscow
Inv. 15285/33-59

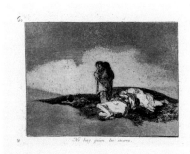

There is no one to help them
Plate 60
Etching and aquatint on paper, 27 × 37 cm
(10⅝ × 14½ inches)
State Central Museum of Contemporary History
of Russia, Moscow
Inv. 15285/33-60

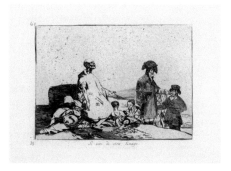

They are of another breed
Plate 61
Etching and aquatint on paper, 27 × 37 cm
(10⅝ × 14½ inches)
State Central Museum of Contemporary History
of Russia, Moscow
Inv. 15285/33-61

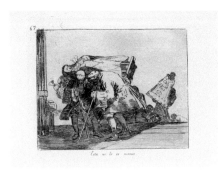

This is not less so
Plate 67
Etching and aquatint on paper, 27 × 37 cm
(10⅝ × 14½ inches)
State Central Museum of Contemporary History
of Russia, Moscow
Inv. 15285/33-67

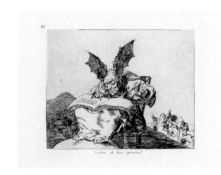

Against the common good
Plate 71
Etching and aquatint on paper, 27 × 37 cm
(10⅝ × 14½ inches)
State Central Museum of Contemporary History
of Russia, Moscow
Inv. 15285/33-71

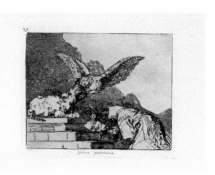

Feline pantomime
Plate 73
Etching and aquatint on paper, 27 × 37 cm
(10⅝ × 14½ inches)
State Central Museum of Contemporary History
of Russia, Moscow
Inv. 15285/33-73

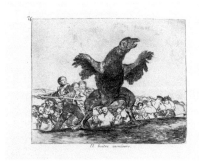

The carnivorous vulture
Plate 76
Etching and aquatint on paper, 27 × 37 cm
(10⅝ × 14½ inches)
State Central Museum of Contemporary History
of Russia, Moscow
Inv. 15285/33-76

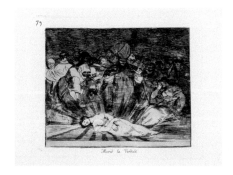

Truth has died
Plate 79
Etching and aquatint on paper, 27 × 37 cm
(10⅝ × 14½ inches)
State Central Museum of Contemporary History
of Russia, Moscow
Inv. 15285/33-79

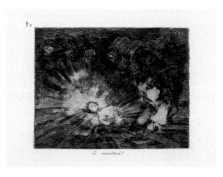

Will she live again?
Plate 80
Etching and aquatint on paper, 27 × 37 cm
(10⅝ × 14½ inches)
State Central Museum of Contemporary History
of Russia, Moscow
Inv. 15285/33-80

La Tauromaquia (Bullfighting) (1815–1816)

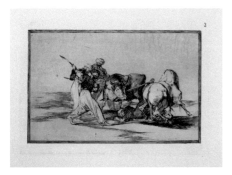

The Moors settled in Spain, giving up the superstitions of the Koran, adopted this sort of hunting, and spear a bull in the open
Plate 3
Etching and aquatint on paper, 34.8 × 44.8 cm
(13¾ × 17⅝ inches)
State Central Museum of Contemporary History
of Russia, Moscow
Inv. 15285/36-3

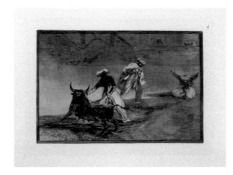

They play another with the cape in an enclosure
Plate 4
Etching and aquatint on paper, 34.8 × 44.8 cm
(13¾ × 17⅝ inches)
State Central Museum of Contemporary History
of Russia, Moscow
Inv. 15285/36-4

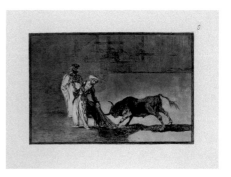

The Moors make a different play in the ring, calling the bull with their burnous
Plate 6
Etching and aquatint on paper, 34.8 × 44.8 cm
(13¾ × 17⅝ inches)
State Central Museum of Contemporary History
of Russia, Moscow
Inv. 15285/36-6

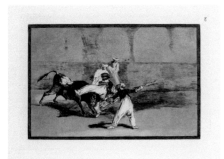

A Moor caught by the bull in the ring
Plate 8
Etching and aquatint on paper, 34.8 × 44.8 cm
(13¾ × 17⅝ inches)
State Central Museum of Contemporary History
of Russia, Moscow
Inv. 15285/36-8

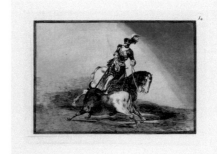

Charles V spearing a bull by spear in the ring at Valladolid
Plate 10
Etching and aquatint on paper, 34.8 × 44.8 cm
(13¾ × 17⅝ inches)
State Central Museum of Contemporary History
of Russia, Moscow
Inv. 15285/36-10

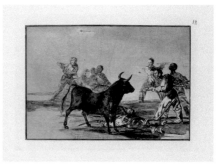

The crowd hamstrings the bull with lances, sickles, banderillas, and other arms
Plate 12
Etching and aquatint on paper, 34.8 × 44.8 cm
(13¾ × 17⅝ inches)
State Central Museum of Contemporary History
of Russia, Moscow
Inv. 15285/36-12

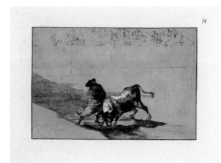

The very skillful student of Falces, wrapped in his cape, tricks the bull with the play of his body
Plate 14
Etching and aquatint on paper, 34.8 × 44.8 cm
(13¾ × 17⅝ inches)
State Central Museum of Contemporary History
of Russia, Moscow
Inv. 15285/36-14

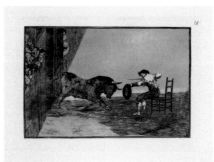

The daring of Martincho in the ring at Saragossa
Plate 18
Etching and aquatint on paper, 34.8 × 44.8 cm
(13¾ × 17⅝ inches)
State Central Museum of Contemporary History
of Russia, Moscow
Inv. 15285/36-18

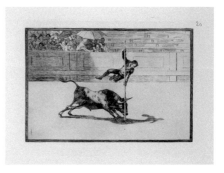

The agility and audacity of Juanito Apiñani in [the ring] at Madrid
Plate 20
Etching and aquatint on paper, 34.8 × 44.8 cm
(13¾ × 17⅝ inches)
State Central Museum of Contemporary History
of Russia, Moscow
Inv. 15285/36-20

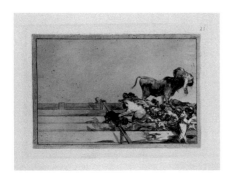

Dreadful events in the front rows of the ring at Madrid and death of the mayor of Torrejon
Plate 21
Etching and aquatint on paper, 34.8 × 44.8 cm
(13¾ × 17⅝ inches)
State Central Museum of Contemporary History
of Russia, Moscow
Inv. 15285/36-21

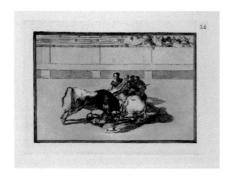

A picador is unhorsed and falls under the bull
Plate 26
Etching and aquatint on paper, 34.8 × 44.8 cm
(13¾ × 17⅝ inches)
State Central Museum of Contemporary History
of Russia, Moscow
Inv. 15285/36-26

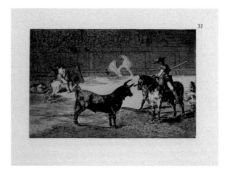

The celebrated picador Fernando del Toro draws the fierce beast on with his pike
Plate 27
Etching and aquatint on paper, 34.8 × 44.8 cm
(13¾ × 17⅝ inches)
State Central Museum of Contemporary History
of Russia, Moscow
Inv. 5285/36-27

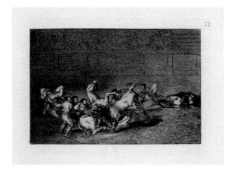

Two teams of picadors thrown one after the other by a single bull
Plate 32
Etching and aquatint on paper, 34.8 × 44.8 cm
(13¾ × 17⅝ inches)
State Central Museum of Contemporary History
of Russia, Moscow
Inv. 15285/36-32

Los Proverbios (Proverbs) (1815–1823)

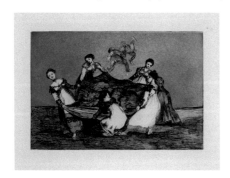

Feminine folly
Plate 1
Etching and aquatint on paper, 38.2 × 56.6 cm
(15 × 22¼ inches)
State Central Museum of Contemporary History
of Russia, Moscow
Inv. 15285/28-1

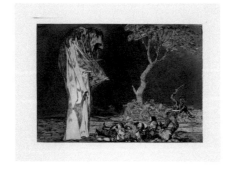

Folly of fear
Plate 2
Etching and aquatint on paper, 38.2 × 56.6 cm
(15 × 22¼ inches)
State Central Museum of Contemporary History
of Russia, Moscow
Inv. 15285/28-2

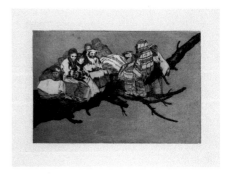

Ridiculous folly
Plate 3
Etching and aquatint on paper, 38.2 × 56.6 cm
(15 × 22¼ inches)
State Central Museum of Contemporary History
of Russia, Moscow
Inv. 15285/28-3

Simpleton
Plate 4
Etching and aquatint on paper, 38.2 × 56.6 cm
(15 × 22¼ inches)
State Central Museum of Contemporary History
of Russia, Moscow
Inv. 15285/28-4

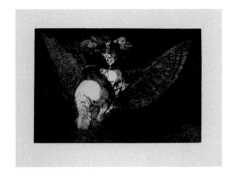

Flying folly
Plate 5
Etching and aquatint on paper, 38.2 × 56.6 cm
(15 × 22¼ inches)
State Central Museum of Contemporary History
of Russia, Moscow
Inv. 15285/28-5

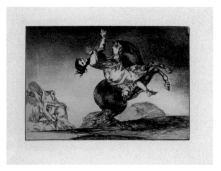

The horse abductor
Plate 10
Etching and aquatint on paper, 38.2 × 56.6 cm
(15 × 22¼ inches)
State Central Museum of Contemporary History
of Russia, Moscow
Inv. 15285/28-10

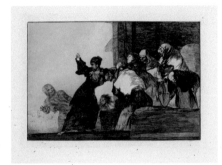

Poor folly
Plate 11
Etching and aquatint on paper, 38.2 × 56.6 cm
(15 × 22¼ inches)
State Central Museum of Contemporary History
of Russia, Moscow
Inv. 15285/28-11

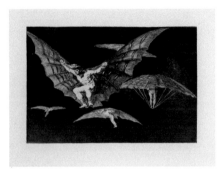

A way of flying
Plate 13
Etching and aquatint on paper, 38.2 × 56.6 cm
(15 × 22¼inches)
State Central Museum of Contemporary History
of Russia, Moscow
Inv. 15285/28-13

Birds of a feather flock together
Plate 18
Etching and aquatint on paper, 38.2 × 56.6 cm
(15 × 22¼ inches)
State Central Museum of Contemporary History
of Russia, Moscow
Inv. 15285/28-18

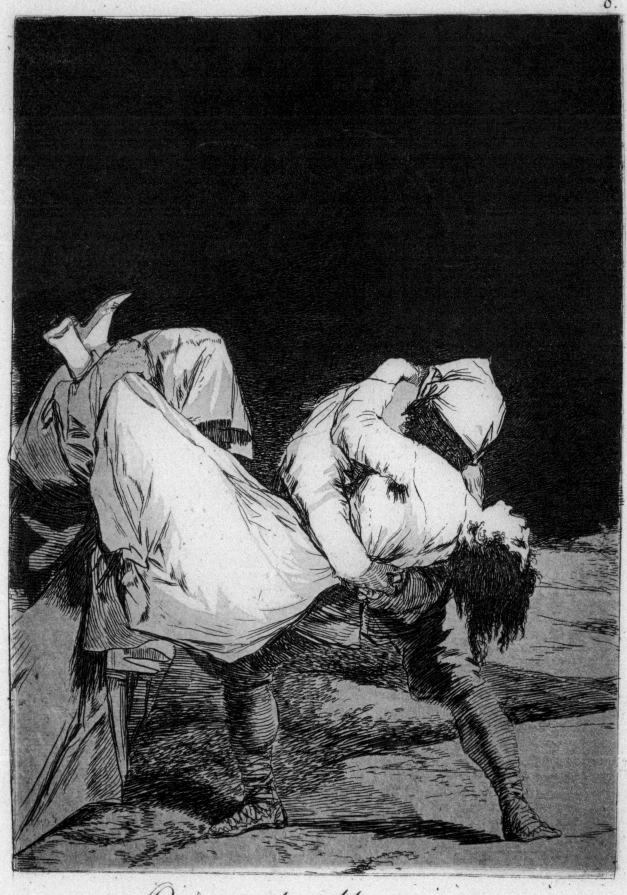

Que se la llevaron!

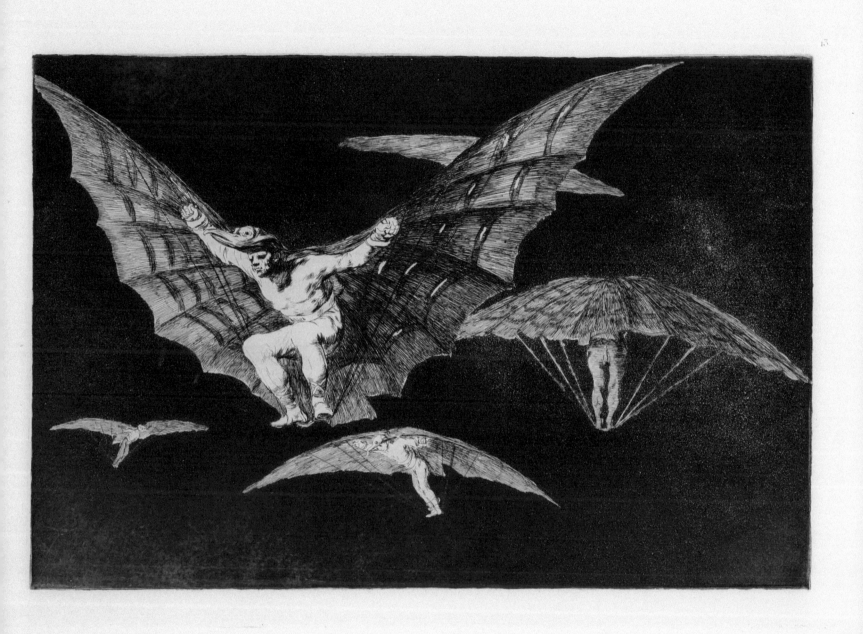

7

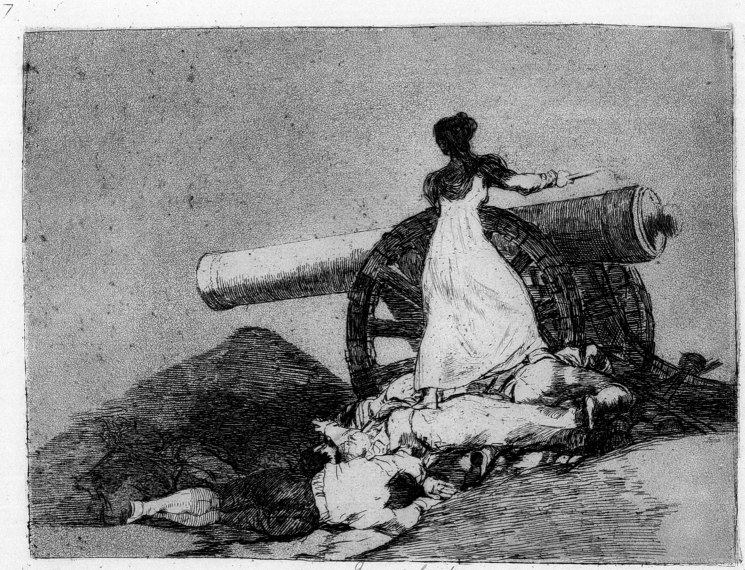

Que valor!

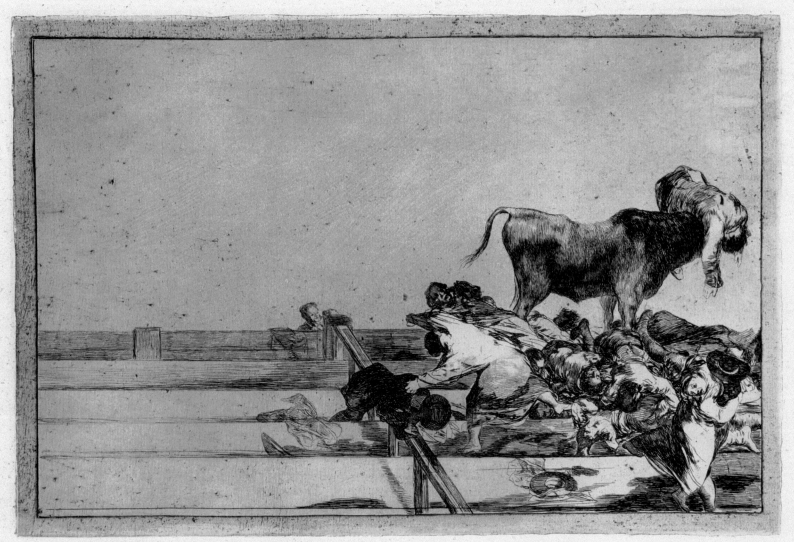

Финал: белая пена и чёрные
деревья.

SERGEI EISENSTEIN

Sketches for the film *Alexander Nevsky*, 1938

The captions include translations of Eisenstein's notes rather than titles. Where possible, they follow the same order as the text on the sketches.

Meeting on the crosses. Pelgusy
at the foot of the cross
Pencil on paper, 28 × 20.5 cm
(11 × 8 inches)
Russian State Archive of Literature
and Art (RGALI), Moscow
Inv. 1923-2-1648-1

The act of crucifixion.
Birch tree crosses. Raising the body
with the cross
Pencil on paper, 30 × 27 cm
(11⅘ × 10⅜ inches)
Russian State Archive of Literature
and Art (RGALI), Moscow
Inv. 1923-2-1648-2

Wives and children near the
crucifixion. Burning piles of books
(Reread Jüdischen Krieg
Feuchtw[anger])
Pencil on paper, 30 × 27 cm
(11⅘ × 10⅜ inches)
Russian State Archive of Literature
and Art (RGALI), Moscow
Inv. 1923-2-1648-3

Tverdila mocks the idea
of unity proposed by Alexander
Pencil on paper, 30 × 27 cm
(11⅘ × 10⅜ inches)
Russian State Archive of Literature
and Art (RGALI), Moscow
Inv. 1923-2-1648-6

The ruler's palace. Wives.
Defenders. Graves. Rogozhin.
Camp. Fires. Monks
Pencil on paper, 20.5 × 27.7 cm
(8 × 10⅞ inches)
Russian State Archive
of Literature and Art (RGALI),
Moscow
Inv. 1923-2-1648-7

The Sun has set…
Pencil on paper, 29.8 × 21 cm
(11⅝ × 8¼ inches)
Russian State Archive of Literature
and Art (RGALI), Moscow
Inv. 1923-2-1648-13

The end of Tverdila
Pencil on paper, 30.3 × 21.3 cm
(11⅞ × 8⅜ inches)
Russian State Archive of Literature
and Art (RGALI), Moscow
Inv. 1923-2-1650-5

Vas[ili] Buslayev meets Gavrila
Olekseevich [Blue line] Model
[Red line] Edges of the drawn-in
section
Pencil on paper, 18.9 × 21.6 cm
(7⅜ × 8½ inches)
Russian State Archive of Literature
and Art (RGALI), Moscow
Inv. 1923-2-1650-8

Vas[ili] Buslayev meets Gavrila
Olekseevich
Pencil on paper, 17.3 × 18.2 cm
(6⅘ × 7⅛ inches)
Russian State Archive of Literature
and Art (RGALI), Moscow
Inv. 1923-2-1650-10

Pencil on paper, 29.1 × 21.1 cm
(11⅜ × 8¼ inches)
Russian State Archive of Literature
and Art (RGALI), Moscow
Inv. 1923-2-1650-13

Not sure about the horizon of the
forest. 28 is our only hope.
1st Zvenigorod version. Here the
contre-jour shot of Alexander and
his fighters entering
Novgorod for the night-time town
meeting is very good. The bridge is
intermittent.
The cathedral and the upper stalls
are on a platform. Zvenigorod, Moscow
Pencil on paper, 29 × 20.8 cm
(11⅜ × 8⅛ inches)
Russian State Archive of Literature
and Art (RGALI), Moscow
Inv. 1923-2-1650-12

Guards 2. Tverdila with a sword. [Left]
Pelgusy. [Right] Vasilisa. Guards 1
A. Commanders stopping people.
B. Group stopping people. Group A
is arrested by guards 2.
Group B is arrested by guards 1
Guards 2. Tverdila with a sword. [Left]
Pelgusy. [Right] Vasilisa. [Left]
Pavsha. Guards 1
① Guards. Guards 1. Tverdila leaves
Pavsha
② Tear him to pieces
③ Tverdila. Pavsha
④ (drawing)
⑤ Ananiy. Pavsha
Pen on paper, 30.3 × 21.3 cm
(11⅞ × 8¼ inches)
Russian State Archive of Literature
and Art (RGALI), Moscow
Inv. 1923-2-1655-1

The proportions of the group of knights are wrong, they are further away and smaller.
Frosty (more trees). The cracks are, of course, crosswise, keeping the direction from Alexander to the knights.
Part A moves away from B — the crack widens and then the ice breaks.
Maybe it breaks through the group of extras? <"Chelyuskin">
10.IV.38
Pencil on paper, 28.8 × 20.6 cm (11¼ × 8⅛ inches)
Russian State Archive of Literature and Art (RGALI), Moscow
Inv. 1923-2-1659-9

Cut. = Knights. + Knights.
Our forces. Two rows of lances.
Savka rushes from ① to ②. Distances are exaggerated.
The logic is of vital import[ance].
(One row of lances). (Cut).
Lances always spread out like sun beams
Pencil on paper, 29.1 × 21.3 cm (11⅜ × 8¼ inches)
Russian State Archive of Literature and Art (RGALI), Moscow
Inv. 1923-2-1660-3

Balk 16-17.II.38
Pencil on paper, 29 × 21.1 cm (11⅜ × 8¼ inches)
Russian State Archive of Literature and Art (RGALI), Moscow
Inv. 1923-2-1656-1

Balk with his horsemen. [Left] Gavrila [Center] Savka [Right] Knecht.
12.IV.38
Pencil on paper, 29.2 × 20.8 cm (11⅜ × 8⅛ inches)
Russian State Archive of Literature and Art (RGALI), Moscow
Inv. 1923-2-1659-10

Pencil on paper, 27.1 × 20.2 cm (10⅝ × 7⅞ inches)
Russian State Archive of Literature and Art (RGALI), Moscow
Inv. 1923-2-1662-2

Anany. Ditliv. Balk. Hubertus. Tverdila
Pencil on paper, 20.2 × 21.2 cm (7¼ × 8¼ inches)
Russian State Archive of Literature and Art (RGALI), Moscow
Inv. 1923-2-1662-3

Sketches for the film *Ivan the Terrible*, 1942

The women of Kazan are throwing themselves under the horses (that horses do not like stepping on humans is a well-known fact). They writhe on the corpses of the slain warriors. An orgy on the corpses
Pencil on paper, 33.2 × 21.1 cm
(13 × 8¼ inches)
Russian State Archive of Literature and Art (RGALI), Moscow
Inv. 1923-2-579-29

A man with a drawn bow (moving)
Pencil on paper, 22.6 × 14 cm
(8¾ × 5½ inches)
Russian State Archive of Literature and Art (RGALI), Moscow
Inv. 1923-2-579-45

With the last movement of the camera – it loses him and comes to rest on the door with an angel. Evstafy goes out. Ivan appears and kneels before the "angel." a – turns his head and immediately moves away. A — the camera moves to the left, leaving Ivan behind
Pencil on paper, 18.4 × 14.4 cm
(7¼ × 5⅝ inches)
Russian State Archive of Literature and Art (RGALI), Moscow
Inv. 1923-2-1670-7

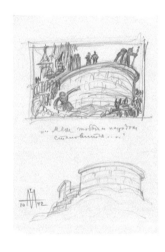

". . .Between you and the people will be. . ."
Pencil on paper, 22 × 15.2 cm
(8⅝ × 5⅞ inches)
Russian State Archive of Literature and Art (RGALI), Moscow
Inv. 1923-2-1674-5

A snow storm . . . covering the bloody trace. . .
Pencil on paper, 22.1 × 15.3 cm
(8¾ × 6 inches)
Russian State Archive of Literature and Art (RGALI), Moscow
Inv. 1923-2-1674-8

Uspensky Cathedral. Ivan begins his speech. NB maybe Ivan's figure should be even lower in the beginning. His figure gradually grows bigger and the camera moves lower and lower in relation to him. 15.I.42
Pencil on paper, 21.9 × 15.2 cm
(8⅝ × 5⅞ inches)
Russian State Archive of Literature and Art (RGALI), Moscow
Inv. 1923-2-1676-4

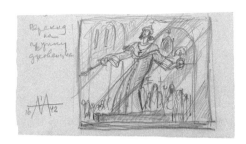

Shift to the clergy. 16.I.42
Pencil on paper, 9.6 × 17.2 cm
(3¾ × 6¾ inches)
Russian State Archive of Literature
and Art (RGALI), Moscow
Inv. 1923-2-1676-6

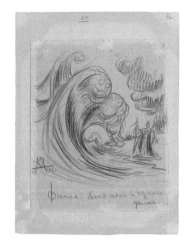

The ending: white foam and black
smoke. 28.II.42
Pencil on paper, 24.2 × 21.4 cm
(9½ × 8⅜ inches)
Russian State Archive of Literature
and Art (RGALI), Moscow
Inv. 1923-2-1678-3

The situation with Malyuta
(Weissenstein). 3.III.42
Pencil on paper, 15.3 × 20.6 cm
(6 × 8⅛ inches)
Russian State Archive
of Literature and Art (RGALI),
Moscow
Inv. 1923-2-1682-2

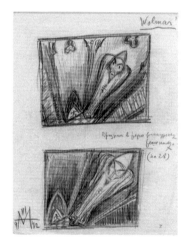

Wolman. The ghost at acute angles
(shot 28). 9.III.42
Pencil on paper, 30 × 23.1 cm
(11¾ × 9 inches)
Russian State Archive of Literature
and Art (RGALI), Moscow
Inv. 1923-2-1685-7

"Alone?. . ." 3.IV.42
Pencil on paper, 13.8 × 16.3 cm
(5⅜ × 6⅜ inches)
Russian State Archive
of Literature and Art (RGALI),
Moscow
Inv. 1923-2-1702-9

Pencil on paper, 22.8 × 15.1 cm
(8⅞ × 5⅞ inches)
Russian State Archive of Literature
and Art (RGALI), Moscow
Inv. 1923-2-1686-14

Kozma drinks from the cup.
12.III.42
Pencil on paper, 14.9 × 11.9 cm
(5⅞ × 4⅝ inches)
Russian State Archive
of Literature and Art (RGALI),
Moscow
Inv. 1923-2-1686-13

Ivan's apotheosis. ("Like Christ walking on water (!)"). In the final scene Ivan rises above the sea like he rose above the people in the Uspensky Cathedral. This is not a coincidence, but well thought out: only after destroying conflict between people, having united them, can one master the nature and its forces. A rear projection—so that Ivan comes out of the water dry. Both axes (a–b) and (c–d) start moving slightly, then shake. Masked filming: the horizon (straight line) coincides with the mask.
3.IV.42
Pencil on paper, 32 × 21.7 cm
(12½ × 8½ inches)
Russian State Archive of Literature and Art (RGALI), Moscow
Inv. 1923-2-1702-6

The ending. Axes meet (before the blackout). Ivan's apotheosis. (Both axes at the highest point). NB The waves should be shot crashing against each other by an animator stop the axes in this position and slowly and symmetrically lower them (but does the technology allow this?). We probably need to print (beforehand). Secuto A shakes, and close the sky with a black board in the scene with the waves! Of course!!! (The only difficulty is, the waves should not rise above the horizon).The black board matches the horizon, and the camera rocks in front of it. The sky should not be cloudy, or the trick with rocking will be too obvious! 3.IV.42
Pencil on paper, 32 × 21.7 cm
(12½ × 8½ inches)
Russian State Archive of Literature and Art (RGALI), Moscow
Inv. 1923-2-1702-7

Malyuta rises in front of Ivan. And Malyuta is entrusted with the sacred banner.
Pencil on paper, 32.4 × 21.6 cm
(12⅝ × 8½ inches)
Russian State Archive of Literature and Art (RGALI), Moscow
Inv. 1923-2-1703-11

The end of the scene with Filipp, shift to the scene with Malyuta. (Ivan kisses F[ilipp]'s robe). Mise-en-scène of the departure of Filipp and Evstafy. The tsar stops and Malyuta stops approaching.
4.IV.42
Pencil on paper, 18.9 × 21.8 cm
(7⅜ × 8½ inches)
Russian State Archive of Literature and Art (RGALI), Moscow
Inv. 1923-2-1703-2

Shot list. The room of Basmanov the father. The light swings. Shadows move. O. Cut. Etc. 17.IV.42
Pencil on paper, 28.6 × 9.9 cm
(11¼ × 3¾ inches)
Russian State Archive of Literature and Art (RGALI), Moscow
Inv. 1923-2-1710-1

On the snow in the background. . . Near them dark shadows slide.
17.IV.42
Pencil on paper, 28.2 × 19.8 cm
(11⅛ × 7¾ inches)
Russian State Archive of Literature and Art (RGALI), Moscow
Inv. 1923-2-1710-4

The skis meet in shot. 17.IV.42
Pencil on paper, 28.7 × 19.8 cm
(11¼ × 7⅝ inches)
Russian State Archive of Literature
and Art (RGALI), Moscow
Inv. 1923-2-1710-7

Hummed introduction before
god etc. The sacred vow. The vow
episode begins. 10.XI.42
Pencil on paper, 33.1 × 20.2 cm
(13 × 7⅞ inches)
Russian State Archive of Literature
and Art (RGALI), Moscow
Inv. 1923-2-1727-1

Pencil on paper, 20.6 × 34.3 cm
(8⅛ × 13½ inches)
Russian State Archive
of Literature and Art (RGALI),
Moscow
Inv. 1923-2-1727-10

Pencil on paper, 21.9 × 15.2 cm
(8⅝ × 5⅞ inches)
Russian State Archive of Literature
and Art (RGALI), Moscow
Inv. 1923-2-1730-2

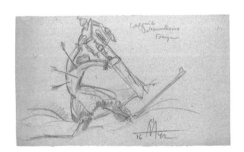

The death of the messenger
from Moscow. 26.XI.42
Pencil on paper, 20.6 × 34.3 cm
(8⅛ × 13½ inches)
Russian State Archive
of Literature and Art (RGALI),
Moscow
Inv. 1923-2-1728-7

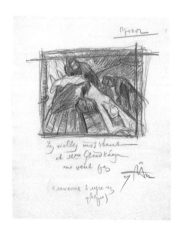

Prologue. The old women insist
and Lady Glinskaya doesn't want
to. (Glinskaya in a shaft of light from
the door). 24.XII.42
Pencil on paper, 28.7 × 23 cm
(11¼ × 9 inches)
Russian State Archive of Literature
and Art (RGALI), Moscow
Inv. 1923-2-1730-5

Strike
Year: 1924
Country: USSR
Director: Sergei Eisenstein
Screenplay: Sergei Eisenstein,
Grigori Aleksandrov,
Ilya Kravchunovsky,
Valerian Pletnev
Producer: Boris Mikhin
Cinematography: Vasili Khvatov,
Eduard Tisse
Music: Sergei Prokofiev
Artistic Director: Vasili Rakhals
Premiere: April 28, 1925
Duration: 82'

Gosfilmofond of Russia, Moscow

Battleship Potemkin
Year: 1925
Country: USSR
Director: Sergei Eisenstein
Screenplay: Sergei Eisenstein,
Nina Agadzhanova,
Grigori Aleksandrov,
Sergei Tretyakov
Cinematography: Eduard Tisse,
Vladimir Popov
Music: Dmitri Shostakovich,
Nikolai Kryukov, Vladimir Heifetz
Artistic Director: Vasili Rakhals
Premiere: December 24, 1925
Duration: 75'

Gosfilmofond of Russia, Moscow

October
Year: 1927
Country: USSR
Directors: Sergei Eisenstein,
Grigori Aleksandrov
Screenplay: Sergei Eisenstein,
Grigori Aleksandrov
Cinematography: Eduard Tisse
Music: Edmund Meisel, Dmitri
Shostakovich
Artistic Director: Vasili Kovrigin
Premiere: January 20, 1928
Duration: 105'

Gosfilmofond of Russia, Moscow

Sentimental Romance
Year: 1930
Country: France
Directors: Sergei Eisenstein,
Grigori Aleksandrov
Screenplay: Sergei Eisenstein,
Grigori Aleksandrov
Producer: Leonard Rosenthal
Cinematography: Eduard Tisse
Music: Alexis Arkhangelsky
Artistic Director: Lazare Meerson
Premiere: September 12, 1930
Duration: 20'

Gosfilmofond of Russia, Moscow

Alexander Nevsky
Year: 1938
Country: USSR
Directors: Sergei Eisenstein,
Dmitri Vasilyev, Boris Ivanov
Screenplay: Sergei Eisenstein,
Pyotr Pavlenko
Producer: Igor Vakar
Cinematography: Eduard Tisse
Music: Sergei Prokofiev
Editing: Esfir Tobak
Artistic Directors: Iosif Shpinel,
Nikolai Solovyov
Premiere: November 25, 1938
Duration: 112'

Gosfilmofond of Russia, Moscow

Ivan the Terrible
Year: 1944
Country: USSR
Director: Sergei Eisenstein
Screenplay: Sergei Eisenstein
Cinematography: Eduard Tisse,
Andrei Moskvin
Music: Sergei Prokofiev
Artistic Director: Iosif Shpinel
Premiere: January 20, 1945
Duration: 100'

Gosfilmofond of Russia, Moscow

Ivan the Terrible, Part II
Year: 1945
Country: USSR
Director: Sergei Eisenstein
Screenplay: Sergei Eisenstein
Cinematography: Eduard Tisse,
Andrei Moskvin
Music: Sergei Prokofiev
Artistic Director: Iosif Shpinel
Premiere: September 1, 1958
Duration: 86'

Gosfilmofond of Russia, Moscow

Успенский собор
Начало речи
Ивана.

NB. Быть может дать еще ниже
фигура Ивана в
первых точках

Постепенное увеличение
размера Ивана и опускание людей
с ними по отношению к Ивану
ниже и ниже.

15/III 42

La situacion
de la
muerte
de Malinta.

(Weißen-
stein).

3 / 42

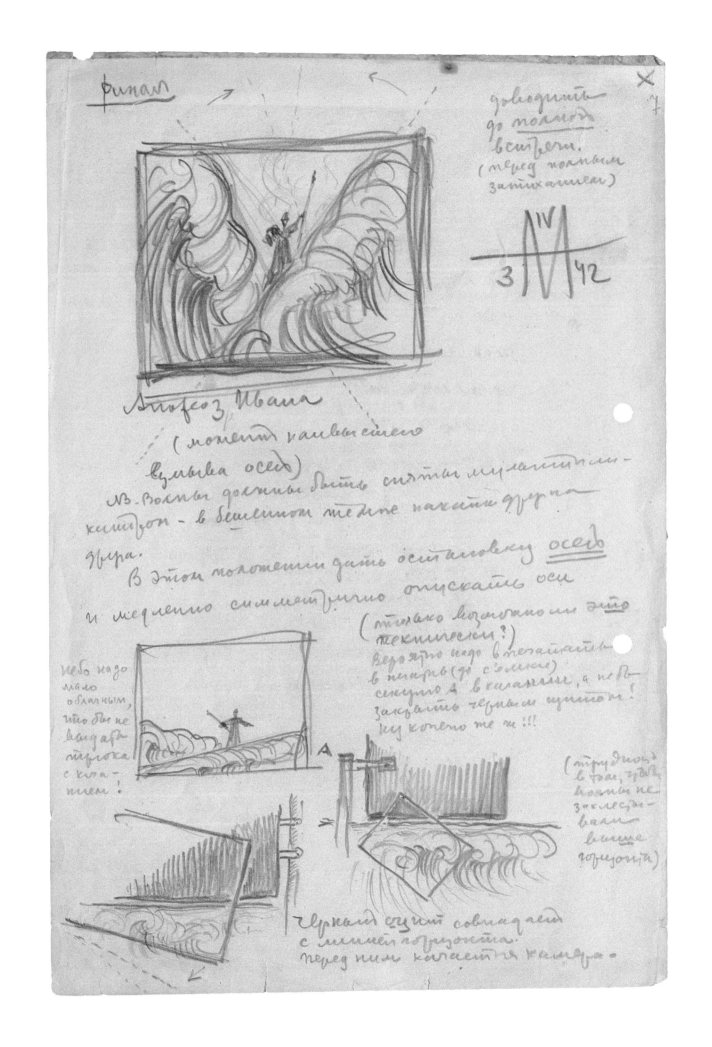

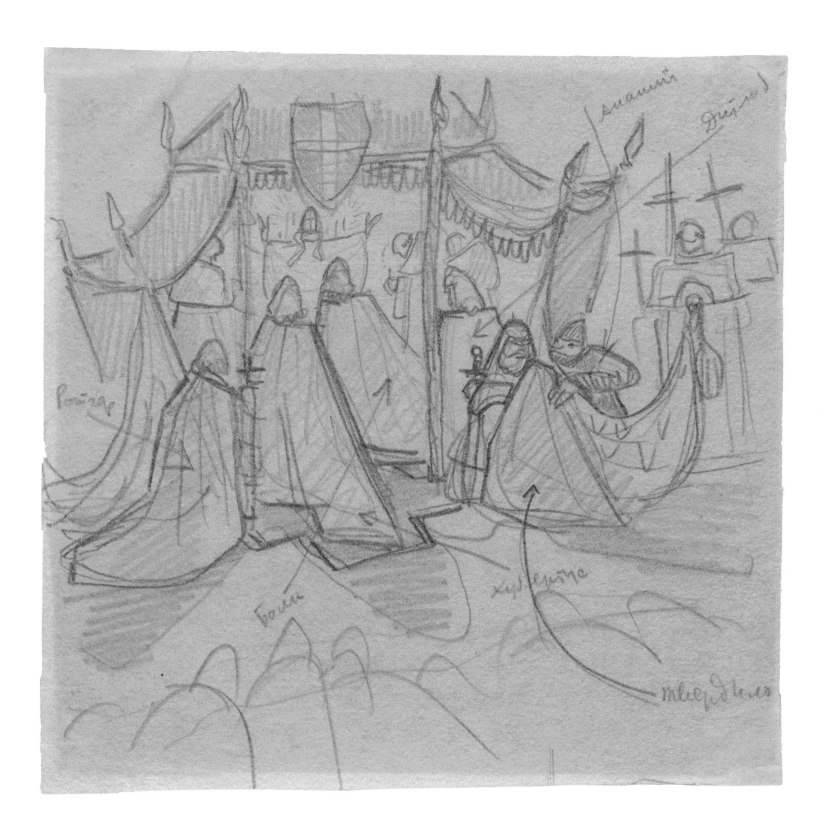

10/IV 38

Трещина конечно поперёк
всё же
на сокрашающем направлении
от Александра к Византии

часть А оттягивается
от В — трещина
ширится и забои
уже лmedia ло-
мастся.

ROBERT LONGO

Untitled (View of Freud's Study Room with Books, Desk and Window, 1938)
(2002)
Charcoal on mounted paper, 167.6 × 274.3 cm
(66 × 108 inches)
Collection of Siegfried and Jutta Weishaupt

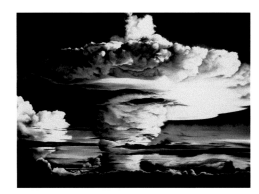

Untitled (Mike Test/Head of Goya)
(2003)
Charcoal on mounted paper, 182.9 × 243.8 cm
(72 × 96 inches)
Collection of the artist

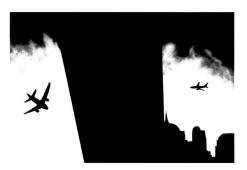

Untitled (The Haunting)
(2005)
Charcoal on mounted paper, overall dimensions
226.6 × 365.7 cm (3 panels) (89 × 144 inches)
Collection of Siegfried and Jutta Weishaupt

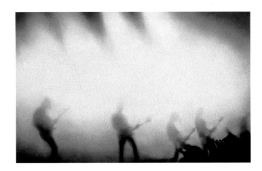

Untitled (The Sound of Speed and Light)
(2009)
Charcoal on mounted paper, 151.8 × 242.6 cm
(59¾ × 95½ inches)
Courtesy Circa 1881, New York

Untitled (Mecca)
(2010)
Charcoal on mounted paper, overall dimensions
421.6 × 640.1 cm (9 panels) (59¾ × 95½ inches)
Private collection

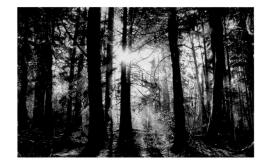

Untitled (Hercynian)
(2011)
Charcoal on mounted paper, overall dimensions
274.3 × 457.2 cm (3 panels) (108 × 180 inches)
ALTANA Kulturstiftung, Germany

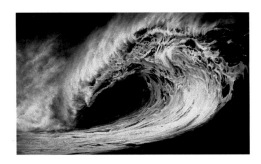

Untitled (Hellion)
(2011)
Charcoal on mounted paper, 176.2 × 303.2 cm
(69⅜ × 119⅜ inches)
Courtesy of the artist and Metro Pictures, New York

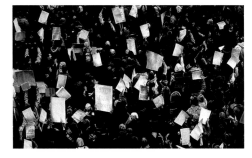

Untitled (Day of Action, OWS)
(2012)
Charcoal on mounted paper, 177.8 × 304.8 cm
(70 × 120 inches)
Private collection, Austria

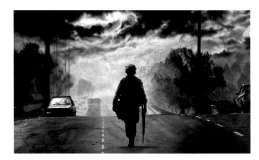

Untitled (Leaving Iraq)
(2012)
Charcoal on mounted paper, 177.8 × 304.8 cm
(70 × 120 inches)
Private collection, Italy

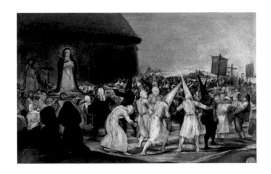

Untitled (After Goya, A Procession of the Flagellants, 1812–1819) (2012)
Charcoal and graphite on paper, 14 × 22.9 cm
(5½ × 9 inches)
Private collection
Courtesy of the artist and Galerie Thaddaeus Ropac,
London · Paris · Salzburg

*Untitled (After de Kooning, Woman I,
1950–1952)* (2012)
Charcoal on mounted paper, 233 × 177.8 cm
(91¾ × 70 inches)
Private collection
Courtesy of the artist and Galerie Thaddaeus Ropac,
London · Paris · Salzburg

Untitled (Russian SU-30 Jet Fighter)
(2012)
Charcoal on mounted paper, 177.8 × 304.8 cm
(70 × 120 inches)
Private collection, Switzerland

Untitled (May 23, No. 2, Brooklyn)
(2013)
Charcoal on mounted paper,
152.4 × 208.3 cm (60 × 82 inches)
Collection of Marvin and Susan Numeroff,
New York

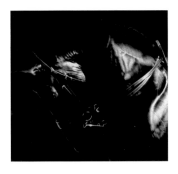

Untitled (Trojan)
(2013)
Charcoal on mounted paper,
177.8 × 203.2 cm (70 × 80 inches)
Bukhtoyarov Family Collection,
Moscow

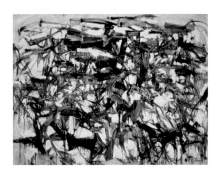

*Untitled (After Mitchell, Ladybug,
1957)* (2013)
Charcoal on mounted paper,
175.6 × 244 cm (69⅛ × 96 inches)
Collection of Bob and Suzanne Cochran,
New York

Untitled (Black Chamber),
2013
Charcoal on mounted paper, wood,
plexi-glass, 319.6 × 121.4 × 121.4 cm
(125¹³/₁₈ × 47¹³/₁₆ × 47¹³/₁₆ inches)
Courtesy of the artist and Galerie
Thaddaeus Ropac, London · Paris ·
Salzburg

*Heretics (After Goya's Procession
of the Flagellants, 1812–1819)* (2013)
Cast bronze with a terracotta finish, leather, wood,
90 × 205.8 × 70 cm (35 × 81 × 27½ inches)
Collection of Ariane Piech, Germany

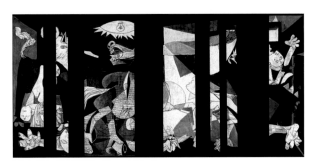

*Untitled (Guernica Redacted,
After Picasso's Guernica, 1937)*
(2014)
Charcoal on mounted paper, overall dimensions
283.2 × 620.4 cm (4 panels) (111½ × 244¼ inches)
Courtesy of the artist and Galerie Thaddaeus Ropac,
London · Paris · Salzburg

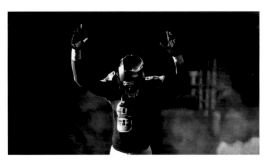

Untitled (St. Louis Rams/Hands Up)
(2015)
Charcoal on mounted paper, 165.1 × 304.8 cm
(65 × 120 inches)
Courtesy of the artist and Metro Pictures, New York

Untitled (Bullet Hole in Window, January 7, 2015)
(2015–2016)
Charcoal on mounted paper, 193 × 363.2 cm
(76 × 143 inches)
Courtesy of the artist and Galerie Thaddaeus Ropac,
London · Paris · Salzburg

Untitled (Gabriel's Wing)
(2015)
Charcoal on mounted paper,
177.8 × 304.8 cm (70 × 120 inches)
Private collection

*Untitled (X-Ray of Bathsheba at Her Bath,
1654, After Rembrandt) (2015–2016)*
Charcoal on mounted paper, 177.8 × 177.8 cm
(70 × 70 inches)
Private collection
Courtesy of the artist and Galerie Thaddaeus
Ropac, London · Paris · Salzburg

Untitled (Rippling Water) (2015)
Charcoal on mounted paper,
224.2 × 177.8 cm (88¼ × 70 inches)
Private collection
Courtesy of the artist and Galerie
Thaddaeus Ropac, London · Paris ·
Salzburg

Untitled (Wall of Ice)
(2016)
Charcoal on mounted paper,
224.2 × 177.8 cm (88¼ × 70 inches)
Private collection
Courtesy Acquavella Galleries,
New York

Untitled (Iceberg for C.D.F.)
(2015–2016)
Charcoal on mounted paper, overall dimensions
304.8 × 510.5 cm (4 panels) (120 × 201 inches)
Private collection
Courtesy of the artist and Galerie Thaddaeus Ropac,
London · Paris · Salzburg

Untitled (American F-22 Raptor Fighter)
(2016)
Charcoal on mounted paper, 177.8 × 304.8 cm
(70 × 120 inches)
Private collection

*Untitled (Einstein's Desk, The Day He Died,
April 18, 1955) (2016)*
Charcoal on paper, 177.8 × 260 cm
(70 × 102 inches)
Courtesy of the artist and Metro Pictures, New York

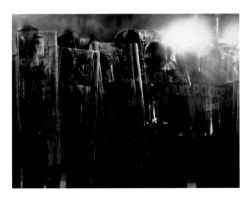

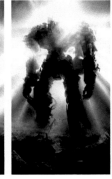

Untitled (Riot Cops) (2016)
Charcoal on mounted paper, 256.5 × 355.6 cm
(101 × 140 inches).
Courtesy of the artist and Metro Pictures, New York

Untitled (Pentecost) (2016)
Charcoal on mounted paper, overall dimensions
304.8 × 426.7 cm (3 panels) (120 × 240 inches)
Courtesy of the artist and Metro Pictures, New York

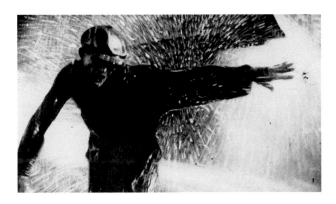
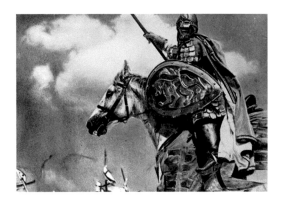

Untitled (After Eisenstein, Strike, 1925)
(2016)
Charcoal and graphite on mounted paper,
10.2 × 17.8 cm (4 × 7 inches)
Courtesy of the artist and Metro Pictures, New York

*Untitled (After Eisenstein, Alexander
Nevsky, 1938)* (2016)
Charcoal and graphite on mounted paper,
12.4 × 17.8 cm (4⅞ × 7 inches)
Courtesy of the artist and Metro Pictures, New York

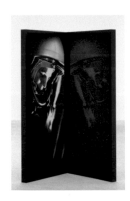
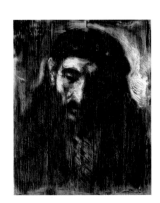
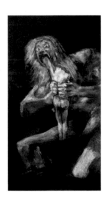
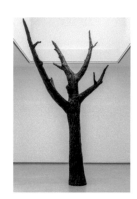

*Untitled (Cosmonaut Tereshkova,
First Woman in Space)* (2015)
Charcoal on mounted paper, overall
dimensions 271.8 × 175.3 × 116.8 cm
(2 panels) (107 × 69 × 46 inches)
Courtesy of the artist and Galerie Thaddaeus
Ropac, London · Paris · Salzburg

*Untitled (X-Ray of Head of Christ,
c. 1648–1656, After Rembrandt)*
(2015)
Charcoal on mounted paper, 224.2 × 177.8 cm
(88¼ × 70 inches)
Courtesy of the artist and Galerie Thaddaeus
Ropac, London · Paris · Salzburg

*Untitled (After Goya, Saturn
Devouring His Son, 1819)*
(2016)
Charcoal and graphite on paper,
17.8 × 9.7 cm (7 × 3⅞ inches)
Collection of the artist

Untitled (A Tree, For Sam)
(2016)
Cast charcoal and resin,
304.8 × 182.8 × 182.8 cm
(120 × 72 × 72 inches)
Courtesy of the artist and Galerie
Thaddaeus Ropac, London · Paris ·
Salzburg

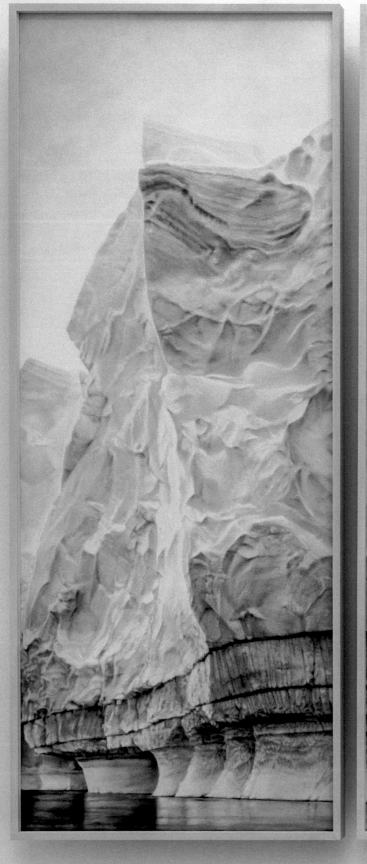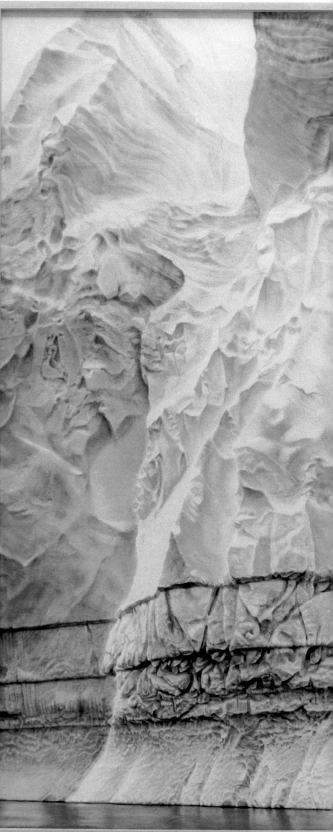

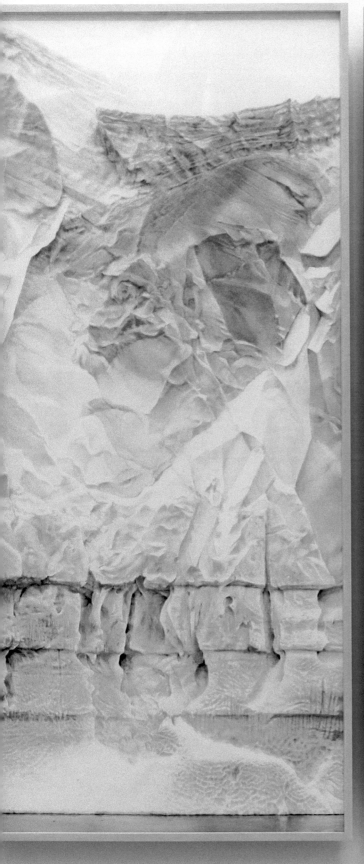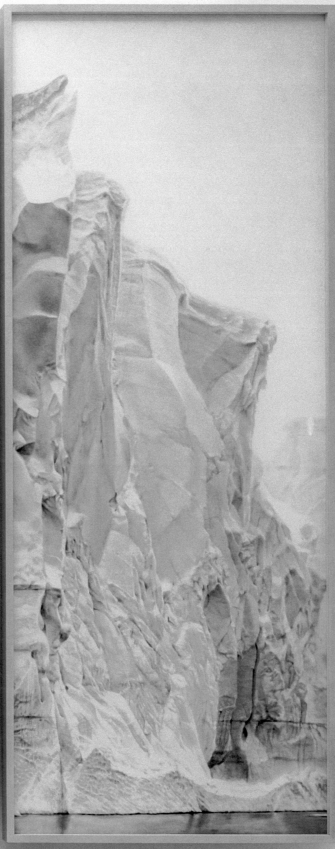

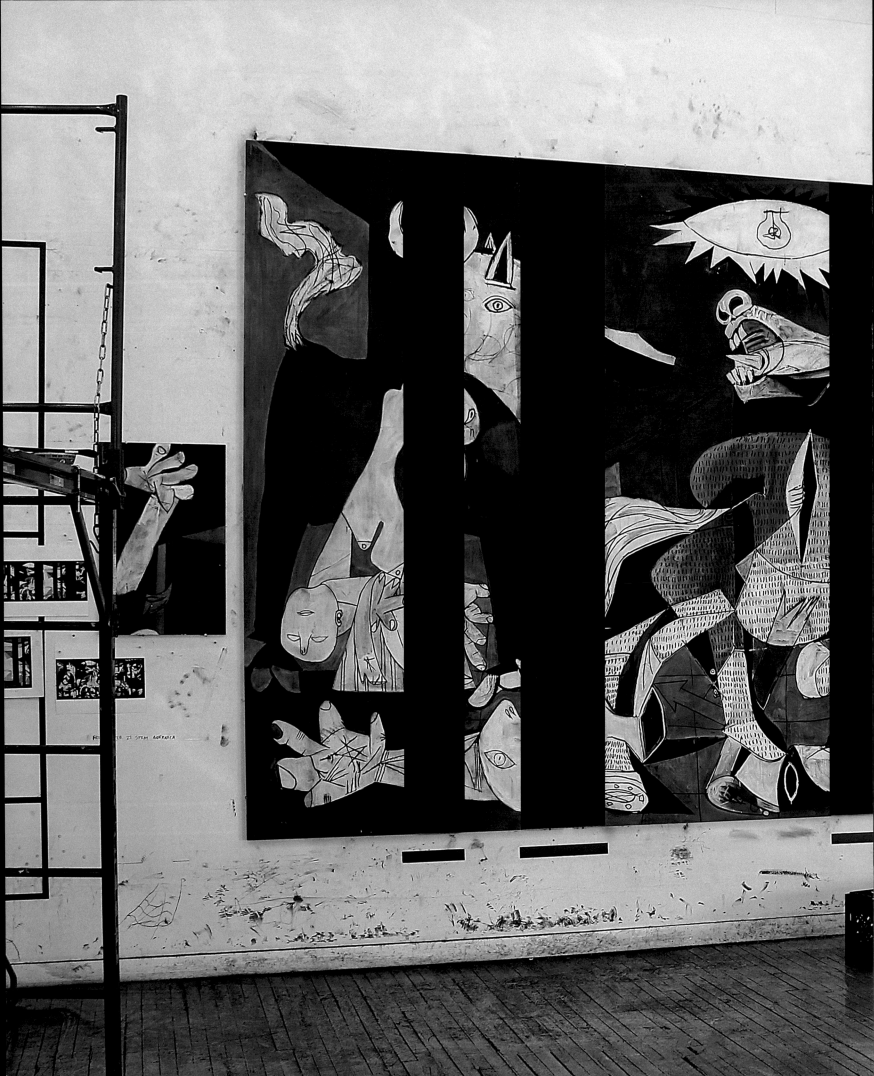

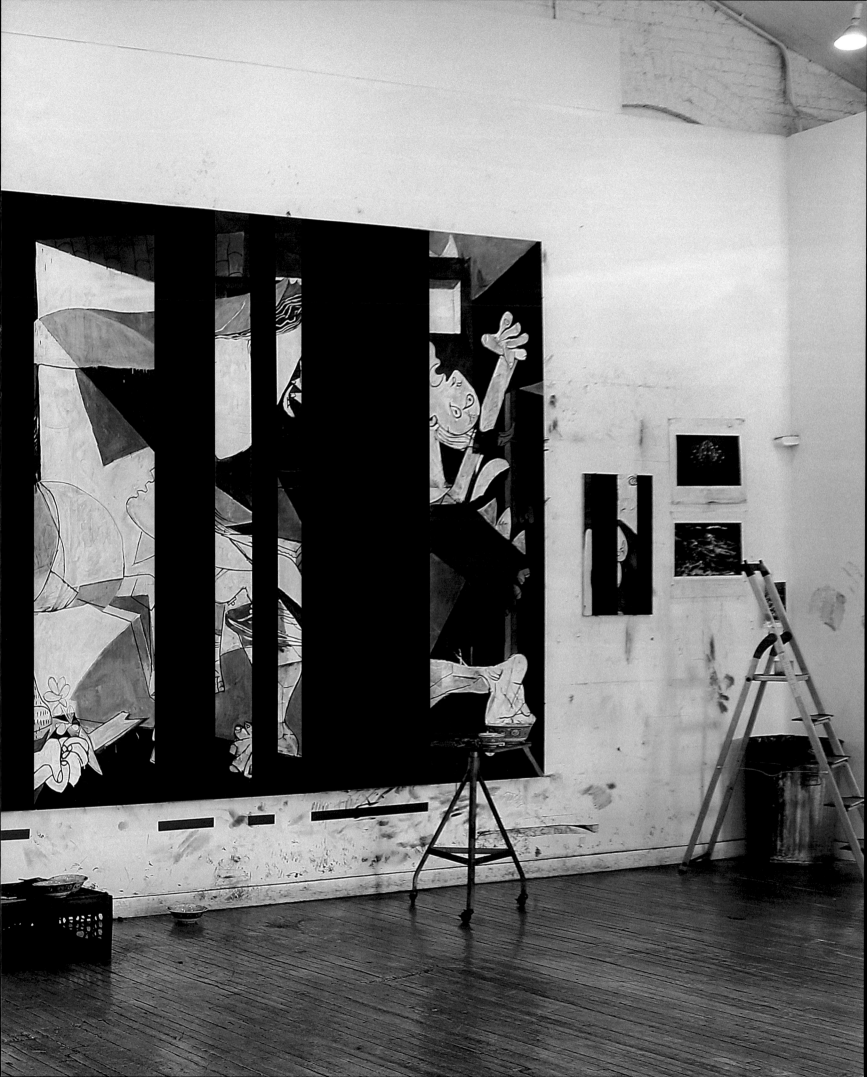

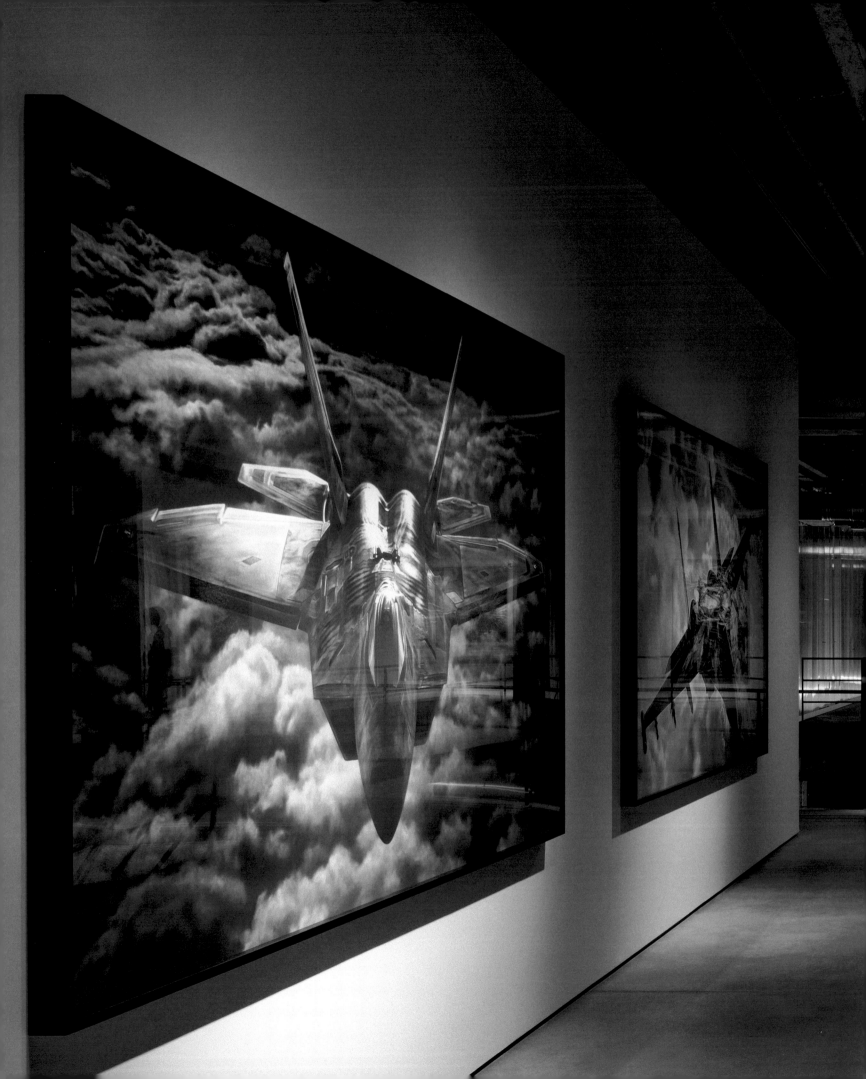

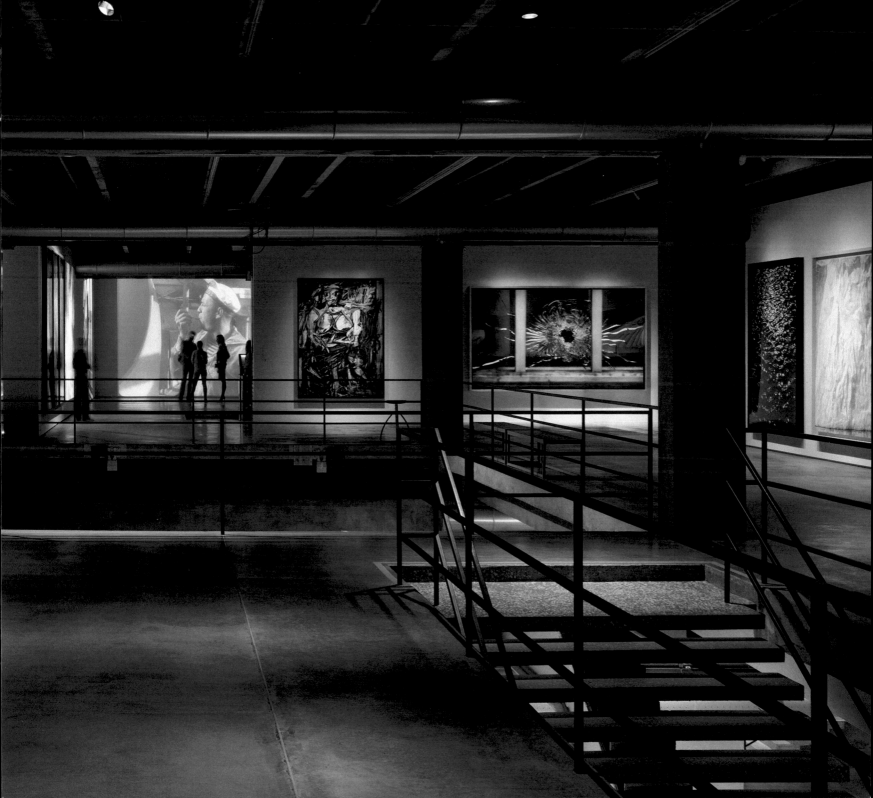

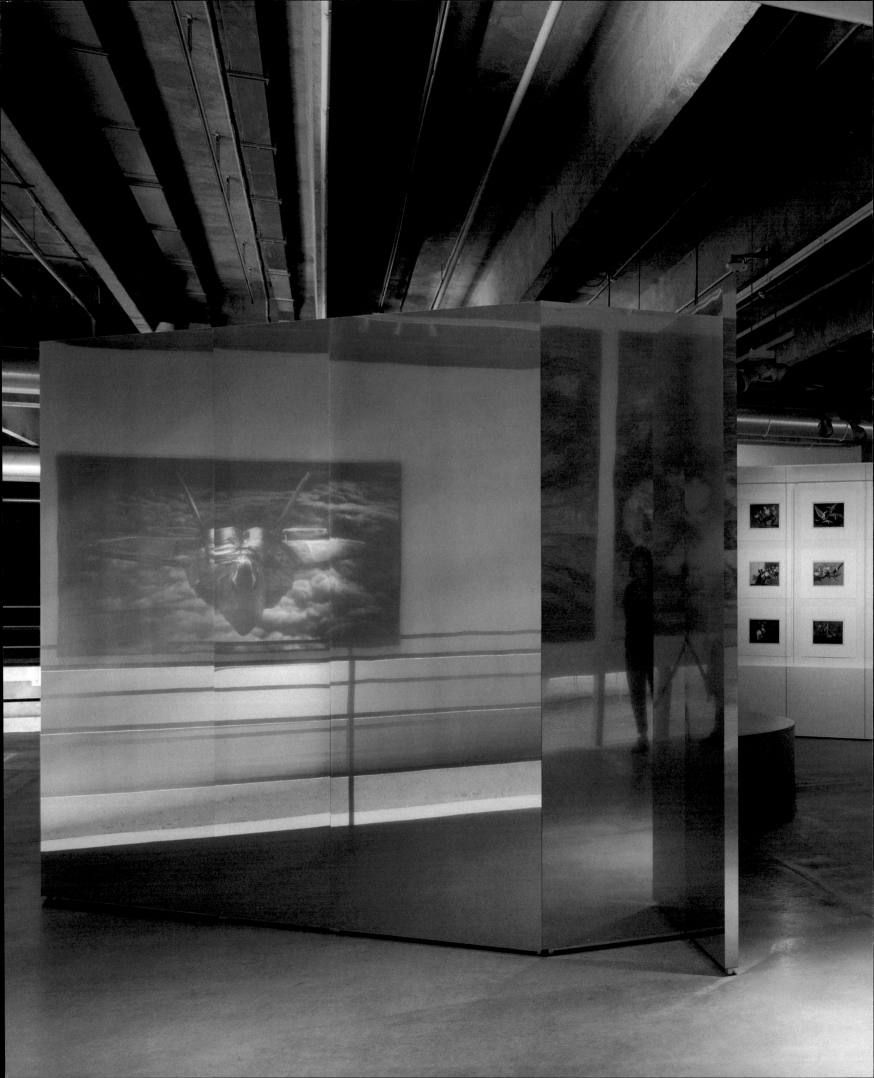

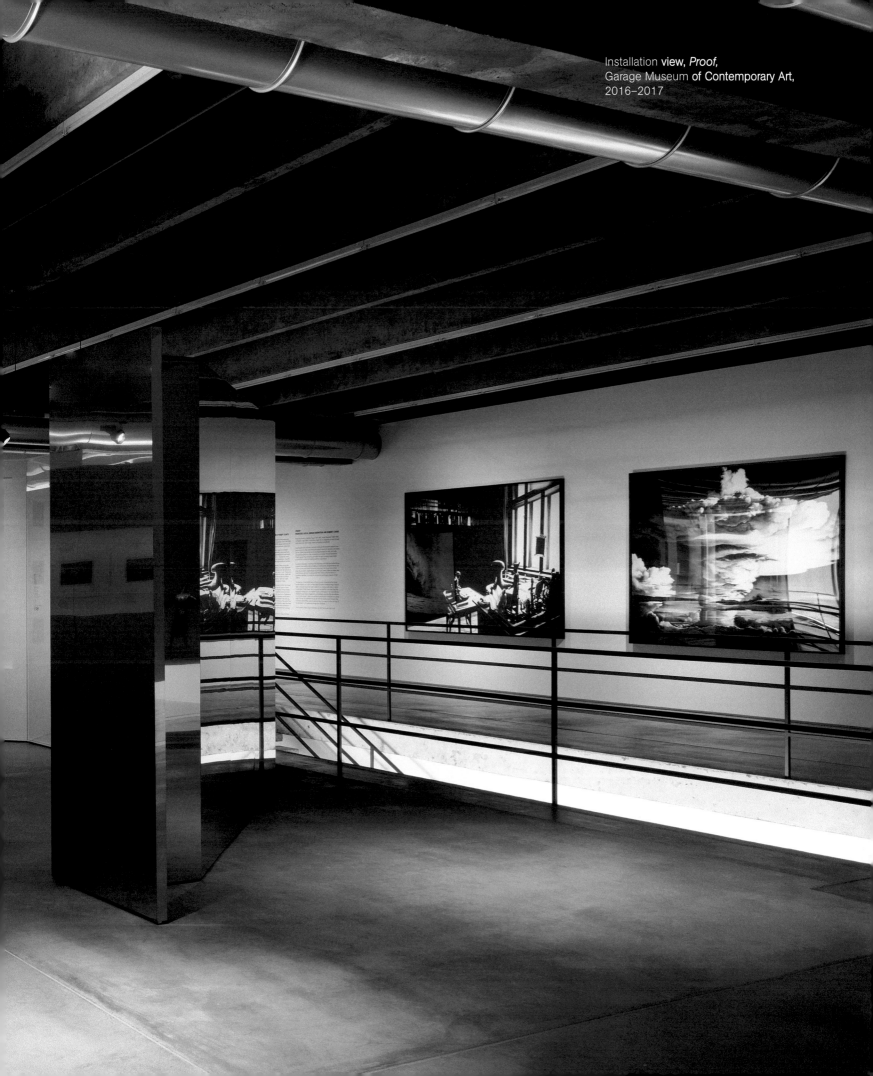

Installation view, *Proof,*
Garage Museum of Contemporary Art,
2016–2017

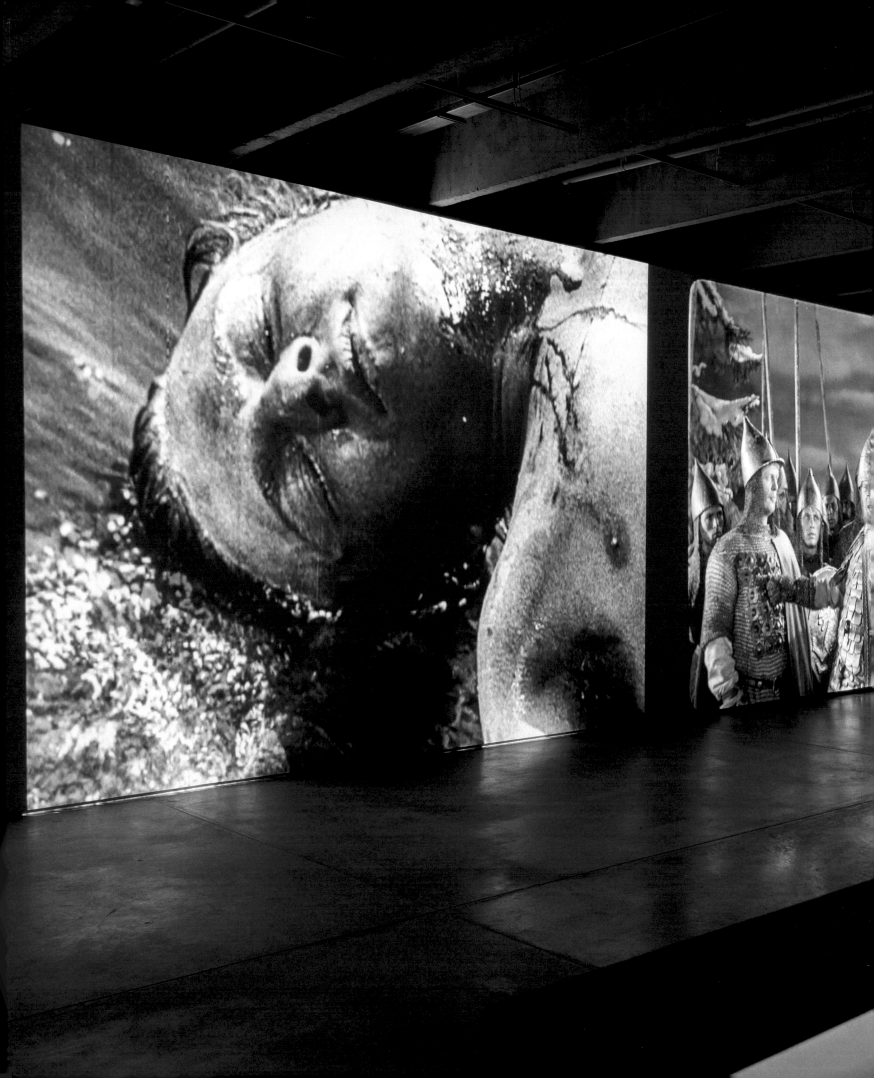

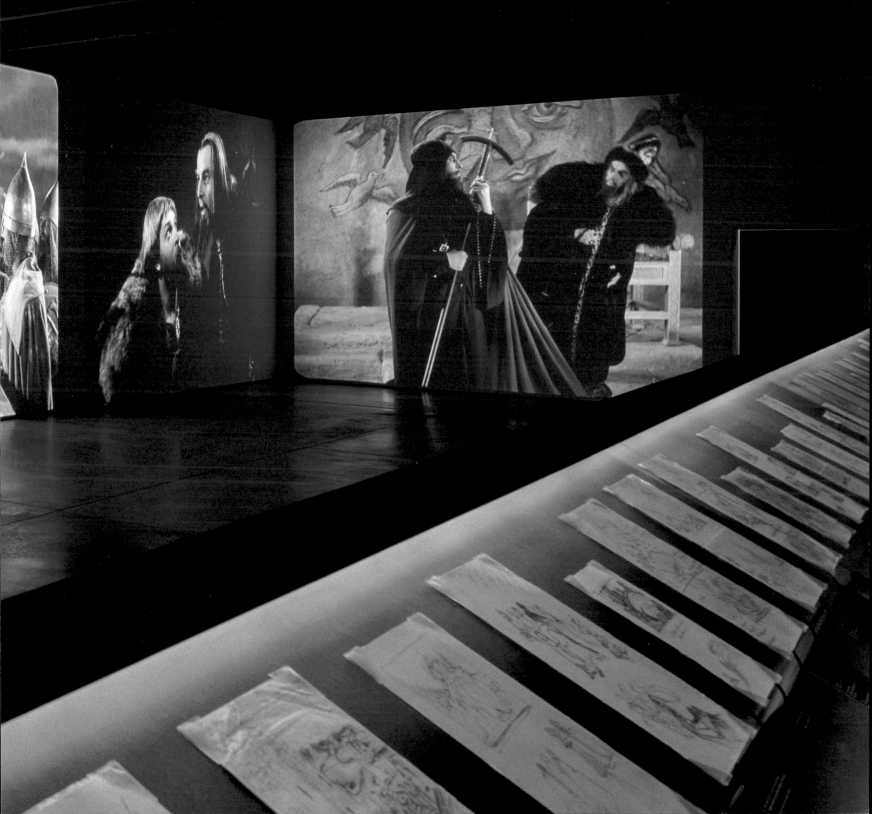

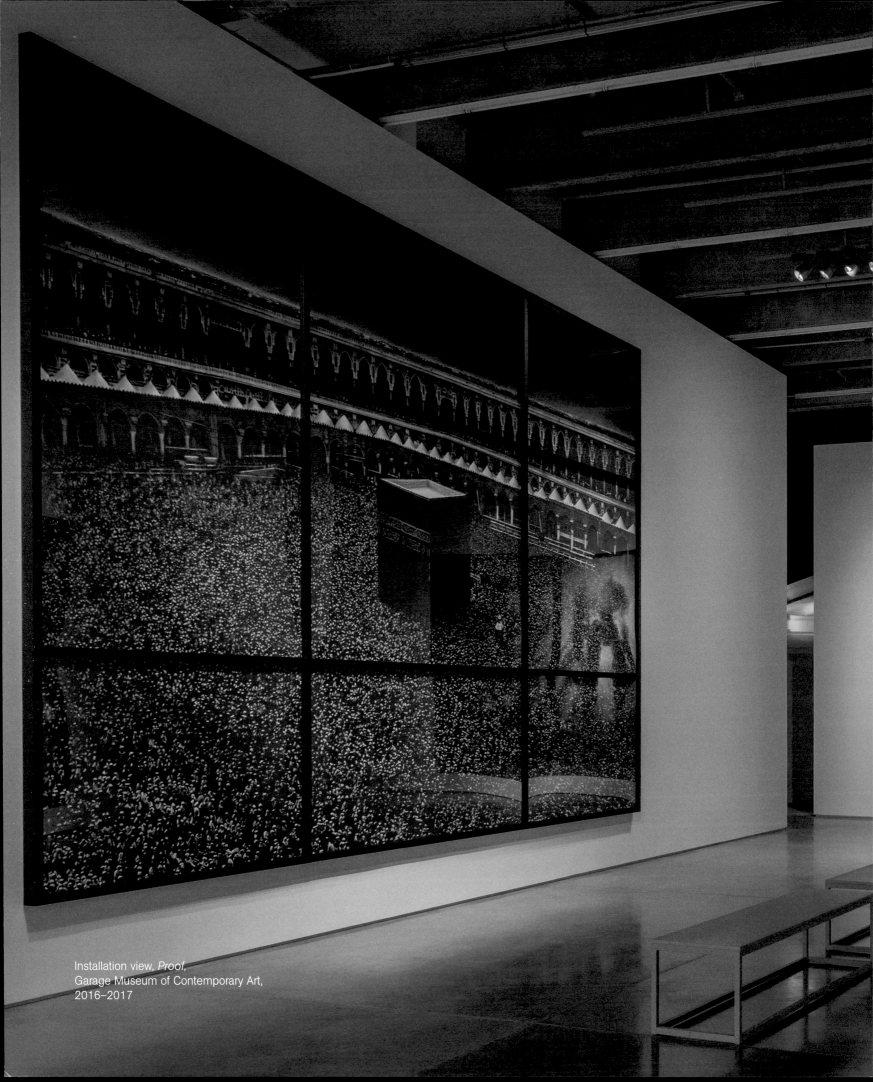

Installation view, *Proof*,
Garage Museum of Contemporary Art,
2016–2017

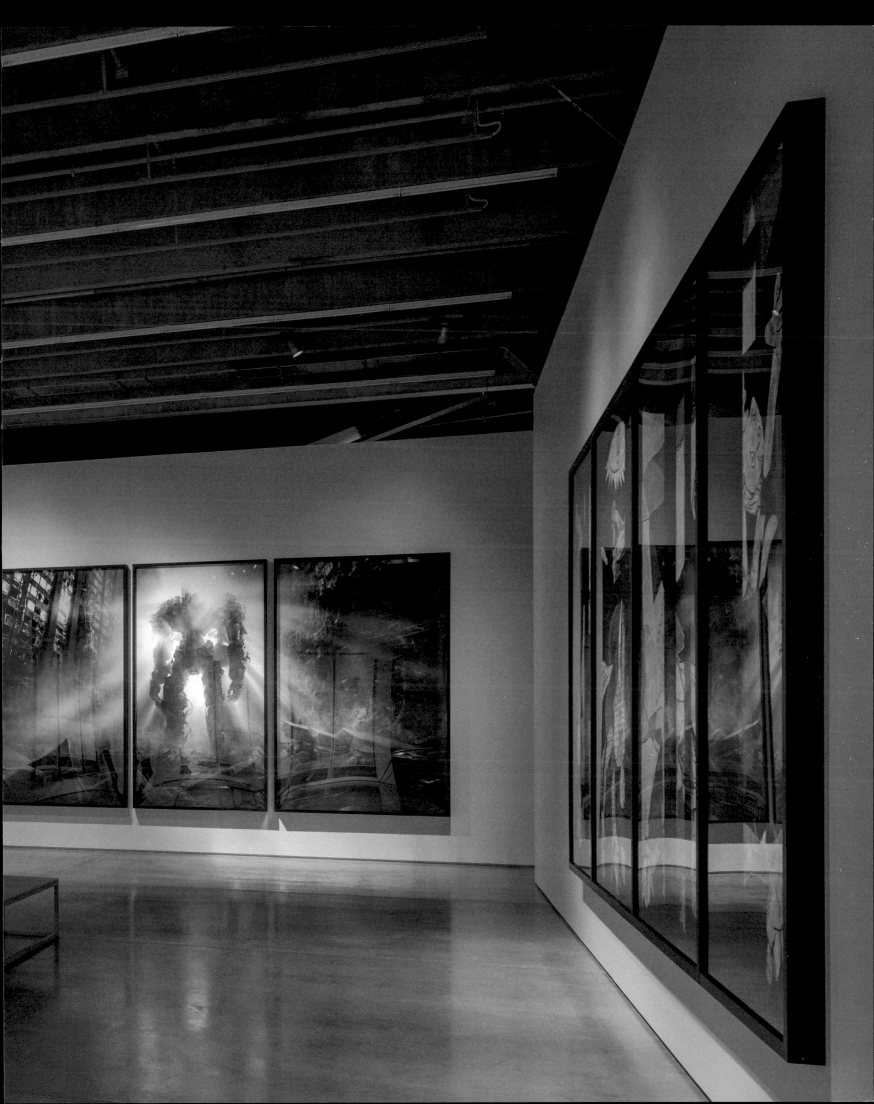

ABOUT THE AUTHORS

KATE FOWLE is chief curator at Garage Museum of Contemporary Art in Moscow and director-at-large at Independent Curators International (ICI) in New York. From 2009 to 2013, she was the executive director of ICI. Previously she was the inaugural international curator at the Ullens Center for Contemporary Art in Beijing (2007–2008) and chair of the Master's Program in Curatorial Practice, which she co-founded in 2002 for California College of the Arts in San Francisco. Before moving to the United States, Fowle was co-director of Smith + Fowle in London. From 1994 to 1996, she was curator at the Towner Art Gallery and Museum in Eastbourne, East Sussex. Fowle's recent curatorial projects include solo exhibitions with David Adjaye, John Baldessari, Urs Fischer, Rashid Johnson, Irina Korina, Robert Longo, Taryn Simon, and Rirkrit Tirivanija, as well as extended essays on Rasheed Araeen, Doug Aitken, Louise Bourgeois, Ilya Kabakov, Sterling Ruby, Qiu Zhijie, and Althea Thauberger.

CHRIS HEDGES is a journalist, activist, author, and Presbyterian minister. He received his Bachelor of Arts degree in English Literature from Colgate University and later graduated as Master of Divinity from Harvard. He is the author of several best-selling books including *War Is a Force That Gives Us Meaning* (2002), *Empire of Illusion: The End of Literacy and the Triumph of Spectacle* (2009), *Days of Destruction, Days of Revolt* (2012, with cartoonist Joe Sacco) and *Wages of Rebellion: The Moral Imperative of Revolt* (2015). Hedges is a columnist for the websites Truthdig and OpEdNews and has hosted television programs on RT and TeleSUR. For about twenty years, he worked as an international correspondent, writing for *The New York Times* (1995–2002) among other periodicals. In 2002, Hedges was among the eight reporters at *The New York Times* awarded the Pulitzer Prize for the paper's coverage of global terrorism. He also

received the Amnesty International Global Award for Human Rights Journalism in 2002 and was named LA Press Club's best online journalist of the year in 2011. Chris Hedges is a senior fellow at the Nation Institute in New York, and has taught at Columbia, New York, Princeton, and Toronto universities. He has also taught college courses in New Jersey prisons. He speaks English, Arabic, French, and Spanish.

NANCY SPECTOR is Artistic Director and Jennifer and David Stockman Chief Curator at the Solomon R. Guggenheim Museum and Foundation. During more than twenty-nine years at the Guggenheim, she has organized exhibitions on conceptual photography, Felix Gonzalez-Torres, Matthew Barney's *Cremaster* cycle, Richard Prince, Louise Bourgeois (with Tate Modern), Marina Abramović, Tino Sehgal, Maurizio Cattelan, and Peter Fischli/David Weiss. She also organized the group exhibitions *Moving Pictures; Singular Forms (Sometimes Repeated)* and *theanyspacewhatever*. She was Adjunct Curator of the 1997 Venice Biennale and co-organizer of the first Berlin Biennial in 1998. She has contributed to numerous books on contemporary visual culture with essays on artists such as Maurizio Cattelan, Luc Tuymans, and Mona Hatoum. In 2007, she was the US Commissioner for the Venice Biennale, where she presented an exhibition of work by Felix Gonzalez-Torres. Spector is a recipient of the Peter Norton Family Foundation Curators Award, five International Art Critics Association Awards, and a Tribeca Disruptive Innovation Award for her work on *Youtube Play, a Biennial of Creative Video*. In 2014, she was included in the 40 Women Over 40 to Watch list. At the Brooklyn Museum, where she worked as Deputy Director and Curator from 2016 to 2017, she launched the ten-exhibition program *Year of Yes: Reimagining Feminism*, and spearheaded the cross-collection, long-term exhibition *Infinite Blue*.

VADIM ZAKHAROV is an artist, editor, collector, and archivist of Moscow Conceptualism. He has collaborated with a number of artists, including Viktor Skersis, Sergei Anufriev, Andrei Monastyrsky, Yuri Leiderman, and Nillas Nitschke. He is the founder of the publisher Pastor Zond Edition and *Pastor* journal, and editor (with Ekaterina Degot) of the book *Moscow Conceptualism* (Moscow: WAM, 2005). Solo exhibitions include: *Vadim Zakharov. Postscriptum after RIP: A Video Archive of Moscow Artists' Exhibitions 1989–2014*, Garage Museum of Contemporary Art, Moscow (2015); Russian Pavilion, 55th Venice Biennale, Venice (2013); and *25 Years on One Page*, State Tretyakov Gallery, Moscow (2006). Zakharov's *Adorno Monument* (2003) in Frankfurt am Main was erected to commemorate 100 years since philosopher Theodor Adorno's birth. Awards include the Kandinsky Prize (Russia, 2009), the Innovation Prize (Russia, 2006), the Renta Prize (Germany, 1995), and the Griffelkunst prize (Germany, 1995). Zakharov lives and works in Berlin and Moscow.

Published on the occasion of the exhibition

PROOF

Garage Museum of Contemporary Art, Moscow
September 30, 2016–February 5, 2017

Brooklyn Museum, New York
September 7, 2017–January 7, 2018

Deichtorhallen Hamburg
February 17–May 27, 2018

Curators
Robert Longo and Kate Fowle

Catalogue
Texts *Anton Belov, Kate Fowle, Chris Hedges, Dirk Luckow, Anne Pasternak, Nancy Spector, Vadim Zakharov*
Editors *Ruth Addison, Kate Fowle, Leigh Markopoulos*
Publication Manager *Maria Nazaretyan*
Coordinators *Katia Barinova, Vika Dushkina*
Translation *Ruth Addison, Daniil Dynin, Lena Solodyankina*
Proofreader *Anne Salisbury*
Photographers *Erma Estvik, Fyodor Kandinsky, Vlad Karukin, Alexey Naroditsky*
Design, layout, and pre-press *Anastasia Orlova*

Garage would like to thank:

Robert Longo and his studio:
Paolo Arao, Alexandra Baye, Sarah Brenneman, Qing Liu, James Sheppard

Film historians:
Vladimir Zabrodin and Naum Kleiman

Lenders:
Acquavella Galleries, New York
ALTANA Kulturstiftung, Germany
Bukhtoyarov Family Collection, Moscow
Circa 1881, New York
Collection of Ariane Piëch, Germany
Collection of Marvin and Susan Numeroff, New York
Collection of Rudi Kobza, Austria
Collection of Siegfried and Jutta Weishaupt, Germany
Collection of Suzanne and Bob Cochran, New York
Collection of Svetlana Kuzmicheva-Uspenskaya, Moscow
Galerie Thaddaeus Ropac, London, Paris, Salzburg

Metro Pictures, New York
Robert Longo Studio, New York

The Embassy of Spain in Moscow:
Jose Ignacio Carbajal Garate, Ambassador;
Álvaro De La Riva, Counselor for Cultural Affairs;
and cultural project coordinators Miguel Ángel Arias Carrascosa and Alberto Castro Martinez

State Central Museum of Contemporary History of Russia, Moscow:
Director Irina Velikanova; Head of Collection
Valeria Kargamanova; and Head of Fine Art Department
Vera Panfilova

The Russian State Archive of Literature and Art (RGALI), Moscow:
Director Tatiana Goryaeva; Head of Archive Communications
Natalia Strizhkova; and Head of Exhibitions Larissa Ivanova

Gosfilmofond (National Film Foundation of Russian Federation):
Director Nikolay Borodachev

Special thanks to:

ALTANA Kulturstiftung, Germany: Andrea Firmenich, Andrea Sietzy
Artcosmo Wien: Yasmina Grabner
Acquavella Galleries, New York: Jean Edmonson, Jennifer Rose
Capitain Petzel, Berlin: Friedrich Petzel, Michael Wiesehoefer, Kathleen Knitter, Elisabeth Pallentin, Svenja Schuhbauer
Galerie Thaddaeus Ropac, London · Paris · Salzburg:
Thaddaeus Ropac, Kristina Tencic, Hella Pohl, Xenia Geroulanos, Arne Ehmann, Verene Demonchy, Markus Kormann
Galleria Mazzoli, Modena: Emilio Mazzoli, Richard Milazzo
Hans Mayer Gallery, Dusseldorf: Hans Mayer, Marie Mayer
Kunsthalle Weishaupt, Germany: Siegfried Weishaupt, Jutta Weishaupt, Kathrin Weishaupt-Theopold, Martina Melzner
Metro Pictures, New York: Janelle Reiring, Helene Winer, Karine Haimo, Tom Heman, Margaret Zwilling
Caroline Gillis
Hanane Hilmi
Thomas Kellein

Publisher
Artguide Editions
Artguide s.r.o., Prague, Czech Republic
editions.artguide.com
for Garage Museum of Contemporary Art
Ulitsa Krymsky Val, 9/32
Moscow, Russia
ISBN 978-8-0906714-0-9

GARAGE

Garage Museum of Contemporary Art is a place for people, art, and ideas to create history. Through an extensive program of exhibitions, events, education, research, and publishing, the institution reflects on current developments in Russian and international culture, creating opportunities for public dialogue, as well as the production of new work and ideas in Moscow. At the center of all these activities is the Museum's collection, which is the first archive in the country related to the development of Russian contemporary art from the 1950s through the present.

Founded in 2008 by Dasha Zhukova and Roman Abramovich, Garage is the first philanthropic organization in Russia to create a comprehensive public mandate for contemporary art and culture. Open seven days a week, it was initially housed in the renowned Bakhmetevsky Bus Garage in Moscow, designed by the Constructivist architect Konstantin Melnikov. In 2012 Garage relocated to a temporary pavilion in Gorky Park, specifically commissioned from award-winning architect Shigeru Ban. A year later, a purpose-built Education Center was opened next to the Pavilion. On June 12, 2015, Garage welcomed visitors to its first permanent home. Designed by Rem Koolhaas and his OMA studio, this groundbreaking preservation project transformed the famous Vremena Goda (Seasons of the Year) Soviet Modernist restaurant, built in 1968 in Gorky Park, into a contemporary museum.

Garage is a non-profit project of The IRIS Foundation.